AMERICAN ETCHINGS
of the Nineteenth Century

115 PRINTS

*Selected and
with an Introduction by*
FRANCINE TYLER

DOVER PUBLICATIONS, INC.
New York

ACKNOWLEDGMENTS

The author and publisher would like to thank the many private collectors and institutions who were generous with their time and the loan of material for reproduction:

Print Department, Boston Public Library: 51
Cincinnati Art Museum: 34 (gift of Frank Duveneck)
Hayward Cirker: 39, 107
Courtesy of Cooper-Hewitt Museum, the Smithsonian Institution's National Museum of Design, New York City: 73, 75
Mrs. Pat Eargle Hayes: 18
Hirschl & Adler Galleries, New York City: 53, 103, 110, 111
Mr. and Mrs. Raymond Horowitz: 96, 105
Kennedy Galleries, New York City: 52, 81, 104
Kraushaar Galleries, New York City: 90
Library of Congress: 17, 27
Patricia C. F. Mandel: 16, 19, 22, 23, 35, 36, 89, 91, 114, 115
Property of Mrs. Harriet McKissock: 49
The Metropolitan Museum of Art: 65 (gift of R. B. Dodson, 1931; all rights reserved)
Museum of Fine Arts, Boston: 41 (Museum Purchase Fund, 1888), 57 (Sylvester Koehler Collection), 98 (Museum Purchase Fund, 1888)
National Museum of American Art, Smithsonian Institution: 44
National Museum of History and Technology, Smithsonian Institution: 42
Art and Music Department, Newark Public Library: 1, 3, 92, 93
Print Collection; Art, Prints and Photographs Division, The New York Public Library; Astor, Lenox and Tilden Foundations: 11, 12, 13, 15, 28, 29, 31, 58, 61, 72, 83, 102, 108
The Parrish Art Museum, Southampton, L.I.: 4, 20, 25, 46, 56, 59, 60, 64, 67, 68, 69, 77, 80, 87, 88, 95, 99
Philadelphia Museum of Art: 97 (given anonymously)
From the collection of the Platt Family: 84, 85, 86
Rona Schneider: 6, 9, 10, 21, 24, 26, 30, 40, 43, 45, 47, 66, 70, 71, 74, 76, 78, 79, 82, 100, 113
The Margaret Woodbury Strong Museum, Rochester, N.Y. (H. L. Bickelhaupt, Jr., photographer): 54, 55
Barry and Deedee Wigmore: 5, 94, 101
Property of Richard York Gallery, New York City: 48

The aid of the Montclair Art Museum, Montclair, N.J., is also gratefully acknowledged.

The captions, in many cases, identify works according to state and the number assigned them in standard catalogues (for instance, "Andrews V/ VI" in the first caption).

Published in Canada by General Publishing Company, Ltd., 30 Lesmill Road, Don Mills, Toronto, Ontario.
Published in the United Kingdom by Constable and Company, Ltd., 10 Orange Street, London WC2H 7EG.

American Etchings of the Nineteenth Century: 115 Prints is a new work, first published by Dover Publications, Inc., in 1984.

Manufactured in the United States of America
Dover Publications, Inc., 31 East 2nd Street, Mineola, N.Y. 11501

Library of Congress Cataloging in Publication Data

Main entry under title:

American etchings of the nineteenth century.

Bibliography: p.
1. Etching, American—Catalogs. 2. Etching—19th century—United States—Catalogs.
3. Etching—20th century—United States—Catalogs. I. Tyler, Francine.
NE2003.7.A43 1984 769.973'074 82-9511
ISBN 0-486-24388-5 (pbk.)

CONTENTS

INTRODUCTION:
AMERICAN PAINTER-ETCHERS

The "etching revival"—that movement in the nineteenth century in which many painters undertook etching as a serious art form—began in England early, blossomed in France by the 1850s, blew on art currents back to England, then spread to other European countries and across the ocean to the United States, where it flourished in the 1880s and early 1890s. American expatriate James Abbott McNeill Whistler was by then the most influential and internationally respected modern painter-etcher. Since his first efforts, in mid-century, he had treated etching as a high art, helping to raise it to a new status from that of a commercial craft, to which it had fallen.

Whistler's etchings may be taken as the exemplar of all that the revivalists strove for. Etcher Joseph Pennell, an American disciple, wrote of Whistler's work:

> A great etching by a great etcher is a great work of art displayed on a small piece of paper, expressed with the fewest vital indispensable lines, of the most personal character: an impression, a true impression of something seen, something felt by the etcher, something that means a great deal to him, which can be expressed only by etching.[1]*

American artists took up copper and needle and in the short space of 13 or 14 years produced a notable body of work.

Personality and the Sketch

The desire to express the "personal character of the artist" was the leitmotif of the revival. Etching suited this quest by calling into play the characteristics of freehand drawing. An early enthusiast saw that etchings were like "thoughts' autographs . . . [their lines] marking every turn and shade of thought. . . ."[2]

Etching's qualities of directness and color possibilities are derived from its technique. S. R. Koehler (1837–1900), the American proselytizer for etching, summed up its characteristics:

> 1. Absolute freedom of line, as the point, . . . plays upon the ground with even less friction than the pencil does upon paper; 2. . . . a possibility of indicating color . . . the etched line . . . is jagged along the edges, and this imparts "warmth" and life to it; 3. A range of color, varying . . . from faintest gray to the deepest, velvety black, such as no other process offers. . . . Its greatest value is to be sought in the free play which it gives to the expression of the personal element in art.[3]

Nineteenth-century etchings were not detailed and highly finished drawings, but had a sketchlike appearance, a kind of impressionism derived from the artist's subjective yet faithful rendering of phenomena. When printed, however, they were more than drawings; they became palpable works of art printed on sheets of beautiful handmade paper marked with physical texture from the indentations in the plate and enriched by manifold lights and shades from the inking and wiping of the plate.

Other Considerations

This graphic medium also has a multiplying nature—numerous impressions may be printed from a single plate, but each is an original work of art. These impressions can be owned by many people, each paying a modest price in comparison with the cost of that art-

ist's oil paintings. Hence, etching suits a democratic notion of fine art for the many, enlarging the market for art. In this vein, Mary Cassatt stated some of her reasons for making prints:

> I love to do the colored prints, and I hope the Durand-Ruels will put mine on the market at reasonable prices. For nothing . . . will inspire a taste for art more than the possibility of having it in the home. I should like to feel that amateurs in America could have an example of my work, a print or an etching for a few dollars. . . .[4]

The artist gains, too; multiples of a work tend to popularize the artist's name and extend his or her reputation as well as providing another source of income.

Etching had become an important commodity in the art market, prompting Robert Hoe, manufacturer, bibliophile and founder of the Grolier Club, to republish an 1844 English guide to graphic art information to which he added comments:

> If we look into this matter from a strictly financial point of view, it will be found that for the last seventy-five years the prices of fine prints . . . have steadily advanced. In this respect they will compare favorably with investments in stocks, bonds, real estates, or perhaps any securities in which money is ordinarily placed. . . . The cause of the rise in values of good prints is evident enough. There is a limit to the supply.[5]

There was clearly a market for etchings.

The Dual Revolution and The Artist

Artists' assertion of individuality through the Impressionist mode was a reaction against the dominant and authoritarian values of the Academy and classical training. Artists and their audiences were developing "new values and new ways of seeing" because of the manner in which they responded personally to a world qualitatively changing. Ideas about art, of artists and their place in society were transformed by the "dual revolution," the democratic French Revolution of 1789 and the contemporaneous British Industrial Revolution. Historian E. J. Hobsbawm tried to characterize broadly the wide-ranging effects of political, social and economic changes in this way:

> If a single misleading sentence is to sum up the relations of artist and society in this era, we might say that the French Revolution inspired [him] by its example, the Industrial Revolution by its horror, and bourgeois society, which emerged from both, transformed [his] very existence and modes of creation.[6]

Critic Raymond Williams studied Romantic artists, finding that they were changed by experiencing through their senses, "hunger, suffering, conflict, dislocation; hope, energy, vision, dedication. The pattern of change was not background, as we may now be inclined to study it; it was rather, the mould in which general experience was cast." He cites five main results (which are interrelated). The direct relationship of artist to the public became cut off, while an impersonal market for artists' works, rather than direct patronage, was instituted. A habitual attitude toward the public by the artist was established, namely an aversion to popular opinion in the marketplace. The making of art came to be regarded as one of a number of specialized kinds of production and a special class of

* See the Notes section beginning on page xxiii.

intellectuals was created that furnished the public with thought, reason or art goods for the market. The theory grew that art was a special activity and a means to imaginative truth. There was an emphasis on the artist as a special kind of person. The last two responses emphasize the artist's wish to add in art certain human values and experiences which the development toward an industrial society was threatening or destroying.[7]

The Academy, content with absolute values and static equilibrium, had a clearly defined and relatively small public that shared its moral principles and taste. With the two revolutions, aesthetic individualism took its cue from the prevailing political and economic freedoms. Art critic Philip G. Hamerton discerned that classical training had outlived its relevance. He said, "Classical training has always made it its business to stifle and repress all personal feelings and affections and even to deny the right of exercising intelligence." He had a solution: With the chaotic pull between the old and the new, the true path for the artist was to follow one's own subjectivity, temperament, feelings and the moment in all its picturesque coloring.[8] Art became as diverse as human temperaments are various. Hamerton's real-life model was the French painter Gustave Courbet (1819–1877), who had strong ideas about his role as a modern artist:

> I have simply wanted to draw from a thorough knowledge of tradition the reasoned and free sense of my own individuality . . . to be able to translate the customs, ideas, and appearance of my time as I see them—in a word, to create a living art—this has been my aim.[9]

Artists painted the natural and familiar, hoping to evoke a direct response in the viewer. They eschewed subjects in which schooling in classics was necessary to comprehend what was considered by the cultured the highest category of art—narratives stressing moral conduct using incidents from ancient mythology or the Bible, and termed "history painting."

S. R. Koehler saw how etching would be revived under these circumstances:

> . . . with the decline of interest in the subject the individuality of the artist gains in importance. Hence the value of etching, at certain times, as the most personal of the multiplying arts. Again, as the importance of the subject declines, more attention is paid to the pictorial qualities of art—to color and to effects of light and shade. And as etching is such a magician in the expression of these qualities, it stands to reason that it should be most highly valued when they are esteemed of first importance.[10]

To realize coloristic effects in etching, artists experimented with "artistic printing"—different ways of wiping and printing the plate. One method was to leave a film of ink on the plate which printed as a tone. Whistler's *Nocturne* is an example of this kind of printing. The printer can also leave a film of ink on the plate and remove it from certain areas which create a sparkle of light when printed. Shadows, reflections and such atmospheric conditions as rain and sunshine were achieved. Another method was retroussage, in which a soft muslin cloth is passed over an inked and heated plate, dragging some of the ink out of the furrows. This binds closely bitten lines together in shadowy masses or softens isolated lines when printed. Retroussage was first used in the United States in the 1870s, following the example of a French etching.

Rembrandt Becomes a Modern Guide

Romantic artists, seeking encouragement for their practices in the precedent of an older art to lend credence to their views, found it in the work of the Dutch seventeenth-century painter-etchers. The "etching revival" was pictured as a renaissance of the art as Rembrandt and other Dutch artists had developed it two hundred years earlier.

Etcher Seymour Haden stated in his characteristically all-or-nothing way: "the history of Rembrandt is the history of the whole art of etching."[11] American art dealer Frederick Keppel found that "there is probably no etcher living who would not be proud to call himself a 'Disciple of Rembrandt!' "[12]

Rembrandt's work appealed to the feelings of nineteenth-century artists as well as being a source book for experimentation. His etchings presented five qualities that were important to them: he expressed his subjective vision; his subject matter (except the religious pieces) was of reality, comprising portraits, landscapes and genre; each motif suggested its own development which he brought into being with an autographic line, "with certain scrawls and scribbles and irregular strokes and without outline";[13] he achieved various moods by manipulating light and shade; he was an experimenter in technique, in "artistic printing" and used various papers. It is also thought that the nineteenth-century preference for warm-toned brown ink derived from the taste for Rembrandt prints which had mellowed with time, the ink turning brown and the paper becoming warm-toned.[14]

Koehler's associate, the first professional woman art critic, Mariana Van Rensselaer, said: "It is . . . power of expression which brings his art so closely home to modern minds . . . to care for the soul more than the body and to care for the passionate and complicated more than for the calm . . . and simple moods of the soul, is the great characteristic of the modern world in art of every kind. . . ."[15]

The English Etching Revival

The Dutch painter-etchers were the impetus for John Crome (1768–1821) to lead the way in the English revival.[16] He collected their works and modeled his etchings on those dune, forest, waterfall and river scenes in the etchings of Jacob van Ruisdael (1628–1682), finding his own sites in the countryside of East Anglia.

The Portfolio magazine published an assessment of Crome's work in 1879, admiring the way he "rendered in etching . . . the little bits of picturesque beauty that he met with in his daily walks."[17] A later writer noted that his etchings were "bits of personal observation . . . done solely for pleasure of remembrance."[18]

The Scottish artist Andrew Geddes (1783–1844), influenced by Rembrandt, completed 40 portraits and landscapes in drypoint between 1822 and 1826, being one of the first artists to revive drypoint.

The vigorous line etchings of Joseph M. W. Turner (1775–1851), executed for his *Liber Studiorum* (1807–1819), were appreciated later in the century, as were the dramatic tones of his mezzotints. Thomas Girtin (1773–1802) made a beautiful series of soft-ground etchings of views of Paris. John Constable (1776–1837) made four breezy etchings in the spirit of his pencil copy of Ruisdael's etching *The Wheatfield*.

Artists founded professional clubs which encouraged original (as opposed to reproductive) etching and published special limited-edition books containing original etched illustrations. The (Old) Etching Club (1838–1885) required members to submit plates based on given themes found in poetry or fables and published several volumes from 1841 to 1880. The members, with some exceptions like Seymour Haden and Samuel Palmer (1805–1881), adhered to the then popular preference for delicately and minutely drawn sentimental subjects in a small format. The plates were wiped clean of surface ink and printed to resemble engravings.

Samuel Palmer received etching instructions by club members in 1850 and created his first etching (*The Willow*) at their prompting. He continued making his rapturous images, which were published between 1850 and 1881.

The Junior Etching Club (1857–1864), an offshoot of the older club, also published several etched volumes. Whistler briefly belonged (having joined in 1859) and contributed two freshly observed etchings of river scenes.[19] Entitled *The Angler* and *A River*

Scene (later retitled *The Punt* and *Sketching No. 1* respectively) they were included in *Passages from Modern English Poets,* 1862. Perhaps because of the membership of Whistler and Haden, the club's etching practice began to change from a strictly illustrative use of etching to a more art-oriented emphasis. Their themes depicted "the daily scenes of social life in our streets and cottages, and in the varied aspects of rural nature."[20]

Haden continued to support group work by being the organizing spirit behind the Society of Painter-Etchers, founded in 1880. He was its president for 30 years. The society stressed an international outlook by trying to reach all painter-etchers and by encouraging original etching. It was also a goal to force the exclusionist Academy to elect painter-etchers to its membership.[21]

Knowledge about etching and original and reproductive plates were disseminated through such art periodicals as *The Art Journal* (1839–1911); *The Fine Arts Quarterly Review* (1863–1967); *The Portfolio* (1870–1893); *The Magazine of Art* (1878–1904); *The Etcher* (1879–1883); and *English Etchings* (1881–1891).[22]

The French Etching Revival

The English etchers were the earliest to draw their impressions of the light and color in nature on copper, but it was the French School that influenced a broad and international movement. The foremost reason for this must be that there were many major French artists whose fame transcended national boundaries and many of them made etchings. There were over 8,000 artists in Paris. The French Etching Club (1862–1867), based on the English, developed an international membership. In addition, an impressive number of the French cultural establishment supported etching. Paris was an international art market in which the sales of paintings averaged 40 million francs each year. American S. G. W. Benjamin wrote, ". . . art is, on the whole, the business engrossing the attention of a larger number and employing more capital than any other legitimate business in Paris."[23]

Barbizon artists initiated the revival. Charles Jacque (1813–1894) is considered the "father" of the nineteenth-century revival of etching. He modeled his work on the Dutch, but perhaps it was in England, where he worked as a wood engraver (1836–1838), that he was influenced also by the landscape school and knew of the activities of the first Etching Club. He returned to France and in the early 1840s began his lifetime production of over 470 tranquil etchings and drypoints depicting pastoral occupations amid seasonal changes. Jacque may have influenced his friend Jean-François Millet (1815–1875) to paint and etch rustic subjects. The two of them found Barbizon, a small forest village three miles north of Fontainebleau, and settled there in 1849. Jacque familiarized Millet with etching and Millet took up the technique seriously in 1855.

Between 1838 and 1874 Charles François Daubigny (1818–1878) was a prolific etcher of country rivers, fields and fauna at various times of day—at sunrise, in the evening, even by moonlight.

Théodore Rousseau (1812–1867) etched four forest scenes in the Ruisdael manner. Jean Baptiste Corot (1796–1875), who made his first etching in 1845, etched landscapes of poetic power on copper plates as well as creating about 65 glass prints (*cliché verre*). Daubigny, Millet and Jacque also experimented with glass prints.

Inspired loner Charles Méryon (1821–1868) developed a series of haunting Paris scenes with imaginative additions. The Dutch artist Johann Barthold Jongkind (1819–1891), who spent most of his career in France, etched effervescent seascapes of the French coast. Alphonse Legros (1837–1911), a powerful etcher of grave peasant life and portraits, crossed the Channel in 1863, settling in London to become a teacher of etching first at the school at South Kensington and later (1876–1894) at the Slade School of Art. A founding member of the French and English etching clubs, he is an important figure in the revival. Until 1867 Legros, Whistler

and Haden were friends and etching companions, going on at least one sketching trip together for six weeks in Holland in 1863. Félix Bracquemond (1833–1914), who accomplished etchings of strong character influenced by Japanese art, was a master printer and taught Corot, Millet, Rousseau, Manet and Degas. He also showed Edmond and Jules Goncourt how to etch. They wrote *Manette Salomon*, a novel in which a failed painter turns to etching as a consolation. Félix Buhot (1847–1898) filled the margins of his work with delightful drawings; Maxime Lalanne (1827–1886) was considered a graceful etcher, but his works are now ignored. He wrote the best technical book of the day, *A Treatise on Etching* 1866, (*Traité de la Gravure d l'eau-forte*) which Koehler translated into English and published in 1880 (Dover 24182-3). Lalanne taught Victor Hugo to etch. A number of Impressionist painters, including Manet, Degas, Pissarro and American expatriate Mary Cassatt, made major statements in etching.

Noting the revival among etchers and hoping to interest a larger public by publishing print portfolios, the French Etching Club (Société des Aqua-fortistes)[24] was founded in 1862 by the dynamic publisher and print seller Alfred Cadart (1828–1875), engraver Bracquemond, Auguste Delâtre and that Renaissance man of etching, Haden. Delâtre, who started his career working the presses for Jacque, ran a large workshop where he printed etchings only. Invited by Whistler and Haden, in 1860 he went to London to print some of their work and to establish a class in etching at the South Kensington Museum school. Delâtre later returned to spend five years in London (1871–1876). Haden became the first president of the French club. Each month the club published five prints in a gray paper cover entitled *Eaux-fortes Modernes* (Modern Etchings).

After the demise of the Société des Aqua-fortistes, Cadart and his partner Luquet founded the Society of Painter-Etchers (Société des Peintres-graveurs à l'eau-forte, 1867–1880) which Cadart's widow continued after his death. It was modeled on the previous society, but contributors to their new publication *L'Illustration Nouvelle* (begun 1868) were not the former brilliant group. Instead, its members were amateurs and mediocre artists, with a few exceptions like Bracquemond and Legros.

Cadart sold etchings to American art dealer George Lucas and others, and he determined to develop commercial relations with the United States directly by setting up etching clubs modeled on the French one. Arriving in 1866 with French etchings, paintings and etching supplies, Cadart made contacts in New York, Boston, Philadelphia and Baltimore (Lucas' hometown) and held exhibitions and etching demonstrations.[25] He provided the general public and collectors with an opportunity to see and buy a collection of the works of such contemporary painter-etchers and reproductive etchers as Daubigny, Jacque, Mariano Fortuny and Jules Jacquemart and painters Eugène Boudin, Jules Dupré, Constant Troyon and Courbet. Boston particularly welcomed Cadart; its artists J. F. Cole, Elihu Vedder, A. H. Bicknell and Thomas Robinson were fresh from the Paris art scene and were ardent advocates of modern French art.[26]

Cadart had some success in the United States but was not able to set up any American branches of the French Etching Club. Several Americans took etching lessons from him here, including J. Foxcroft Cole, Edwin Forbes, J. M. Falconer and C. H. Miller. Edwin Forbes was elected a member of the French Etching Club and his etching *Épisode de la Guerre d'Amérique* was published by the club in October 1866.[27] This print is similar but not identical to *Through the Wilderness* in his series on the Civil War, "Life Studies of the Great Army," published ten years later. This contact with Cadart seems to be the catalyst for Forbes's decision to etch rather than engrave his drawings of Civil War scenes. Thus Forbes is considered a pioneer of the American etching revival, although he did not have the true "etcher's spirit."

French etching was popularized by being published in the

French art magazines that printed modern original and reproductive work: *L'Artiste* (1831–1904); *Gazette des Beaux-Arts* (1859–); *L'Art* (1875–1907).

Etching in Munich

American etching also received an impetus from the many younger artists who studied in the art schools of Munich, another great art capital, often with teachers who were influenced by the breadth of handling and color of contemporary French art. Some of the students included Charles H. Miller, who went to Munich in 1862, and Frank Duveneck, William Merritt Chase, Henry Twachtman, Otto Bacher, Robert Koehler and Frederick Dielman, who were there in the 1870s. Students often sketched from nature in the medium of etching; while a student, Bacher etched a series of the outskirts of Munich, which brought him to the attention of S. R. Koehler. Both Chase and Duveneck studied with Wilhelm Leibl (1844–1900), a painter-etcher who had studied previously in Paris and worked in rural Bohemia, like a German Millet.

The German art magazine *Zeitschrift für bildende Kunst* (1866–1930) was read in the United States.

Hamerton

Among the influences that were the most highly motivating to the American etching revival, according to Van Rensselaer, were a respected art writer's handbook, an art amateur and a professional artist. To be specific, Philip Gilbert Hamerton's book *Etchings and Etchers* (1868) was effective in "prompting artists to take up the point, and in telling the public how to appreciate their efforts"; Seymour Haden "opened the market to all good workmen, for he opened the eyes of his countrymen and our own"; James A. McN. Whistler "had a strong direct influence upon some few of our men as well as a stronger indirect influence upon the art in general."[28]

Philip Gilbert Hamerton (1834–1894) was an essayist, art critic, autobiographer and lesser painter-etcher. He was an Englishman who studied art in Paris and made a home ever after in France but also remained involved with the English art world.[29]

His first book, *The Painter's Camp* (1862), which detailed his adventures painting out of doors in the Scottish Highlands, gained him a readership in the United States. He continued to write for a number of magazines in America, including *Atlantic*, *Putnam's* and *Old and New*.

His book *Etchers and Etching* (1868) met the need for a philosophical and technical investigation of etching and was successful, going through several editions in 1876 and 1880. It discussed the qualities one could achieve in etching and the various schools, and was also a practical manual of detailed instructions for constructing a press (which would cost £2 to make) and technical hints and formulas for acids for biting the plate. He illustrated it with newly printed etchings from original plates (restrikes) of Palmer, Haden, Jongkind, Rembrandt, Adriaen Van Ostade (1610–1685) and Paul Potter (1625–1654). American artists used *Etchers and Etching*. Henry Farrer built a press and crafted some etching tools in 1868, probably following Hamerton's instructions. Farrer also about this time made a highly uncharacteristic etching *The Washerwoman*, freely copying, I believe, a plate in the book by Armand Gautier *Le Travail: Femme Repassant* (Work: Woman Ironing; 1864). Otto Bacher, in Munich, had a press built based on the instructions in the book and took the press with him to Venice, along with the book for reference.

Hamerton also published *The Portfolio* (1870–1893), and commissioned etchings to illustrate it. It became one of the prototypes for the *American Art Review*. The early issues contained his journal and slight etchings of picturesque moments from the leisurely sketching journey he made by canoe down the French river Arroux. His illustrated journey might have been influenced by Daubigny's etchings made during his travels in a studio-boat. This impelled Hamerton to invite Joseph Pennell in 1886 to travel with him and etch the sights seen from a boat voyaging down the Saône River from Lyons.[30] Hamerton felt that etching "is the only kind of engraving which can be done directly from nature, and the only engraving, too, which has enough of the spirit of liberty to harmonize with such a state of mind as that of a wandering canoist."[31]

The American art critic J. R. W. Hitchcock credited Hamerton's influence:

> Mr. Hamerton's writings have been read from the Atlantic to the Pacific and it has dawned upon many readers that a liking for etchings is an evidence of a refined and cultivated taste. . . . It has become fashionable to show an interest in and love for etchings.[32]

Haden

Sir Francis Seymour Haden (1818–1910) was a frank and forceful person, a busy physician-surgeon, a haughty Tory aristocrat, yet an etcher of great sensitivity, a print collector, a connoisseur. In the late 1850s and early 1860s he was a friend and an etching companion to Whistler, his young brother-in-law. With Rembrandt's work in his memory, he rendered rivers, foliage, shadows and reflected lights of the rising or setting sun, producing lush views of a well-loved English landscape.

Haden developed art ties in France, England and the United States. He had studied in Paris as a medical student, had made his first etchings (1843–1845) on a holiday in Southern France and had exhibited some of his work at the Paris Salon of 1859. The French Etching Club gave him his first exhibition in 1864 and in 1865 a portfolio of 25 etchings was published in France. These and succeeding years were active in etching. When Whistler moved to London in 1859, the two encouraged each other by etching the family at home and went on sketching trips together, often working side by side in front of the same subject. They carried plates to Greenwich Park and etched there in 1859, Haden producing *Sub Tegmine* and Whistler *Greenwich Pensioner*. *Trees in the Park* (1859) was a plate signed by both artists, Whistler probably etching the figures and Haden the landscape.

For his Society of Painter-Etchers (renamed, with royal patronage, the Royal Society of Painter-Etchers and Engravers) he enlisted American artists. His efforts were fruitful; in the first exhibition (1881) 492 etchings were shown, 121 of which had been sent by Americans.

American artists were well aware of Whistler's and Haden's art reputations and felt some trepidation about entering their work. J. M. Falconer wrote to Koehler:

> I too await the events of the Etchings sent to London not feeling anything can be predicted of them. Haden and Whistler are lords of the domain there and if they but nod approvingly, some crumbs may come hitherwards, but I do not think the expectation will be large.[33]

Haden approved of their work and this acceptance bolstered the confidence of the artists involved. J. D. Smillie wrote to Koehler:

> By the by, will tell these sluggish home buyers that if they don't look out we won't let them have any of our work, preferring the English market, then probably the Snobs will discover that sometimes something is done here that is worth having.[34]

Between 1880 and 1887, 16 American artists were elected fellows of the English society.[35] It made arrangements to sell works in its exhibition on a commission basis. The New York Etching Club reciprocated in 1883; eight members of the English club showed with it and Haden wrote the introduction to the catalogue. American etchers did not stay long. Many of Haden's promises to them were not fulfilled (although he bought American etchings for his own collection) and no American was elected to their executive committee.

Haden was an authority on etching and created an interest in it.

The Magazine of Art quoted extensively from a series of three lectures in which he stated his main idea: "The best art is . . . suggestive rather than imitative. . . . To say then of the etched line that it is merely suggestive is to acknowledge its power."[36]

In 1882 Haden lectured on the merits of original etching in many of the principal cities of the United States—New York, Boston, Chicago, Cincinnati, Philadelphia, Detroit, St. Louis and Baltimore. In New York, his dealer Keppel arranged an exhibition of his work at the Lotos Club, where the large attendance at a reception included some members of the English etching club and the American painter-etchers Thomas Moran, Mary Nimmo Moran, Kruseman Van Elten, George H. Smillie, Charles H. Miller, the art critic S. G. W. Benjamin and dealer Samuel Avery. Haden's work encouraged American artists to find their inspiration at home. Keppel reported a train journey from Yonkers to New York City when the sun setting behind the Palisades was mirrored in the Hudson River. Haden remarked, "Now why have I never been told of the beauty of all this?"[37]

Haden was ranked "the greatest living landscape etcher" yet he was an "amateur."[38] Being an amateur was his source of strength as he etched for the love of the art without need to earn his living at it and thus did not have to satisfy a market, but only himself. He would ignore then-current dictates of pretty storytelling pictures and pursue an individual course. He told Keppel, "I have never been a reading man . . . my aim through life has always been to be an observer, an investigator, an original thinker—always with some definite aim and with some progressive purpose."[39] Hamerton recognized that Haden had created an art of his own: "But the artist who neither works for an income nor reputation need not suffer . . . His art is not speech from a platform, but a sincere soliloquy in the presence of nature and God."[40]

Haden collected Rembrandts and other old-master prints and those of Whistler. Even before he began to collect he would borrow a portfolio of etchings from a London dealer and, said Keppel: "carrying home such treasures he would sit up all night with them—not only delighting in their beauty as other amateurs do, but also studying and analyzing the method and technic of each master."[41] His work was exhibited in the United States in the 1870s and 1880s and was studied by artists. J. D. Smillie wrote to Koehler: "There is a fascinating lush mellowness about the drypoints that is almost wholly a matter of printing. I would be willing to give liberally from my poor pocket if that collection could be permanently placed where I could get at it for study."[42]

Whistler

American expatriate James Abbott McNeill Whistler (1834–1903) became internationally known as a great creative artist and as a fascinating personality. He made his first mark as an etcher and his influence in this art was pervasive over a period stretching from the 1880s into the 1920s. Of him, art historian Richard Muther has written:

Etching, as Rembrandt showed, permits the artist to create a dreamy world of sentiment, light and poetry far more readily than painting. It was not by chance, therefore, that Whistler, the great composer of symphonic tones, made it his medium also, and became a master of etching with whom no other artist of the present age can be compared.[43]

Van Rensselaer said he was "one with whom no other—man or woman—can possibly compete."[44] Of his influence she said, "his plates assisted those of Mr. Haden in the good work of bringing the etcher's art once more into wide popularity."[45]

His work was deeply respected by artists. When a wealthy collector asked William M. Chase what to purchase, Chase answered, "By all means get a set of Whistler's etchings . . . he will make you a selection."[46] Mary Cassatt advised her friends to buy his work. Otto Bacher and Joseph Pennell were two artists among many who benefited from his work. Bacher said: "I had studied his works and enthusiastically searched for the subjects depicted in his etchings on the Thames."[47] Pennell: "Though I never studied under Whistler—never was his pupil—he is and always will be my master."[48] Whistler's influence on Pennell began in his early Philadelphia scenes, which reflect the "Thames" etchings. Pennell and his wife later became friends and biographers of Whistler. A group of artists, including Bacher, Blum, Duveneck, Corwin, Rosenberg and John Twachtman, were directly influenced by Whistler in Venice in 1880.

Whistler derived satisfaction from every phase of etching; he labored over his plates and was an indefatigable experimenter in printing them; he was able to create a reputation for the art as being truly of consequence. He was a severe critic of others but no more so than of his own works; the many plate states and variations in printing bear this out. He also destroyed unworthy plates and tore up unsatisfactory proofs. Howard Mansfield, who knew Whistler's work well, wrote: "Every change which the artist makes must be regarded . . . as a criticism of what had gone before, instead of a mere development of a theme."[49]

When he was satisfied with his line work and printing he penciled in "imp" (printed by) and a butterfly (his ideograph) on the proof. He had shown that modern life could be interesting and picturesque, depending on how the artist saw it. In his "Thames" series, he discovered for himself and others that industries sprawling alongside rivers were aesthetic material. The French poet Charles Baudelaire described the prints as "profound and intricate poetry of a vast capital."[50]

In his etchings of Venice Whistler did not seek out the routine sights of the cultured tourist with Baedeker in hand. As critic Frederick Wedmore stated:

. . . the lines of the steamboat, the lines of the fishing-tackle, the shadow under the squalid archway, the wayward vine of the garden had been as fascinating, as engaging, as worthy of chronicle, as the domes of St. Mark's. His subject was what he saw, or what he decided to see, and not something that he had heard about. It [Whistler's work] has at all costs to be exquisite evidence of Art.[51]

One of Whistler's devoted admirers was Otto Bacher, who in *With Whistler in Venice* reported how Whistler worked, how he would carry grounded plates with him out of doors and draw in front of the motif—for in Venice life and occupations were carried out in the open. Whistler rented a gondola as a traveling studio-boat and took with him etching plates, both grounded and ungrounded (for drypoints), protected between the pages of a book. He carried his needles in his pocket, punched in a cork. He bit and printed the etchings in his careful manner in Venice or on his return to London. Bacher at first was skeptical that Venice, "a wealth of color," could be treated in line. During this period the glorious color of Venice did affect Whistler. He painted on his plate with an inky rag or left a film of ink after hand-wiping, so that each impression was a unique work of art. He obtained tones and shadows, water effects and reflected lights this way, achieving a softer more painterly treatment of Venice, as in *Nocturne*. The printer Thomas Way related: ". . . he confessed he was a little homesick in Venice with its eternal blue skies, and that he pined for London with its hansoms and fogs 'of which I am the painter.'"[52]

The apprehension that Whistler turned out masterpieces in front of the motif at will has to be qualified. Robert H. Getscher has found that: "Whistler used his drawings to help him solve problems of composition, perspective, and shading before he touched the copper, so that he could then work deftly, swiftly, and knowingly before his subject."[53] An example of "planned spontaneity" is the etching *The Balcony*. Whistler first worked out the structure of a balcony and the doorway in a pencil drawing and then in pastel, so that in the etching "he could concentrate on the

graphic freedom and lightness of his touch." Rembrandt's practices, researched by Christopher White, seem to be essentially the same. He sketched in front of a motif to get to know the subject, then, when etching, "he learned to allow the etching to suggest its own way . . . keeping the forces of the unexpected on a loose rein."[54]

Whistler looked for beautiful old paper to print on, trying "unused sheets from old account books and the blank sheets from old printed books,"[55] and Chinese, Japanese and Van Gelder papers.

Americans began to learn of Whistler through travel and personal contact, recommendations by artists and dealers commuting between Europe and America and through exhibitions. Whistler had been acquainted with George Lucas, an American art dealer living in Paris, since 1858. Lucas collected his works, either buying them or accepting them as gifts for favors done. Lucas' business associate Samuel Avery also collected, exhibited and sold Whistler etchings in his New York gallery.[56] In 1874 the first catalogue of Whistler's etchings was published. Avery was directly involved in its publication; he paid half the cost of printing 50 copies and received half of the edition.[57]

The American Experience

Koehler often spoke in the 1880s of the boom in etchings, which were becoming the most popular art of that time. The revival included several mutations. There were the personal, artist's etchings which a connoisseur described: ". . . the witchery of the painter's etchings, with their freedom and grace; often mere suggestions, but fresh from the mind—full of spirit and genius. The point gliding easily over the surface, follows the inspiration of the moment."[58]

Haden defined their scope as having "the more precious and less heroic qualities."[59] These works had a limited audience; for example, critic J. R. W. Hitchcock noted Whistler's "etchings, despite his real eminence . . . his notoriety, still appeal to connoisseurs rather than our public."[60] One can call them works embodying the real spirit of the etching revival, for it was this kind—a personal work by a caring artist—which survived the fad and became important in the twentieth century.

An elaboration of "artistic printing" alone, without etched lines, produced a painterly type of graphic work—a monotype—from which one print could be made. It was a technique of the seventeenth century reintroduced in the early 1880s; a number of artists, including Peter Moran, Charles A. Walker, Albion Bicknell and the Duveneck "boys"—the group of students who were with him in Italy—took it up. Koehler described William B. Chase's process with the monotype:

These impressions—heads, landscape sketches, and the like—are produced by covering a metal plate uniformly with printer's ink, . . . the design is wrought out upon the plate by wiping away the ink with the finger, a rag, or stumps. . . . The results . . . are very fascinating, and offer pecularities which it would not be easy to obtain by any other method.[61]

There also was developed, and quite early, a large, "decorative" full-toned etching which looked more like a monotone painting, or even a photograph. Properly displayed in a large, ornate frame, it was deemed suitable to decorate the walls of the house. These were either original etchings or reproductive etchings after famous old-master or contemporary paintings. By reproduction, masterpieces of art were brought into "daily companionship" with the average person. Americans wanted pictures, and oils cost too much. They demanded in prints "as much of a picture as possible for the money."[62]

Etchings became valued as illustrations for deluxe books and magazines; in low-priced publications they were copied in the more easily reproducible medium of wood engraving.

Etchings by as many as 20 different artists were assembled in a "deluxe" book along with an introduction by a noted etching authority. A sheet of explanatory writing was interleaved between each work. These notes were of the most banal type, describing the literal subject in a superrefined air.

Etching was in vogue with hobbyists too, for the interested person could achieve artistic effects rapidly and without a high degree of specialized training.

All the latter variations of the revival should be termed the etching craze, which was spurred on by a new and dynamic marketing system. Competing print publishers produced large etching editions by using factorylike methods. They advertised nationally in magazines and did business by catalogue, reaching buyers from the East to the Pacific by the transcontinental railroad, which distributed goods cheaply. Print dealers began to open art shops in principal cities. The etching craze was a fad of perhaps ten years' duration that was replaced by other fashions for the mass market.

The collectors of fine etchings were important business magnates in shipping, manufacturing, railroads and energy sources who traveled to Europe and bought art and architecture on trips that also served business purposes. This double purpose is illustrated by the international trade expositions that exhibited all the wares of a country—from huge machinery to art. The Great Exhibition of 1851 at the Crystal Palace in London was the beginning of these panoramic fairs in industrialized countries.

Of the Universal Exhibition held in Paris in 1867, "every civilized nation on earth had sent thither a contribution of its products," reported the Vermont Commissioner Albert D. Hager:

. . . considered in its narrowest sense . . . in a pecuniary point of view . . . I am of the opinion that . . . the new avenues of trade that will be opened to American manufacturers and the useful hints that our artists and artisans will acquire and bring home with them, will more than compensate for the aggregate expense incurred by American contributors.[63]

Included in the American art section were oil paintings, sculpture, "Native American objects," drawings, crayon work, engravings on medals, architectural designs and models, steel engravings, a few etchings—only by Whistler—and lithographs.

The rise of American etching can be charted in three other exhibitions. At the American Centennial Exhibition of 1876, held in Philadelphia, Forbes, Peter Moran and G. L. Brown exhibited etchings, but they were considered a novelty. The Universal Exposition of 1878, held in Paris, displayed about 12 etchings by three Americans. At the World's Columbian Exposition, held in Chicago in 1893, approximately 340 etchings by 33 American artists were exhibited.

The American Etching Clubs

The sale of etchings in multiple copies was just one of the ways, besides painting, by which American artists sought a livelihood. They also taught art in schools, became writers on art or illustrators for the magazines. To promote their professional standing they united in various clubs, hoping to sell new forms of art to American and European patrons.

In 1879 the American revival, said Hoe, was "in its incipient stages . . . a matter of the future and not of the past or present." Although he cited Whistler, there were few other etchers he would name, but he noted, "professional artists are turning their attention to it and practicing it to some degree."[64] The professional artists to whom he referred were the members of the New York Etching Club, founded in 1877, which was beginning to exhibit their works. In the years following the Civil War, artists, as other professionals in specialized fields of education, law, medicine, journalism and social work, were organizing and joining free associations to promote their special aims through their own activity. In New York over 20 clubs were formed, including the American Society of Painters in Watercolor (1866), the Art Students League

(1875), The Society of American Artists (1877) and The American Society of Painters in Pastel (1882). Koehler said:

[For etching] the necessity of mutual support and encouragement was . . . felt by those who took it up, and the result was the formation of societies and clubs, most of which combined the ideal interests to be subserved by the advantages of fellowship with the more practical aim of becoming publishers, either directly or indirectly, of the etched work of their members.[65]

The real activation of a popular interest in etching came about through the organization and activities of these clubs: Chicago formed a short-lived one in 1870; the New York Etching Club was formed in 1877; the Etching Club of Cincinnati began in 1879; the following year the Philadelphia Society of Etchers and the Boston Etching Club were organized; in San Francisco one was contemplated but failed to materialize; the Brooklyn Etching Club was organized in 1881; and the Brooklyn Scratcher's Club, organized in 1882, closed after a short time.

But the strongest, longest-lived and most productive was the New York Etching Club, founded by 20 artists. At their first meeting in a "captive studio," there was a demonstration of etching even though half of them already knew the technique. James D. Smillie grounded the plate, Robert Swain Gifford drew the small landscape, and Dr. Leroy M. Yale, "an elegant brother, who had dined out early in the evening, laid aside his broadcloth, rolled up the spotless linen of his sleeves, and became for the time an enthusiastic printer."[66]

It was generally the younger artists who were members. They were expected to meet on the second Monday of each month and bring with them specimens of their latest etchings. Classes in etching were given at the club, a press was provided from which proofs were pulled, and informal discussions were held. Above all, every year from 1879 to 1893 (except 1890), exhibitions were mounted at the National Academy of Design. From 1882 on the club published catalogues of their exhibitions containing a few small etchings—miniature original facsimiles of the full-scale prints on display.

As we have seen, there was a sporadic interest in etching by individual artists who had exhibited before the New York Etching Club's first exhibition in 1879. Etchings were included in "Black and White" exhibitions, which also featured work in pencil, charcoal, chalk, pen and ink, washes, monochromes, oil sketches and wood and steel engravings. Some were sketches done for their own sake, but a great many were illustrations made for magazines. With the development of photography, black-and-white drawings became a distinct art for illustration; they printed well and harmonized with type. The Salmagundi Club had initiated the first "Black and White" exhibition in 1872, but it did not become a fixture until 1878. Works in black and white were featured at the annual American Society of Painters in Watercolor exhibitions, which included etchings from 1874.[67] The exhibitions enabled artists to sell works from the walls as well as serving as a showcase for the publishers.

The introduction to the New York Etching Club's first catalogue noted: "The interest begun in studios goes out with stimulating effect to amateurs, connoisseurs and collectors, and has of late developed into almost a passion."[68]

Harper's Weekly reported on the 1882 exhibition:

The Etching Club has marched at a single stride from one panel of proofs to the occupation of two entire galleries in the National Academy and there is no part of the Watercolor Society's exhibition that is more interesting. New men, as in the watercolor school, are rapidly coming to the front.[69]

Women Etchers

The number of women artists increased during the latter half of the century; a number of them took part in the etching revival along with their male colleagues. Women had been involved in printmaking since the sixteenth century, many as professional engravers and etchers connected to the shops of artisan fathers, husbands or sons, executing reproductive engravings. Engraving, one of the first trades that women entered, was a necessary and highly esteemed occupation. As artist and teacher Judith Brodsky points out:

. . . the anonymity of printmaking, its classification much of the time as a craft rather than an art, and the proto-capitalist cottage industry nature of the engravers' shops led to more involvement by women in printmaking than the more prestigious mediums of painting and sculpture from which they were likely to be excluded.[70]

Several women engravers became very well known as professionals. Of the women painters, including Elisabetta Sirani (1638–1666) and Angelica Kauffmann (1741–1807), some made original etchings. Madame de Pompadour in the eighteenth century and Queen Victoria in the nineteenth were famous amateurs.

Like their male counterparts, most women etched during the etching boom, but a few continued to make etchings throughout their careers. They exhibited their work at the New York Etching Club annuals or at art galleries. Their etchings were published by print publishers who sold them to a mass market; they were also included in the volumes of etchings which were bought by collectors and museums.

In 1887, under the curatorship of S. R. Koehler, the first exhibition of the work of American women etchers was organized at the Boston Museum of Fine Arts. It comprised 388 etchings by 22 artists. The museum bought 16 etchings by seven artists for its collections.

The following year an expanded exhibition was held in New York. Of the 513 etchings by 35 women, the earliest was a work made in 1844 by Sarah Cole, Thomas Cole's sister. Van Rensselaer, who wrote the catalogue introduction, commented that women had shown "their wish and established their right to be judged in the same temper and by the same standards as their brethren."[71]

Of all the painter-etchers of this newly emancipated American group, Mary Nimmo Moran became internationally best known and most richly rewarded. Emily Faithfull recorded that: "In England, from Mr. Ruskin downwards we recognize that in Mrs. Mary Nimmo Moran, New York possesses the best woman etcher of the day."[72]

Partly because Mary Cassatt did not reside or exhibit often in the United States, her work then was little known in her native land except by a few collectors and artists, although it was esteemed by the Paris art world. Keppel included four of her drypoints in the exhibition of his collection at the Woman's Building of the 1893 Columbian Exposition; in the same year the New York Etching Club exhibited her drypoint *The Parrot*.

A number of women etchers received professional art instruction at the Pennsylvania Academy of Fine Arts and learned to etch with Stephen Parrish.[73] Gabrielle de Veaux Clements and Blanche Dillaye were two of his students. Women were especially encouraged to enter the Academy when males entered military service during the Civil War.

The Philadelphia School of Design for Women had been founded in 1844 with the purpose of being a professional school for women. By the 1880s it taught oil and watercolor painting, modeling from life, etching, wood engraving, china decoration, wood carving and illustration.[74] One of the founders of the two schools was engraver and illustrator John Sartain (1808–1897). Of his eight children, four became engravers or painters. His daughter Emily (1841–1927) became known as "the world's only woman artist in mezzotint" and was also an authority on art education for women. She was the principal of the Philadelphia School of Design for Women for 33 years (1886–1919). Peter Moran was the etching instructor there.

A similar school, the Cooper Union Free Art School for Women opened in New York City in 1854. R. Swain Gifford became affiliated with it in 1877. The Art Students League accepted women in 1875.

Outspoken Anna Lea Merritt felt that it was easy to get an art training but most difficult to become a professional artist. She wrote of her experience:

> In America the patronage of native art used to be so exceedingly timid, though enormous prices were given for French pictures, that formerly young American artists had either to live abroad, so as to enter their native land under foreign colors, or open a studio and teach amateurs—almost exclusively lady amateurs.[75]

Most of the women spent long years of art training in Europe, particularly Paris. In 1880 the Académie Julian became one of the first Paris art schools to admit women. Clements, Ellen Day Hale and Margaret Lesley Bush-Brown studied there. Hale had begun in Boston as a student of William Morris Hunt, a disciple of French modern art who, as a teacher, encouraged spontaneity and originality and "stressed the primacy of the artist's impressions or feeling."[76] Hale was taught to etch by Clements in 1885 in France. Anna P. Dixwell was another student of Hunt who made etchings, which she exhibited at the New York Etching Club in 1883 and 1884. Eliza Greatorex and her daughter Eleanor both studied in Paris and were etchers. Anna Lea Merritt studied in London.

An art career could be open to women, said English art writer Leader Scott (the pseudonym of Lucy E. Baxter):

> New careers must be made for women, and art opens a wide field for her. . . . It is by no means necessary for her to confine her efforts to mere watercolors and oils. She may etch, and draw on wood. She may design chintzes and wall-papers for manufacturers, paint on china in a porcelain manufactory; paint tapestries for hangings, portieres, and screens and also paint on silk dresses. . . . Again, why should not women take up the art of wall-decoration as a profession? . . . and the more delicate uses of wood-carving, as for frames, letter-cases, work boxes.[77]

Single, widowed or divorced women were entering the work force using the new job opportunities to escape the terrible poverty and dependency of lives without steady wages, or the drudgery of teaching at low wages. Art training and an art profession were welcome possibilities for them.

The handbook of the Women's Building at the World's Columbian Exhibition (where 19 American women etchers' work was exhibited) observed that, of those with families: ". . . women must contribute to the expenses of the household. It is this economic necessity which has forced the vast army of women workers into the higher fields of labor. . . . Today the struggle for bread has become so fierce that no allowance is made for sex."[78]

The American Art Review and S. R. Koehler

Another important catalyst to the revival was the publication of the art magazine American Art Review; a Journal Devoted to the Practice, Theory, History and Archaeology of Art (1879–1881). It was the idea of Sylvester Rosa Koehler, who became editor, and of Charles Callahan Perkins (1823–1886) and William Cowper Prince (1825–1905), who became associate editors. They convinced the publishing company of Estes and Lauriat that the public was open to "the only true representative American Art Magazine."

The magazine would publish original etchings by American artists, "executed either directly from nature, or under the immediate impulse of inspiration." It promised that the copper plates would be printed by "an artistically endowed printer, capable of understanding and following out the artists' intentions,"[79] complementing their work. Each artist would have a short biography and a listing of etchings done to that date. In this way American art would have a showcase.

Of the first movers of the magazine, Prince was an editor-publisher, a professor of art history at Princeton University, an art collector, and one of the advocates of the establishment of the Metropolitan Museum of Art, of which he became a trustee and vice-president. Perkins was a wealthy art critic who had studied etching with Bracquemond and Lalanne in Paris. He illustrated himself the books he wrote and was one of the promoters of the Boston Museum of Fine Arts. Koehler, son of an artist, was born in Leipzig, Germany and emigrated to the United States in 1849. He worked as the technical manager of the lithography firm of Louis Prang and Co. from 1869 until 1879. An ardent champion of the etching revival, he was appointed acting curator of the Department of Prints at the Boston Museum in 1885, and was curator from 1887 to 1900. He was also the first curator of the Graphic Arts Section of the Smithsonian Institution. Koehler wrote on art subjects for American, German and English periodicals, lectured on etching, compiled Etching (1885) and translated Lalanne's A Treatise on Etching (1880).

It was at this time that a dichotomy began to develop between the artist and the larger public. Artists and their supporters saw themselves as an aesthetic elite, as evidenced by the correspondence between Dana Estes and Koehler (of which only Estes' letters are preserved), charting the development and the demise of the magazine. They based the magazine on European art publications. The publishers had been looking at the etchings in these magazines. March 27, 1879: "[Mr. Schoff] has been looking over L'Art with me and feels confident he can etch in the style of their best and most pleasing subjects and without traces of his engraving style."[80] They discussed making a profit:

> The etchings ought to be made a source of revenue aside from their value as illustrations in the Monthly. Both the Festschrift and the Gazette publish and sell extra editions of their etchings on large paper. They can be thus sold here or united into series and sold in portfolios.[81]

This practice was begun at the 1880 exhibition of etchings at the National Academy of Design when four etchings owned by the American Art Review were exhibited and offered for sale.

Estes replied to Koehler's general plans on March 24, 1879: "Don't build a beautiful monument to your own taste and our loss. Remember most people are fools and devoid of taste."[82] March 29, 1879:

> We merely wish to keep the thing commercially within the comprehension of the mass of people whom we are to depend upon for support. Artists and art students are not a wealthy class, and no doubt we shall have to depend upon merchants, doctors, lawyers, and others to keep the enterprise afloat.[83]

Estes believed that the public really wanted to see copies of such well-known paintings as Frederic E. Church's landscapes or portraits of the famous such as Longfellow or Whittier. He suggested: ". . . if we could open . . . with a copy of a hundred thousand dollar Gérôme or Meissonier."[84]

Koehler often brought artists together; he asked artists to teach fellow artists or asked them to tell other artists about the project. Samuel Colman, who wanted to write an article on Japanese netsuke and illustrate it with etchings, wrote from East Hampton, Long Island: "T. Moran is down here, and we are both deep in acid."[85] William M. Chase, whom Koehler commissioned to make an etching of his painting The Court Jester, Keying Up, which he had successfully exhibited at the Centennial, wrote from New Bedford: "I am here with Twachtman and Gifford."[86] J. Foxcroft Cole wrote: "I saw Winslow Homer on Wednesday. He was just starting for the country but will return Saturday. He was much interested in your project and promised to aid it in a contribution."[87]

J. D. Smillie and Koehler had an extensive correspondence;

Koehler depended on Smillie for technical assistance in securing "artistic printing" for the magazine. Smillie conveyed his experiences with the printers Kimmel and Voight in 1880. June 5: "I can teach K. V.'s printer to take just as good proofs as I have done."[88] June 14: "I went to Kimmel and Voight ... I was pleased to find that the printer took hold of the plate at once very intelligently and I think successfully. I fear only that he will give me a little too much ink and a little too much retroussage."[89]

The magazine was clearly highbrow and not of a "pleasing, popular nature" to attract a sufficient readership to keep it going and ceased publication.

Subject Matter

Americans chose to express themselves in an autographic line, depicting nature *en plein air* in the Barbizon mood (suggesting the poetic and subjective) or the Impressionist mode (sparkling broken lines, unsentimental fleeting impressions of a sunshot world) or with an eye that delighted in the "quaint" or "picturesque." In paintings of the time the Barbizon mood relates to Tonalism and the Impressionistic mode to Impressionism. They stopped in rural locales and observed animal and vegetable life, almost never the working peasant or farmer; they were drawn to watery views on rivers, seas, in harbors and coastal areas, with their ships, fishing boats and other craft either in their native land or in the Old World, such as Normandy, Brittany or Holland. They sought the picturesque in historic cities: Venice, London, Paris and later in New York. They were interested in "exotic" California and Florida and in the native peoples and their ancient customs found in the Southwest. Some also chose as subjects portraits of friends and family, figure studies, genre scenes and still life.

The etchings, for the most part, express a passive and lonely mood and arouse an agreeable "happy-sadness" train of thought, and so are comforting. Technically, they are visually interesting. They avoid the real conditions in American life: the constant movement and change, the loss of community, the alienation in the cities, the misgovernment, the factory, cutthroat competition, exploitation of labor, strikes, racism, poverty, the development and exploitation of natural resources. They showed a private world, but one overlaid with a malaise of repose and solitude. Artists took their viewers to vacation areas of fields and forests, water and weather untouched by "the great magician Improvement [who] fled along the outermost strand, leaving only the faint lines of railway and the trailing smoke of a locomotive to mark his flight, [having been barred] by the genius of repose."[90]

The products of the modern industrial age were not picturesque, a critical observer said:

> ... the convenient and now indispensable steam railway ... its cuttings and embankments, its iron bridges and machine-shops, are cruel scars upon the face of nature which no feeling eye can regard without pain ... at least ... when constructed as they are in America, with reckless disregard of everything but the commonest utilitarian and financial ends.[91]

The painter-etchers' practice was to gather the visual data necessary for their oil or watercolor paintings and to make etchings on their vacation travels or sojourns in summer away from the art capitals. Their winter studios were in these cities; there they painted works for exhibition, exhibited them, engaged in art politics, taught and illustrated to earn a living. The city was a place different from the other where "progress," competition and personal aggrandizement played their parts.

The artist wanted a quiet place to work and found it in nature. *Solitude* was the title of many of their paintings and etchings and the public liked them. A painting with this title drew the following comment when it was exhibited in 1881: "Although the picture well suggests its title, there is no feeling of depression from isola-

tion for the solitude is of that character in which Nature herself supplies the place of human companionship for the time."[92]

A "poetic" school of art developed which Koehler defined as the latest school of landscape painting; the artists were "painters of sentiment" (he termed it *Stimmung-Malerei*). Explaining what he meant by sentiment, he said it is:

> ... a thought prompted by passion or feeling; *a state of mind in view of some subject.* ... [It reflects] the soul of nature ... [and is] sympathetic [to] the expression of the sentiments which nature awakens in us, or ... we reflect upon her. ... We have here the basis of true and legitimate impressionism,— that power of selection which seizes instinctively the salient features, the expression-carrying elements of the scene ... is poetical.[93]

Artists, pent-up city dwellers, visited the land as observers; they were not tied to it by hard labor. The times of day, weather conditions and seasons did not demand exertion as they did of farmers. Artists exercised only their eyes and brains and saw different and beautiful sensations.

Etching, like drawing in various media, could capture these fleeting effects and etchers painted with printer's ink on their plates, creating emotional meanings from the chiaroscuro of nature.

Twilight was especially evocative. Of Henry Farrer's *Winter Evening*, Koehler wrote:

> This lacework of nature is one of the greatest charms of the winter landscape, ... it is never more beautiful than at the time of the afterglow, when the fading light melts the bewildering entanglement into still greater mystery. ... The close of day has set the poets asinging ever since man learned to think. ... [It is] poetry felt rather than spoken, ... filling the soul with a passing glow.[94]

By the 1880s French art and art instruction were the most powerful and dominant influences in American art circles. The "poetic" landscapes, animal and genre paintings of the Barbizon artists, with their emphasis on painting in the open air, directly from nature, were particularly consequential.

American artists, including the Morans, established an "American Barbizon" in the village of East Hampton, on the South Shore of Long Island. One writer described it as a place with

> ... a charm of old associations combined with pastoral simplicity ... In a place so remote, it is natural that the quaintness and pastoral simplicity of country life a hundred years ago should prevail. At sunset and sunrise herds of sleek matronly cows, with barefoot boys in attendance, wind through the streets; scythes and sickles hang in the willows by the wayside. ... Most truly rural are the orchard farmyards ... in front perhaps set thickly with apple and pear trees, and behind these showing open spaces covered with a deep green sward, with cart, plough, ... woodpile, sheep, and poultry, disposed in picturesque confusion. ... [In other places] when the wind blew, there were waves in the wheat as well as in the sea. ... Out-door work was usually done in the soft light and shade of early morning or evening. In-door work occupied a part of the intervening hours if the artists were industrious.[95]

Hamerton felt that the city dweller could receive valuable teaching from the peasant and the ox. Time spent in their company produced a soothing calm on ruffled nerves. They traveled at a speed of two miles per hour, time to them was played in adagio. Of the peasant, he said: "He has no notion of getting through small and easy duties ... he considers time only in very large spaces, such as the space between seed time and harvest."[96]

Unfortunately this way of life was being destroyed even as artists were trying to hold on to it. Charles H. Miller's woodsy landscapes were also protests against "apparent insatiate tree-murderers." Koehler noted that although Miller offered praise "at the altar of nature ... the joy is toned down by the pre-monition of coming destruction and the notes of a dirge mingle with the song of praise."[97]

The Picturesque

Artists settled in places that were unchanged survivors of the past in their search for the picturesque. These places held an aura of pleasant associations. The picturesque, said writer Charles Moore, "bespeak[s] a human energy acting in sympathy with nature. . . . Scenes of rural and pleasant industrial life are permanently enjoyable."[98] In old cities such as Venice, the picturesque, said art critic S. G. W. Benjamin, is

> whatever seems to convey suggestions of humanity, or bear evidence whether actual or symbolical, of the fight which man and nature have to wage with time, decay and destruction . . . It is not until time has modulated their outlines and tints into harmony with nature and the traditions and tragedies of life have clustered about them, that the dwellings of man really enter into the domain of the Picturesque.[99]

Artists lived and worked in the older cities of Europe, liking their associations with tradition. Venice attracted a school of artists and writers; her gorgeous skies, exotic settings and busy outdoor life was a magnet to them.

A mass audience bought the new illustrated newspapers and magazines to see picturesque subjects. They were appreciated, said one American writer, because:

> The illustrated magazine [is] one of the essentials of a beautiful homelife; while we sit by the fireside, the pictured page lets us see the art and sciences, the habits and customs, of all the great historic ages, and at the same time represents to us the remarkable and beautiful things scattered over our contemporary world.[100]

A whole avenue of art was opened to artists who furnished the drawings and etchings for the periodicals. Drawings in crayon, charcoal, pencil, wash or gouache on plain or tinted papers, or etchings, were made for reproduction. Wood engraving was the usual way to reproduce them (until photography was used) and a new school evolved to reproduce accurately the lines and tones of the original work. Pennell, for example, was commissioned by *Century* magazine to illustrate, with etchings, an article by William Dean Howells on Tuscan cities. For publication they were reproduced by wood engravings. Pennell's images were sought after, and he was able to sell the edition of his original etchings illustrating the article through his dealer.

Pennell's career consisted of supplying paintings, drawings and etchings of "picturesque" places to meet a demand. He fulfilled commissions for *Century* and *Harper's Magazine* and illustrated books and articles written by his wife Elizabeth. In 1881 he collaborated with regional writer George Washington Cable and made a series of illustrations of New Orleans. *Twilight, Pilottown, La.*, an etching made at that time, depicts a shantytown on the delta of the Mississippi where houses stood on stilts. The place was referred to as the "American Venice."

In Europe the Pennells actually found the "most picturesque place in the world" (which they refrained from naming):

> We had always been hunting for it. We had always felt sure that somewhere . . . we should find the perfect place which was to combine the charm of the middle ages with the comfort of the 19th century—the Albert Dürer town which could be reached in a railway train, with medieval streets through which the dinner bell could make a pleasant sound, where there would be plenty of picturesque dirt in other people's houses, plenty of fresh water and clean rooms in our hotel. Perhaps this is a bourgeois idea.[101]

New York City was to become an important subject for artists in the twentieth century, when it began to acquire interest as a "picturesque" city. *Rainy Night, Madison Square* by Mielatz, a precursor of this interest, was one of several illustrations he made for the article "Picturesque New York" by Van Rensselaer. She wrote that young artists were beginning to paint and etch New York and she enumerated its aesthetic materials, and thought it most picturesque when "seen at night from a boat on the water. The abrupt, extraordinary contrasts of its sky-line are then sub-dued to a gigantic mystery; its myriad, many-colored lights spangle like those of some supernally large casino." Of Madison Square she said: "Even this same shabby corner, as our etcher shows, is not unpicturesque when veiled by night and a rainstorm."[102]

The Morans, Gifford and Pennell chose industrial sites, factories, shops and refineries to paint and etch, but saw them through Whistler's sensibility, "[as] when the evening mist clothes the riverside with poetry."[103]

Women, as a motive, were important to painter-etchers. Whistler etched the women in his family, his friends and lovers as well as female models and the many women, young to old, that he encountered on his etching walks.

Of working women, there were the lacemakers, beadstringers or washerwomen among the colorful crowds in Venice or in their workshops. There were the beautiful and strong fisherwomen of Tynemouth portrayed by Homer. French peasant women caring for their children were often models for Mary Cassatt and she drew her housekeeper Mathilde Vallet. Upper middle-class women—members of Cassatt's family at the opera, at the dressmaker, drinking tea together, reading by lamplight and with their children—were also her subjects. Weir depicted his wife and children in homely occupations. His daughter Caroline and her pet are shown in *Gyp and the Gypsy* and his wife and Caroline are depicted in *Christmas Greens*. Church placed women in fairytale settings. Chase and Duveneck made monotype portraits of them and Dielman portrayed only them. Bacher etched an *Arachne* weaving a web with her hair. Usually the women are absorbed either in self or their occupations and the mood is a quiet one. Often women view the viewer in a dreamy reflective manner.

Reproductive Etching

Before photography was used to reproduce paintings, "the rarest and sublimest conceptions of art" could reach a growing circle of interested people only by the labors and artistry of the reproductive engravers. They rendered an incalculable service and created a vast industry.

In an expanding market, to reduce costs, increase production and compete with other reproductive means, methods of reducing the time of hand-labor were developed. Before the revival, etching was not generally considered an art form in its own right but an easy substitute for line engraving. It was labor-saving to draw in the preliminary design on the metal by etching, then to complete it by the burin. Sometimes an entire picture was done by etching, which did not exploit the medium's own characteristics; instead the line imitated the impersonal, formal conventions of the engraved line. J. G. Chapman's *The American Drawing Book* (1858) on art gave directions on how to do it and noted: "The highly finished Landscapes of modern engravers are almost entirely etchings, as well as a great deal of all other subjects, especially in background and accessories."[104]

The prominent engraver Asher B. Durand followed this practice in reproducing *Ariadne* after a painting by John Vanderlyn. The first state is entirely etching. In subsequent states the burin was used to rule in the lines of the sky, to delineate the nude figure and to darken some lines.[105] *View of Rome* by G. L. Brown and *The Roman Campagna* by J. G. Chapman are entirely etchings made with the engraver's conventions. Whistler, too, first learned to etch in the engraver's manner for the Coast Survey.

When the tendency for a more coloristic pictorial treatment, closer to the look of a painting, became popular, etching replaced the impersonal "mechanical" look of the engraving and spoke in its own language of form.

Reproductive etching, said critic J. W. R. Hitchcock in 1886, "has risen to a place of no little importance."[106] In the 1880s etching was admired as a reproductive art as well as an original art. Painters reproduced their own oil or watercolor paintings in the medium but they were translating private ideas into another form;

therefore such works are not strictly reproductive. Often the artists made changes in composition and emphasis. Lloyd Goodrich has shown that in Homer's etching *The Life Line,* which is after his oil painting of the same name, the artist altered the composition by eliminating some of the top and sides, the ship's sail and some of the sea and cliff. The figures have become more important. In his second etching after *The Life Line,* which received the new title *Saved* (1889), Homer went even further and fundamentally transformed the painting.[107] William Merritt Chase etched *The Jester, Keying Up,* in an entirely impressionistic, sketchy manner. J. D. Smillie etched Homer's watercolor *Voice from the Cliffs* with Homer's permission, but Homer criticized it and made his own deeply felt version. Reproducing Homer's work, Smillie said, was "flattering recognition of his place among American artists."[108] Between 1884 and 1889 Homer made eight large etchings based on his own oil or watercolor paintings. These are nearer in technique to engraver-etchings than painter-etchings; the emphasis is on his powerful subject matter and they were, he hoped, to be sought out by a popular audience—not by the print collector. Original versus reproductive etching was discussed, but there was a high regard felt for the reproductive etcher at the time.

Modern technology killed the profession of the reproductive hand engraver. Keppel noted that in "this utilitarian age when 'time is money' . . . reproductive methods founded on photography . . . as well as the etcher's rapid method have forever killed line engraving."[109] But the reproductive etcher was also fearful of his future. J. D. Smillie said: ". . . with the reproductive etcher it will be the survival of the fittest with mechanical processes."[110]

American artists who made reproductive etchings included Chase, Hamilton Hamilton, Thomas Moran, Mary Nimmo Moran, Peter Moran, James Nicoll, Stephen Parrish, Thomas Hovenden, Walter Shirlaw and James D. Smillie. Many of those engravers who depended on the profession exclusively later became artist-workmen in shops producing photographically engraved plates.

Business and the Etching Craze
By 1893 there were a number of companies publishing, selling and advertising etchings to a mass market. The United States had become the largest picture-purchasing country in the world.

Many firms, however, in their desire to make as much money as possible, while promoting the art interest into a booming fad, used questionable practices on a gullible and largely uninformed public. One of them was the proliferation of the use of the remarque, a little sketch scribbled by the artist on the margins of the plate to try out the etching needle. It soon wore off in the printing of trial proofs or was scraped away before printing an edition. Collectors, aware that they were among the earliest proofs, the best impressions and rare, eagerly sought them and they were sold at higher prices. In the period of the etching revival, however, steel-facing had been invented, which coated the plate with an infinitesimal coating of steel. Therefore, an almost unlimited number of good impressions could be printed from one plate, the incised lines never wore down and the last impression was as good as the first. The remarque no longer indicated an early and best impression. Koehler said, "The height of folly is reached when the real 'proofs' are actually without remarques and these latter are added only after the plate is finished and by order of the publisher for the sole purpose of gain. . . . Today they are absolutely valueless."[111]

Another disturbing practice was the excessive use of different papers to distinguish regular from luxury editions solely for commercial purposes and not because the papers used had any influence on the quality of the impressions. Rembrandt had experimented with different papers to achieve certain effects as had

Méryon and Whistler. The commercial use of this practice began in the early nineteenth century and was followed later by Cadart. It reached an excess in 1886 when a portfolio, *American Etchings,* edited by Koehler, was published in five separate and different paper editions: five copies on "genuine parchment," 15 on satin, 40 on Japan and 250 on Holland paper. Curator Andrew Robison calls it a "perversion of variations in receptivity"[112] of papers. (Receptivity is how a paper receives the printed impression from the plate.)

As an antidote to sharp practices, the "modern refinement" of signing a print in pencil by the artist began. Keppel said:

> . . . a more valuable evidence of high quality . . . is the autograph of the artist written in the lower margin of an etching. The etcher . . . should be the judge *par excellence* of quality and no conscientious artist will affix his signature to a proof unless that proof is all that it should be. The artist's signature may thus be compared to the endorsement by a solvent man of a promissory note.[113]

The Collector magazine, which had been established to warn the public "against the dishonesty of corrupt tradesmen, who have hitherto made a prey of the American amateur," warned against "the incredible rubbish which is now displayed with remarques and signatures and impressions on parchment and japan paper."[114]

An End and a Beginning
Van Rensselaer found that the public lacked "true discrimination" and some artists were unsympathetic to the medium. She said:

> The etcher's serious, beautiful and individual craft is in danger of degenerating into mistaken rivalry with other forms of graphic expression. The virtues which etching should have—succinct expression by means of line, clear contrasts of black and white, . . . the preservation of the peculiar quality of the bitten or drypoint stroke [is superseded by the demand for] large, showy, finished etchings which try to be as unlike etchings, as like steel engravings of elaborate drawings as possible.[115]

Koehler noted too that much American etching was "false, immature, uninspired. . . ."[116]

Because of much bad etching, indiscriminate overproduction and underselling, because new fads, such as the poster craze, developed, and because photogravure and improvements in the chromolithographic process made the reproduction of paintings cheap, the etching craze collapsed.

But in 1894 Smillie had cause for an optimism which has proved to be true:

> Better etchings, in the best sense of the word, are now produced here than ever before. They are not done to meet a business demand, but in answer to a desire to give expression to some ideas through a pictorial medium most suitable to them. Some of the young students in our art schools have recently taken hold of etching with enthusiasm, a fact full of promise for the future.[117]

The first etching revival, which succumbed in the early 1890s, was the stimulus for a second, which occurred in the early twentieth century. Etchers of the first—Pennell, Smillie and Mielatz—taught the artists of the second at the Art Students League and the National Academy of Design. Whistler was still strongly admired, and new etching societies, emulating the old, were formed. There was a living link between the old and the new. His influence continued in the etchings of such artists as Frank Benson, John Taylor Arms, Ernest Haskell and Childe Hassam, while John Sloan and John Marin were just two of many who were influenced directly by the first revival but moved to new themes or styles reflecting a different era in the next century with copper and needle.

BIOGRAPHIES OF THE ARTISTS

OTTO BACHER (*Plates 1–3*), painter, illustrator, etcher. Cleveland, O., 1856–Bronxville, N.Y., 1909.

Bacher, who began his study of art in Cleveland in 1874, first experimented with etching in 1876. In October 1878 he entered the Royal Academy in Munich. The next summer he roamed the environs of Munich and along the Danube, producing a series of 24 etchings, titled *Etchings in Bavaria*. From late 1879 to fall 1882 Bacher was one of the Duveneck "boys," working in Florence and Venice. He spent the summer and fall of 1880 in Venice in a close working relationship with Whistler. The sale of these and other etchings allowed Bacher to study in Paris at the Académie Julian in 1885–1886. He continued to etch, making his last plate in 1900.

ALBION HARRIS BICKNELL (*Plates 4 & 5*), portrait and landscape painter, etcher, book illustrator; instructor at his Malden summer sketching school. Turner, Me., 1837–Malden, Mass., 1915.

Bicknell was a painter of subtle light and atmosphere. He was in Boston by 1855. In 1860 he studied in Paris at the École des Beaux-Arts, primarily in Thomas Couture's class. He traveled to Venice before returning in 1864 to Boston where he opened a studio. In 1875 he moved to Malden, which was a summer area popular with artists. He etched from about 1865 into the 1890s and was an early artist of the monotype, beginning in 1881.

WILLIAM HENRY WARREN BICKNELL (*Plate 6*), painter, original and reproductive etcher, book illustrator. Boston, Mass., 1860–Provincetown, Mass., 1947.

An etcher of quiet charm, Bicknell is known in the twentieth century for his depiction of snowy winter landscapes. A pupil of Otto Grundman, his career extended over two etching revivals. In his earlier work he made portrait etchings and book illustrations. He began to make drypoint landscapes and later etchings of Cape Cod, progressively developing a freer handling and economy of line.

ROBERT FREDERICK BLUM (*Plates 7 & 8*), figure painter, illustrator, popular pen-and-ink draughtsman, pastelist, etcher, muralist. Cincinnati, O., 1857–New York City, 1903.

Blum's technique was of a "peculiar richness and snap."[118] He was apprenticed to the lithographic firm Gibson and Sons in 1873 and later studied at the Mechanics Institute and the McMicken Art School of Design (now the Art Academy of Cincinnati) in 1875, the Pennsylvania Academy of Fine Arts, 1876–77, and in Munich (but not at the Academy). He established a studio in New York City in 1879, and illustrated for *Scribner's* (later *The Century*) and *St. Nicholas* magazines. For his themes he traveled extensively in England, Italy, France, Spain, Holland and Belgium and, in 1890–1892, was one of the first Western artists in Japan. In 1880 he met Whistler and Duveneck in Venice, where he returned in 1881 and 1885. He also drew modern American life, illustrating summer scenes at Coney Island. He was a friend of Chase, Duveneck, Bacher and Twachtman. His style was greatly influenced by Mariano Fortuny (1838–1874), whose anecdotal themes and vigorous technique won him a wide audience.

GEORGE LORING BROWN (*Plate 9*), landscape, portrait and miniature painter, lithographer, etcher, wood engraver. Boston, Mass., 1814–Malden, Mass., 1889.

Brown's contemporaries called him "Claude" Brown because of his idealized Italian scenes in the vein of Claude Lorrain. Brown was apprenticed at 12 to a wood engraver, later received art instruction from Washington Allston, then studied in France with Eugène Isabey. From 1839 to 1859 Brown worked in Florence and Rome and produced (between 1853 and 1859) a series of nine etchings in a delicate engraver's manner, entitled *Etchings of the Campagna, Rome*, which was published in New York in 1860.

JOHN GEORGE BROWN (*Plate 10*), genre painter. Durham, England, 1831–New York City, 1913.

Brown immigrated to the United States in 1853. He was a painter of homeless boys, a legion of whom he found on New York City streets selling newspapers or shining shoes. He had studied with Scott Lowdes and William B. Scott at the Royal Scottish Academy and at the National Academy of Design with Thomas Cummings. He made one etching and one lithograph (*Independence*).

MARGARET W. LESLEY BUSH-BROWN (*Plate 11*), portrait painter, miniaturist, etcher. Philadelphia, Pa., 1857–Ambler, Pa., 1944.

Pupil at Pennsylvania Academy of Fine Arts, 1800–1884, and the Académie Julian, 1886–1889, with Lefebvre and Boulanger. She married sculptor Henry Kirke Bush-Brown in 1886.

MARY CASSATT (*Plates 12–15*), painter, etcher, mural painter. Allegheny City (now part of Pittsburgh), Pa., 1845–Mesnil-Théribus, Oise, France, 1926.

Cassatt lived with her family in Paris and Germany from 1851 to 1858. In the United States from 1858 to 1868, she studied at the Pennsylvania Academy of Fine Arts from 1861 to 1865. She was in Paris from 1866 to 1870; in Italy in 1872, where she learned graphic techniques from Carlo Raimondi. In 1874 she settled in Paris, establishing a close professional relationship with Degas, and became part of the Impressionist circle, exhibiting with them. With deep insight into personal feelings, the natural caresses of mother and child or the moods of women alone or in the company of other women are expressed by fleeting facial expressions and shifting body poses. In early etchings she used softground and aquatint. In 1880 Cassatt began to make drypoints. Of them Weitenkampf wrote: "In its forceful technic, its firmness, its spontaneous vitality, its succinct straightforward manner of statement, its judicious and effective economy of line, her work forms an admirable model in the art of etching."[119] She set up a press in her country home in 1890. Then she began a new phase in her graphic work, making a series of ten color prints, reflecting her interest in color woodcuts by Japanese masters exhibited in 1890.

CARLTON THEODORE CHAPMAN (*Plate 16*), marine and landscape painter, etcher, illustrator. New London, O., 1860–New York City, 1925.

Chapman's interest was in the sea and ships. He drew fishing boats on Long Island Sound, in Gloucester harbor and at St. Ives, Cornwall. He studied at the National Academy of Design and the Art Students League, ca. 1886–1889, and the Académie Julian in Paris.

JOHN GADSBY CHAPMAN (*Plate 17*), landscape, portrait and historical painter, wood engraver, etcher, book and periodical illustrator. Alexandria, Va., 1808–Staten Island, N.Y., 1889.

A prolific artist in many media, Chapman executed work with an aura of tranquility and quiet charm. He studied with George Cooke and C. B. King and, in 1827, at the Pennsylvania Academy of Fine Arts. From 1828 to 1831 he painted historical pictures in Italy. After his return to New York City he became a noted illustrator. In 1848 he returned to Europe. From 1850 until his return to the United States in 1884, Chapman, in Rome, supplied, as travel souvenirs to American and English tourists, small etchings on steel of views in the engraver's style, which he often colored in oil paints. He wandered over Calabria with friends dressed in goatskins and the untanned shoes of the peasant, sketching and painting.

WILLIAM MERRITT CHASE (*Plate 18*), portrait, genre and landscape painter, etcher; instructor, Art Students League, Brooklyn Art School, Chase School, summer schools in Europe, 1903–1914; Shinnecock, N.Y., 1891–1902, and Carmel, Calif., 1914. Nineveh, Ind. 1849–Atlantic City, N.J., 1916.

Chase was a painter in the composite style of bright Impressionism, with the bravura brushwork of Sargent. He studied with local painters in Indianapolis at the National Academy of Design in 1869; in 1872–1878 at the Royal Academy, Munich, with Dielman and Duveneck. He was particularly attracted to the art of Wilhelm Leibl. In 1877 Chase went to Venice with Duveneck and Twachtman. Returning to New York in 1878, he taught at the Art Students League and opened a studio at the famous building at 51 West 10th Street. Chase made many monotypes, only a few etchings and some reproductive etchings.

FREDERICK STUART CHURCH (*Plate 19*), painter, illustrator for magazines, etcher. Grand Rapids, Mich., 1842–New York City, 1924.

In his "quaint conceits" Church created an ideal of lovely American womanhood in the midst of enchanting nature. He studied at the Chicago Academy of Design, the National Academy of Design and at the Art Students League with L. E. Wilmarth and Walter Shirlaw. Church made comic sketches for *Harper's Weekly* and *Harper's Bazar* and did commercial drawing. In 1875 he began to paint seriously. *L'Art* published his etchings.

GABRIELLE DE VEAUX CLEMENTS (*Plate 20*), painter, muralist, etcher, art teacher at Bryn Mawr, Baltimore. Philadelphia, Pa., 1858–Rockport, Mass., 1948.

A graduate of Cornell University, Clements later studied at the Pennsylvania Academy of Fine Arts, learning to etch with Parrish; at the Académie Julian (1883), and with Robert Fleury and William Adolphe Bouguereau. In the twentieth century she made "soft-ground aquatints" in color. Clements lived for years in Baltimore, spending summers in Gloucester, Mass.

JOSEPH FOXCROFT COLE (*Plate 21*), landscape and cattle painter, lithographer and etcher. Jay, Me., 1837–Winchester, Mass., 1892.

A Boston painter, Cole chose as his subjects atmospheric pastoral landscapes with sheep or cows grazing. The locale of these works was often in Normandy or rural Belgium or at home near Winchester or Providence, R.I. Cole began his career as an apprentice lithographer at J. H. Bufford and Sons Lithography in Boston in 1855, where a fellow apprentice was Winslow Homer. From 1860 until 1863 he studied in France with Normandy landscape painter Émile Lambinet. He spent a summer with the Cernay-la-Ville group of painters, and was with Charles Jacque in his Paris studio in 1865. Cole, along with William Morris Hunt, was influential in promoting Barbizon art in America. He began to etch ca. 1866.

SAMUEL COLMAN (*Plates 22 & 23*), landscape, marine and architectural painter, etcher and illustrator. Portland, Me. 1832–New York City, 1920.

Colman depicted what he saw on his many travels to Europe, North Africa, and the American West. He was a pupil of the landscape painter (and former engraver) Asher B. Durand and later taught himself while traveling in Europe in 1860–1862 and 1871–1875. He first attempted etching in 1867 but gave it up because of a lack of good printers, but he began again in 1877, with the start of the New York Etching Club. He drew his East Hampton plates side by side with T. Moran. He was also a collector of Oriental art and etched some pieces from his collection.

CHARLES ABLE CORWIN (*Plate 24*), painter, etcher, teacher at The Art Institute of Chicago, staff artist from 1903 for the Field Museum of Natural History, Chicago. Newburgh, N.Y., 1857–Chicago, Ill., 1938.

Corwin was one of Duveneck's "boys" in Venice in 1880. His etching career was limited to this period. He also made monotypes, including a portrait of Whistler.

REGINALD CLEVELAND COXE (*Plate 25*), marine painter, etcher, illustrator. Baltimore, Md., 1855–?

Coxe studied at the National Academy of Design and in Paris with Léon Bonnat and Gérôme. He worked in Buffalo, N.Y., and began to exhibit with the New York Etching Club in 1886. His etchings are highly finished versions of his paintings. He continued his art career in the 1920s in Seattle, Washington.

MAURITZ FREDERIK HENDRIK DE HAAS (*Plate 26*), marine painter, etcher. Rotterdam, Holland, 1832–New York City, 1895.

Haas studied at the Academy of Fine Arts, Rotterdam, and, in London in 1851, painting in watercolor. Later he was a pupil of Louis Meyer in The Hague for two years. He came to the United States in 1859. He made few etchings.

FREDERICK DIELMAN (*Plate 27*), portrait, figure and genre painter, book illustrator, reproductive and original etcher, designer of mosaic panels in the Library of Congress, instructor of perspective in National Academy of Design School and Art Students League, Director of Cooper Union Art School, 1903. Hanover, Germany, 1847–Ridgefield, Conn., 1935.

As his subjects Dielman chose charming women or genre scenes in the various ethnic quarters of New York. A graduate of Calvert College, Baltimore (1864), he became a topographical engineer in the South. In 1872–1876 he was in Munich (with Chase and Duveneck) at the Royal Academy with Wilhelm Diez. He began his art career in New York in 1876.

BLANCHE DILLAYE (*Plates 28–30*), watercolor painter, etcher, illustrator, teacher at Ogontz School (near Philadelphia). Syracuse, N.Y., 1851–Philadelphia, Pa., 1932.

Dillaye, with her penchant for odd nooks and alleys, recorded unassuming subjects in Holland, provincial France, Norway and England. She studied at the Pennsylvania Academy of Fine Arts where she learned to etch with Stephen Parrish and in Paris with Garrido. She also made monotypes. Dillaye signed some of her etchings with a small snail, a play on her name (pronounced "delay"). *Mist on the Cornish Coast* was shown at the Paris Salon.

ASHER B. DURAND (*Plate 31*), engraver, landscape and genre painter. Jefferson Village (now Maplewood), N.J., 1796–Jefferson Village, N.J., 1886.

Durand was apprenticed to engraver Peter Maverick from 1812 until 1817 and established a reputation as an engraver of paintings, portraits and banknotes. He began to paint about 1835, helping to found the Hudson River School, and advocated painted *en plein air*.

FRANK DUVENECK (Plates 32–34), portrait and landscape painter, etcher, private art teacher and at the Cincinnati Art Academy. Covington, Ky., 1848–Cincinnati, O., 1919.

Duveneck was an exponent of "dark impressionism," which he studied at the Munich Royal Academy, and was also influenced by the work of Wilhelm Leibl. In 1878 Duveneck became an inspiring teacher to a number of Americans and others in Munich. He took some pupils to Italy in 1879; they were known as Duveneck's "boys." The group included Twachtman, Bacher, Corwin and Rosenberg. Although Duveneck made his first etching in 1879, he became truly interested in the medium in 1880, working in Venice near Whistler and producing 30 line etchings of Venice and her people by 1885. His later plates, 1883–1885, are more vigorously drawn and heavily shaded than the earlier ones. He also experimented with monotypes during social evenings with his students, beginning in 1879 in Florence. He married his student, painter and socialite Elizabeth Boott, and after her death in 1888 he returned to Cincinnati, often spending his summers painting in Gloucester, Mass.

JOHN MACKIE FALCONER (Plate 35), portrait, landscape and genre painter, etcher, enameler and watercolorist. Edinburgh, Scotland, 1820–Brooklyn, N.Y., 1903.

Falconer's subjects were picturesque sites, often tumbledown buildings, old mills and other rural ruins. He came to the United States in 1836. He made two small etchings in 1849, a few others with Cadart's class of the French Etching Club in 1866, and began to etch again in a "rough and ready fashion [with an] open eye for the poetry of decay."[120] He collected etchings and watercolors.

HENRY FARRER (Plates 36–38), marine and landscape painter, etcher. London, England, 1843–Brooklyn, N.Y., 1903.

Farrer pictured glorious American skies: sunrise or sunset effects enveloping shipping on the East River, the docks of New York or rural scenes. He immigrated in 1863. His first etchings were done in 1868, when he made a series of 11 plates illustrating picturesque old New York buildings that was published in 1872 in a portfolio (by dealer E. B. Patterson) under the title *Old New York*. His later works were landscapes and marines in the free mode of the painter-etcher, enhanced by artistic printing. He was prolific and popular.

EDWIN FORBES (Plate 39), staff artist for *Frank Leslie's Illustrated Newspaper* (1861–1865), illustrator, etcher, historical painter. New York City, 1839–Brooklyn, N.Y., 1895.

Forbes is best known for the studies he made during the Civil War as a field artist (1861–1864) for the Union Army, studies he reproduced in various media for the rest of his life. He was a pupil of Arthur F. Tait in 1859. Cadart taught him to etch and he became a member of the French Etching Club. In 1876 Forbes produced a portfolio of etchings, *Life Studies of the Great Army: A Historical Art Work in Copper Plate Etching Containing Forty Plates*. The biting and printing were done by professionals. He won a gold medal at the Centennial Exposition of 1876.

IGNAZ MARCEL GAUGENGIGL (Plate 40), genre painter, etcher, teacher at the Boston Museum of Fine Arts School. Passau, Bavaria, 1855–Boston, Mass., 1932.

Arriving in the United States in 1880, Gaugengigl was called the "Meissonier of Boston" because of his choice of subject (eighteenth-century people, costumes and ambience) and meticulous attention to detail. He studied with Wilhelm Diez in 1878. His etchings are free translations of his paintings.

EDITH LORING PEIRCE GETCHELL (Plate 41), original and reproductive etcher, designer of patterns for Livingston Mills. Bristol, Pa., 1855–Worcester, Mass., 1940.

"[Her] vistas of moor and coastland, with gnarled trees by placid pools, show a pleasing craftsmanship and a clever use of tints of ink, an effect produced in the printing."[121] She studied at the Pennsylvania Academy of Fine Arts and in Europe in 1884. Began to etch 1882–1883. *Solitude* is based on a small watercolor sketch of Peck's Beach, N.J. She wrote to a collector: "I am not a painter, but I always sketch in color for my etchings."[122] She was affiliated with the Worcester Art Museum and its school.

ROBERT SWAIN GIFFORD (Plates 42–46), landscape painter, original and reproductive etcher and illustrator; art instructor at Cooper Union for the Advancement of Science and Art, 1877–1896; Director of Women's Art School, 1896–1903; Art Director of All Art Schools, 1903–1905. Nonamesset, Mass., 1840–New York City, 1905.

Gifford's subjects were wide vistas, long sweeps of moorlands under gray skies, cold somber woods and barren dunes, picturesque industrial subjects and oriental scenes from his travels. His landscapes were often of the low coast scenery of Nonquitt, his summer home. Gifford was a pupil of the Dutch artist Albert Van Beest and Benjamin Russell in New Bedford in the late 1850s. He opened a studio in Boston in 1864, then moved to New York in 1866. Gifford and his artist wife (née Eliot) made extended sketching trips to the Far West, Europe, North Africa and Alaska in the 1860s and 1870s. He first began to experiment with etching in his teens. Gifford was considered the best American etcher after Whistler.

ELIZA PRATT GREATOREX (Plate 47), landscape and cityscape painter, etcher, illustrator in pen and ink, drawing teacher at the Henrietta Haines School for 15 years. Manor Hamilton, Ireland, 1820–Paris, 1897.

Greatorex, who came to the United States in 1840, was left a widow at age 38. She studied with William Wallace Wotherspoon, James and William Hart in New York City, in Paris with Émile Lambinet (1861–1862), in Munich at the Pinakothek in 1870, and with Charles Henri Toussaint in 1879 in Paris. She traveled in Europe and visited Africa. Greatorex learned to etch in 1878–1879 in order to make better reproductions of her popular pen-and-ink drawings. These picturesque views, including those of New York City, had previously been reproduced by photography. In the summer of 1880 she etched at Cernay-la-Ville. She exhibited at the Paris Salon in 1881, 1889–1890, 1894; at Berlin in 1891. Her daughters Kathleen and Honora were artists.

ELLEN DAY HALE (Plates 48 & 49), landscape, portrait and genre painter, etcher; art instructor, Marlborough Street School, Pa., art correspondent and author of *History of Art* (1888). Worcester, Mass., 1855–Brookline, Mass, 1940.

Hale was born into a prominent family. She attended (irregularly) Dr. William Rimmer's classes in Boston (1873–1879), studied with William M. Hunt and Helen Knowlton in Boston (1874–1879) and in 1878 attended classes at the Pennsylvania Academy of Fine Arts. There she met Margaret Lesley (later Bush-Brown). She traveled in the United States in 1879 and in Europe 1881–1882, studying at several Italian and French schools. In 1883 she met Gabrielle de Veaux Clements, who taught her to etch in Paris in 1885. She traveled in the United States again (1891–1893 and 1896), in Europe in 1885 and 1898 and to the Middle East in 1929. She continued to etch into late life, making soft-ground etchings in the twentieth century.

HAMILTON HAMILTON (Plate 50), landscape and portrait painter, reproductive and original etcher. Middlesex County, England, 1847–Norwalk, Conn., 1928.

Largely self-taught, Hamilton had immigrated when an infant. In 1872 he opened a studio in Buffalo to paint portraits. In 1875 he explored and painted in the Rocky Mountains. In 1878–1879 he was at Pont-Aven, Brittany. He returned to New York City 1881.

JOHN HENRY HILL (*Plate 51*), landscape painter, etcher. West Nyack, N.Y., 1839–[?], 1922.

Hill was an American follower of John Ruskin, with whom he corresponded, and of the English Pre-Raphaelite movement. With others he formed the Society for the Advancement of Truth in Art in 1863. Its credo was to paint nature in reverent detail. Hill's grandfather, John Hill, and father, John William Hill, were both aquatint engravers. Hill began to etch in 1857. He admired Turner, studying his work in London in 1864–1865, and made reproductive etchings after some of Turner's paintings. In 1866 he etched 24 plates for the book *Sketches from Nature*; a few were shaded by aquatint imitating the mezzotints of Turner. When Koehler published *Moonlight on the Androscoggin*, from this set, in the American Art Review in 1880, he transformed it with "artistic printing" in brown ink.

WINSLOW HOMER (*Plates 52–55*), painter, etcher, illustrator. Boston, Mass., 1836–Prout's Neck, Me., 1910.

Homer is one of America's major artists. An independent, he profoundly, and with great beauty, realized complex human passions in stark settings, usually in American nature and American light. His mother was an amateur watercolor artist. At 19 Homer was apprenticed to Bufford and Sons, Lithography, in Boston. In 1857 he was a freelance artist working for *Ballou's Pictorial* (Boston) and *Harper's Weekly* (New York), becoming a leading illustrator (1859–1874). Homer was essentially self-taught. He moved to New York 1859, and made a famous series on the Civil War. Homer spent 1866–1867 in France; 1881–1882 on the bleak North Sea Coast of England at Tynemouth. He settled in lonely Prout's Neck in 1883 and his subject matter continued to be that started in England—the perilous sea and the men and women who struggle to live and work by it. The bulk of his etchings was made between 1884 and 1889 when, prompted by the success of the etching craze, and the etchings others made of his work, he translated his oil and watercolor paintings into etchings. They were not the free, sketchy style called for by the painter-etchers, but large, highly finished, severe line etchings in the tradition of large reproductive work, intended for a popular audience. Homer drew on the grounded plates and bit them in Maine, but sent them to his printer George W. H. Ritchie for proofing. *Mending the Tears* is after a watercolor of 1882 made in Tynemouth. One woman is mending a sock; the other a torn net. *Perils of the Sea*, also derived from his Tynemouth experience, is after a watercolor of 1881. *Fly Fishing, Saranac Lake* is based on an atmospheric study made on a trip to the Adirondacks, where he experimented further with etching techniques, using line etching, aquatint and burnishing to create effects of foliage and water.

LEIGH HARRISON HUNT (*Plate 56*), etcher, critic of art, lecturer in art at City College, New York, and a physician. Galena, Ill., 1858–New York City, 1937.

Hunt, an amateur etcher who looked for the picturesque in nature in many locales, was a pupil of Henry Farrer, George Inness and J. Francis Murphy. Hunt said that he brought the technique of soft-ground to America from France by buying a "working outfit" of *vernis mou* from the printer Delâtre.[123]

GEORGE INNESS (*Plate 57*), landscape painter. Newburgh, N.Y., 1825–Bridge of Allan, Scotland, 1894.

Inness is considered the most important American landscape painter of the second half of the nineteenth century. Apprenticed in 1841 to be an engraver to Sherman and Smith, Map Makers, in New York City, he left to be a painter, studying with Regis Gignoux in 1846. Soon afterward he set up his own studio and, in 1847, made the first of several European study trips. He later traveled to Mexico City, Cuba, Florida and Yosemite and moved his studio frequently. He took up etching in 1879; only one landscape in the medium is known.

ROBERT KOEHLER (*Plate 58*), genre painter, etcher, director of the Minneapolis School of Fine Arts, 1893–1917. Hamburg, Germany, 1850–Milwaukee, Wis., 1917.

Koehler, whose father was a machinist in a factory, chose as his theme the daily life of working men and women. He immigrated with his family in 1854 and was apprenticed to a lithographer in 1866. He studied at the National Academy of Design and the Royal Academy in Munich in 1873–1875 and with Ludwig von Loffitz in 1879–1892. He was in New York City 1875–1879. *"Prosit"* is after a pencil sketch drawn from life, other etchings are after his paintings.

WILLIAM LANGSON LATHROP (*Plate 59*), landscape painter, etcher. Warren, Ill., 1859–Montauk Point, N.Y., 1938.

Lathrop's work has a feeling of solitude. His subjects were "gray days, gray twilights, flat pasture lands, close cropped almost to the very roots, enlivened by . . . a few naked trees."[124] He came to New York in 1874 to study art but had to return home penniless to teach school. He then built his own press and made materials to work with and was an etcher. In the 1880s in New York he began to sell his etchings. He went to Europe in 1886, and returned to United States for a successful career.

JAMES W. McLAUGHLIN (*Plate 60*), architect, etcher. Cincinnati, O., 1834–New York City, 1923.

An early architectural professional and organizer of the Cincinnati Chapter of the American Institute of Architects in 1870, McLaughlin began work as a draughtsman in 1853 and set up his own architectural office in 1858. He was a special artist for *Frank Leslie's Weekly* in 1862, following the Army of the Southwest. In 1912 he moved permanently to New York City. Mary Louise McLaughlin was his sister.

MARY LOUISE McLAUGHLIN (*Plate 61*), painter, wood carver, decorator of silver, stained-glass maker, inventor of methods of working and decorating clay for pottery and author of books on ceramics, etcher and maker of colored monotypes. Cincinnati, O., 1847–Cincinnati, O., 1939.

McLaughlin studied in 1873–1877 at the Cincinnati School of Design. She later took courses in painting and drawing with Duveneck at the Art Academy. She invented methods for producing Rookwood pottery and created Losanti ware. She began to etch in 1877.

THOMAS R. MANLEY (*Plates 62 & 63*), landscape and miniature painter, original and reproductive etcher. Buffalo, N.Y., 1853–Montclair, N.J., 1938.

Manley made softly luminous drypoints and soft-ground etchings of lush American meadows and meandering streams. He studied at the Pennsylvania Academy of Fine Arts.

CHARLES FREDERICK WILLIAM MIELATZ (*Plates 64 & 65*), graphic artist, illustrator, etching instructor at National Academy of Design, 1904–1919. Breddin, Germany, ca. 1860–New York City, 1919.

Mielatz came to the United States at the age of six. He was attuned to the "picturesque"; his urban vistas, harbors, architecture and landmarks of New York City were popular. He studied at the Chicago School of Design with F. Rondel. Mielatz began his career with the U.S. Engineers in Rhode Island, surveying and learning to etch to make maps and plans. He came to New York City in the 1880s and made his first artist's etching in 1883. Mielatz belongs to the first and second etching revivals. He was an experimenter, making color etchings and monotypes, and printing his own work.

CHARLES HENRY MILLER (*Plate 66*), landscape painter and etcher. New York City, 1842–New York City, 1922.

Miller portrayed the old farms and mills of then-rural Queens

County. He painted and exhibited from 1860 at the National Academy of Design. Having received a medical degree, in 1864 he traveled through the art museums of Europe and, resolving to be an artist, returned again for formal study (1867–1870) at the Bavarian Royal Academy under Adolf Lier. He was among the first Americans to study in Munich. Miller learned to etch from Alfred Cadart in 1866, but did not continue until 1876, when he made a series of freestyle etchings after his paintings.

JOHN AUSTIN SANDS MONKS (*Plate* 67), landscape and animal painter, etcher, illustrator. Cold-Spring-on-Hudson, N.Y., 1850–Chicago, Ill., 1917.

Monks painted sheep in the gray twilight of November or December landscapes. Some of his scenes of animal death and abandonment subtly evoke the human condition. He was a pupil of George Inness, with whom he shared a studio for years. Monks learned to etch in 1883 to reproduce his paintings, becoming his own publisher in 1885.

MARY NIMMO MORAN (*Plates* 68–70), landscape painter, etcher and illustrator. Strathavon, Scotland, 1842–East Hampton, N.Y., 1899.

Moran achieved an international reputation as one of the best American etchers. She was known for her vigorous etchings of sunny or twilight skies over woods, dunes and water. Her sites were often those near her summer home in East Hampton, the meadows of New Jersey, the hills of Pennsylvania or the Florida subtropics. She was the pupil of her husband Thomas and traveled with him to visit art collections in England, France, Italy and, in 1867 and 1872, the Far West. Moran began to etch *en plein air* in 1879. She was experimental in technique, utilizing line etching, drypoint, mezzotint, Scotch stone, roulette and artistic printing to create coloristic effects.

PETER MORAN (*Plates* 71 & 72), animal and landscape painter and original and reproductive etcher; instructor in painting and etching at the Philadelphia School of Design for Women. Bolton, England, 1841–Philadelphia, Pa., 1914.

Known as an artist who depicted quiet Pennsylvania farm life, Moran also treated themes from the Southwest. Having come to the United States in 1844, he was the first nonnative American to portray aspects of the life of the Pueblo Indians. He was in New Mexico in 1864. In 1879 he went with his brother Thomas to the Tetons. In 1881 he was in New Mexico and Arizona on an ethnographic visit to the Indian pueblos with Captain Bourke. In 1890 he traveled as an artist for the Bureau of Indian Affairs. He had been apprenticed at 16 to the lithographic firm of Herline and Hersel, drawing advertisements. A year later he began to study with his brothers Edward and Thomas Moran. He was influenced by the animal paintings of Rosa Bonheur and Constant Troyon and visited England in 1863 to see those of Edwin Landseer. Moran began to etch in 1874. His wife Emily was an artist.

THOMAS MORAN (*Plates* 73–76), landscape painter, original and reproductive etcher, book and magazine illustrator, worked in cliché verre, lithography and engraving. Bolton, England, 1837– Santa Barbara, Calif., 1926.

Moran's themes range from "placid pasture lands and somnolent old homesteads to the frowning splendor of pinnacled crags, . . . and the tremendous swing and illimitable vastness of the sea."[125] In 1844 Moran's family immigrated to Maryland. Moran was apprenticed to Scattergood and Telfer, wood engravers, in Philadelphia from 1853 to 1855. In 1862 he and his brother, the marine painter Edward Moran, went to London, where they studied paintings, most by Turner and Claude Lorrain. Turner's dramatic effects had a long-lasting influence on Moran. There was another trip to Europe in 1866. In 1871 Moran went to the Yellowstone region with Dr. F. V. Hayden and his U.S. Geological and Geographical Survey of the Territories (1867–1879). His spec-

tacular paintings from this trip were displayed in Washington, D.C. in 1871–1872 and encouraged Congress to establish Yellowstone National Park. After a trip to Wyoming in 1879, Mount Moran was named after him. Moran made his first etching in 1856. He took up etching again in 1878, producing about 100 plates by 1888. He had made glass etchings (cliché verre) earlier. Moran moved to Newark, N.J. in 1872, and in 1884 built a studio-house in East Hampton, N.Y., where he and his artist wife Mary Nimmo summered. He traveled extensively. *Communipaw, New Jersey* depicts the lower end of Jersey City, where, behind the waterfront, were factories, shops and refineries. *An Apple Orchard* is one of his East Hampton works drawn directly from nature.

JAMES CRAIG NICOLL (*Plate* 77), marine painter, etcher. New York City, 1847–Norwalk, Conn., 1918.

Nicoll is best known as a watercolorist portraying marine scenes along the Atlantic coast. He painted for two years in the studio of De Haas and on sketching trips with De Haas and Van Elten. *In the Harbor* has an effect of double printing in the sky produced by using a double needle.

STEPHEN PARRISH (*Plates* 78–80), painter, original and reproductive etcher, teacher Pennsylvania Academy of Fine Arts. Philadelphia, Pa., 1846–Cornish, N.H., 1938.

Parrish found the picturesque from the Bay of Fundy to Florida, and in England and France. He made his first plate in 1879. He worked in the painter-etcher mode and also made large prints suitable for framing. Sometimes Parrish printed his own work. His etchings sold well in England and the United States. An etching teacher to many, he settled in Cornish in 1895. His son was artist Maxfield Parrish.

JOSEPH PENNELL (*Plates* 81–83), illustrator, etcher, lithographer; art critic; author; teacher of etching at the Art Students League, 1922–1926. Philadelphia, Pa., 1857–Brooklyn, N.Y., 1926.

Pennell, who was "referred to in his early days as 'the Méryon of Philadelphia' [was] known . . . as an etcher of city views, a draughtsman of astounding sureness of eye and hand."[126] Later, in his "Wonder of Work" series, he was among the first artists to honor heavy industry. Pennell studied at the Pennsylvania School of Industrial Art and the Pennsylvania Academy of Fine Arts. Opening his own studio in Philadelphia in 1880, he began to illustrate picturesque buildings and sites for various publications. In 1883 he went to Italy to draw Tuscan cities. Pennell chose to make his home in London in 1884 to be able to fulfill his many assignments. He bought a press in the 1890s and was his own experimental printer. His wife, the writer Elizabeth Robins Pennell, often was the author of the books and articles which he illustrated. He returned to the United States in 1917. He had been taught to etch in the late 1870s by reproductive etcher Stephen Ferris, who also showed him the technical brilliance of the work of modern Spanish etchers like Fortuny. Parrish, Ferris and Pennell were a few of the founders of the Philadelphia Society of Etchers. Pennell's work reflects the "stamp of Whistler."

CHARLES ADAMS PLATT (*Plates* 84–86), landscape and marine painter, etcher, architect and landscape architect. New York City, 1861–Cornish, N.H., 1933.

Platt's quiet depictions of rivers and river traffic, picturesque old fishing villages and harbor scenes animated by local light and atmosphere were much admired. He began to study art in 1879 at the Art Students League and National Academy of Design, often painting at resort villages in the summer. From 1882 to 1889, he studied in Paris with the painters Boulanger and Jules Lefebvre. He became interested in the formal garden designs of Le Nôtre and in the Renaissance gardens in Italy. Stephen Parrish taught him to etch during the summer of 1880 in Gloucester and he was

a prolific etcher (of 100 plates) until he became involved in a new career as architect and landscape architect in 1890. He completed a few more etchings in 1917, 1920 and 1932. Platt was innovative in technique. In his etching *Evening*, sky and water were made by acid tint and the distant city was achieved by Scotch stone.

HENRY M. ROSENBERG (*Plate 87*), painter, etcher, director of the Victoria School of Art and Design, Halifax, Nova Scotia. New Brunswick, N.J., 1858–Dartmouth, N.S., 1939(?).

Rosenberg, a student at the Royal Academy in Munich, also studied in Florence and Venice, etching while one of Duveneck's "boys."

ALEXANDER SCHILLING (also spelled **SHILLING**) (*Plate 88*), landscape painter, etcher. Chicago, Ill., 1859–New York City, 1937.

Schilling depicted in drypoint agitated weather over rural landscapes in American or Dutch locales. He also depicted moonlight. He studied with the painter Henry C. Elkins in Chicago at age 18 and at 19 opened his own studio.

STEPHEN ALONZO SCHOFF (*Plate 89*), reproductive engraver, etcher. Danville, Vt., 1818–Norfolk, Conn., 1905.

An engraver of the formal reproductive style, during the revival of the 1880s Schoff became a reproductive etcher, breaking his line with freedom and spirit to translate tones, color values and brush marks. *The Prelude* is from this last period. Schoff's early training was with Oliver Pelton, a Boston engraver, then with engraver Joseph Andrews. In 1839–1840 he studied in Paris with Paul Delaroche.

JOHN SLOAN (*Plate 90*), figure painter, etcher, illustrator. Lock Haven, Pa., 1871–Hanover, N.H., 1951.

One of America's great etchers and a member of "The Eight," Sloan is noted for the realism which he achieved by a straightforward line technique and retroussage. He learned to etch during the revival from Hamerton's book and taught the technique to William Glackens. Sloan spent ten years as a pen-and-ink illustrator for the Philadelphia papers. Sloan thought that *The Schuylkill River* (1894) " 'looks like an etching from the connoisseur's point of view.' "[127] He drew it directly on the plate at the water's edge and returned to his studio to bite it in. In 1904 Sloan moved to New York, where he captured the life of the city's ordinary people.

GEORGE HENRY SMILLIE (*Plate 91*), landscape painter, watercolorist, etcher. New York City, 1840–Bronxville, New York, 1921.

Son of engraver James Smillie (1807–1885) and brother of James David Smillie, George was a pupil of James M. Hart at the National Academy of Design. Smillie sketched in the Rockies, Yosemite Valley and Florida.

JAMES DAVID SMILLIE (*Plates 92 & 93*), landscape painter, reproductive and original etcher, engraver, illustrator; instructor of etching at the National Academy of Design. New York City, 1833–New York City, 1909.

Smillie, trained by his father James Smillie as a banknote engraver on steel in the English tradition, became an expert in the intaglio processes and taught American artists who wished to become etchers. One of the founders of the New York Etching Club, he was one of the most influential figures in the American etching revival, allied with Koehler, who relied on him for technical advice. Smillie learned to etch at the age of eight but only began to persevere at it from 1878 on. Wishing to become a painter, he traveled to Europe in 1862 and by 1864 was also struggling in the etching medium to "rid himself of the restraint of engraver's methods, and to attain to the breadth and freedom which are valued in the productions of the painter-etchers. . . ."[128] In the late 1880s he experimented with drypoint, mezzotint, soft ground and aquatint, making demonstration plates for the Graphic Section of the Smithsonian Institution and the Pratt Institute in Brooklyn.

ALBERT STERNER (*Plate 94*), figure painter, printmaker, illustrator; instructor, Art Students League, New York. London, England, 1863–New York City, 1946.

Sterner's figures project subjective moods. He studied and lived in Munich and in Paris at the Académie Julian and the École des Beaux-Arts. He came to the U.S., worked as a scene painter and lithographer in Chicago from 1879 to 1884, and opened a studio in New York City in 1885, becoming active in the art world. Sterner, Joseph Pennell and George Bellows were pioneers in the revival of lithography in America in the early twentieth century.

JOHN HENRY TWACHTMAN (*Plates 95–97*), landscape painter, original and reproductive etcher, illustrator; art instructor, Art Students League, New York, 1889, Cooper Union, 1894 and at Cos Cob. Cincinnati, O., 1853–Gloucester, Mass., 1902.

Twachtman was an American Impressionist whose etchings "echoed the delicate impressions of evanescent light and color effects of his paintings."[129] In 1871–1875 he studied at the McMicken School of Design. He was in Munich 1875–1877 to study at the Royal Academy under Ludwig Loefftz, and was a member of the life class of Duveneck, with whom he went to Venice in 1877 and to Florence in 1880. It was probably then that Twachtman saw Whistler's etchings and those of Duveneck's "boys." He subsequently studied at the Académie Julian (1883–1885). Twachtman, his wife Mattie and Weir took a sketching trip to Holland in 1881 and drew on copper from nature. In 1888 the two families settled on neighboring farms in Connecticut and drew in the vicinity. Weir bought an etching press and both worked together. These etchings, executed as sketches from nature, may have been first thoughts to painting the same scene.

MARTHA (MATTIE) TWACHTMAN (*Plate 98*), etcher. Cincinnati, O., 1861–[?].

An etcher of slight, intimate glimpses of nature, she was active in the 1880s. Née Scudder, she married John Henry Twachtman in 1881.

CHARLES A. VANDERHOOF (*Plate 99*), illustrator, etcher; instructor, Cooper Union, 1889–1897. Locust Point, N.J., 1853–Locust Point, N.J., 1918.

Vanderhoof was active in the 1880s as an illustrator for *The Century Magazine*. His drypoints and soft-ground etchings are poetic in sentiment. He found his motifs in Holland and England.

HENDRIK DIRK KRUSEMAN VAN ELTEN (*Plate 100*), landscape painter, etcher. Alkmaar, Holland, 1829–Paris, 1904.

Van Elten's subjects were the expanses of flat grainfields and meadows, quiet copses, weed-grown riverbanks and dilapidated structures he found in the U.S. or in his native Holland. He trained under the landscape painter C. Lieste in Haarlem, studied in art schools in Amsterdam and Brussels and traveled in Germany and Switzerland. He came to the United States in 1865. He was active in Ellenville, N.Y., a favorite haunt of artists. Van Elten began to etch in 1876. He had already studied the work of the Dutch seventeenth-century artists and gathered a small, fine collection of their etchings.

CHARLES ALVAH WALKER (*Plate 101*), painter, wood engraver, original and reproductive etcher. Loudon, N.H., 1848–Brookline, Mass., 1920.

Walker was one of the earliest artists to work in monotype, beginning in Boston in 1881.

ANDREW W. WARREN (*Plate 102*), marine and landscape painter, etcher, Civil War illustrator for *Harper's Weekly*; art instructor, Annapolis. Coventry, N.Y., [?]–New York City, 1873.

Warren was an early etcher of individuality. His little land-scapes were "unpretentious, simple in method, showing much of what etchings should have."[130] He studied with T. H. Matteson in Sherburne, N.Y. Warren lived largely on Mt. Desert Island, Me. In his lifetime his plates were mechanically printed but after his death they were reissued "artistically printed."

JULIAN ALDEN WEIR (*Plates 103–106*), figure and landscape painter, etcher; teacher, Cooper Union Woman's Art School, 1878, and Art Students League. West Point, N.Y., 1852–New York City, 1919.

Weir's work is quiet and introspective. Gentle, dreamy women and children in protected environments are drawn in contrasts of rich darks and hazy lights. Julian Weir studied at the National Academy of Design in 1867–1868 and in 1873 enrolled at the École des Beaux-Arts under the academic painter Jean Léon Gérôme; but the chief influence on his work was Jules Bastien-Lepage. He returned to the United States in 1877, but went again to Europe. He learned to etch in Paris in 1875 and began to practice the art seriously from 1887 to 1893, producing over 140 etchings. He was greatly influenced by Whistler's etchings, which he had studied and several of which he owned. In 1888 he bought a small press and installed it at his farm in Branchville, Conn. In 1889 he was on the Isle of Man, where he made 18 light-shot views. Weir was his own experimental printer, trying various old papers. He often worked side by side with Twachtman.

JAMES ABBOTT McNEILL WHISTLER (*Plates 107–112*), painter, printmaker. Lowell, Mass., 1834–London, England, 1903.

Whistler took art lessons at the Imperial Academy while in Russia with his father (a military engineer) and family, 1843–1847. In 1848 he entered school in England and resided with his half-sister Deborah and her husband, Seymour Haden. From 1849 until 1855 he was in the United States, attending for a time West Point and working as a draughtsman for a Baltimore locomotive works. At West Point his art training included drawing from plaster casts and engravings. In the winter of 1854–1855 Whistler drew and etched precise topographical views on the borders of maps for the U.S. Coast Survey in Washington, D.C. In two days he learned how to draw on a grounded plate and bit it in acid; the Survey's workshop printed it for him. At the Coast Survey, Whistler learned to etch in the engraver's formula; finding it boring, he drew some little freehand sketches on survey plates that strongly contrast with the earlier style. Whistler left for Paris to study art and arrived in the midst of the etching revival, making contacts with the most avant-garde trends in French art. The etchings he executed in the next years were influenced by Rembrandt, Jacque and Méryon. *Twelve Etchings from Nature*, or the "French Set," which depict French rural scenes by day or night, some Parisian subjects and portraits of his niece and nephew, was printed by Delâtre and issued in 1858. He etched *Finette*, one of his earliest full-length portraits, around that time. In 1859 he settled in London and etched a series of works on the Thames River in minutely observed detail. At first the plates were issued separately; in 1871 they were published as *Sixteen Etchings of Scenes on the Thames and Other Subjects*, or the "Thames Set," which was also printed by professional printers. *Eagle Wharf* is from this set. Whistler joined the Junior Etching Club in 1859. From the 1860s, influenced by the Aesthetic Movement and his love of Japanese prints and Chinese porcelains, he reshaped his art to the poetic and exquisite. In 1879–1880 he was in Venice, carrying out a commission for the London Fine Art Society. In The *"Adam and Eve," Old Chelsea* he rejects his former tight manner for the freer one he developed in Venice, where he influenced directly American students and they him. The *Venice, A Series of Twelve Etchings*, or "First Venice Set," 1880, and *Twenty-Six Etchings*, or "Second Venice Set," 1886, were published from the etchings he had made. *The Bridge* is from the latter series. Whistler printed the editions himself. His total output of etchings and drypoints is about 450 plates.

THOMAS WATERMAN WOOD (*Plate 113*), portrait and genre painter, etcher. Montpelier, Vt., 1823–New York City, 1903.

Wood was a painter of nostalgic narratives of the American farmer and mechanic, black or white, in an idealized rural New England. He studied in Boston with Chester Harding in 1846 and worked in various places after 1852—New York City, Quebec, Washington, D.C., and Baltimore. He was in Europe 1859–1861 and in the South until he settled in New York City in 1867. Wood etched to reproduce his paintings.

GEORGE HENRY YEWELL (*Plates 114 & 115*), painter, etcher. Havre de Grace, Md., 1830–Lake George, N.Y., 1923.

Yewell was a pupil of Thomas Hicks. He studied at the National Academy of Design, 1851–1856, in the Paris studio of Thomas Couture, 1856–1861, and in Rome 1867–1878.

NOTES

See Bibliography for full titles of works cited (other than certain journal articles).

1. Joseph Pennell, *Etchers and Etching*, p. 15.
2. "The Deserted Village, Illustrated by the Etching Club," *Blackwood's Magazine* (Jan. 1842), p. 123, and "Etched Thoughts by the Etching Club," *Blackwood's Magazine* (Aug. 1844), p. 153.
3. Sylvester Rosa Koehler, "Introduction," *American Art Review*, 1880, p. 3.
4. Mary Cassatt, quoted in Nancy Mowll Mathews, "Reviews and Reviews, *Woman's Art Journal*, Spring–Summer 1981, p. 60.
5. Joseph Maberly, ed., *The Print Collector*, p. 69.
6. E. J. Hobsbawm, *The Age of Revolution: 1789–1848*, p. 302.
7. Raymond Williams, "Romantic Artist," *Culture and Society: 1780–1950*, New York, 1958, pp. 31–36.
8. Philip Gilbert Hamerton, *Painting in France*, p. 29.
9. Gustave Courbet, quoted in Robert Goldwater and Marco Treves, *Artists on Art*, p. 295.
10. Koehler, *Exhibition of American Etchings*, p. 13.
11. Seymour Haden, quoted in Koehler, "The Works of American Etchers," *American Art Review*, 1880, p. 5.
12. Frederick Keppel, *The Golden Age of Engraving*, p. 66.
13. F. Baldinucci, quoted in Christopher White, *Rembrandt as an Etcher*, p. 9.
14. Keppel, *op. cit.*, p. 273.
15. Mrs. Schuyler [Mariana Griswold] Van Rensselaer, *Rembrandt's "Gilder*," pp. 9–10.
16. Henry Studdy Theobald, *Crome's Etchings*, pp. 62–64.
17. Mary M. Heaton, "John Crome," p. 50.
18. Martin Hardie, quoted in Norman L. Goldberg, *John Crome the Elder*, p. 81.
19. Robert Rankin White, "Whistler and the Junior Etching Club," pp. 38–39.
20. Junior Etching Club, *Passages from Modern English Poets* [n.p.].
21. Francis George Newbolt, *History of the Royal Society of Painter-Etchers and Engravers*, pp. 11 and 24.
22. Trevor Fawcett and Clive Phillpot, eds., *The Art Press, passim*.
23. S. G. W. Benjamin, "Practice and Patronage of French Art," p. 259.
24. Janine Bailly Herzberg, *L'Eau-forte de Peintre au Dix-Neuvième Siècle: La Société des Aqua-fortistes, 1862–67, passim*.
25. The *New York Times*, April 8, 1866, p. 5, noted of the exhibition at the Derby Gallery that "there are none to whom the collection of etchings can fail to be of absorbing interest."
26. Frederic P. Vinton, *Memorial Exhibition of the Works of J. Foxcroft Cole*, pp. 6–7.
27. Herzberg, *op. cit.*, p. 213. American members of the French Etching Club were Whistler (1865), Alfred Wordsworth Thompson, George Snell and Edwin Forbes.
28. Mariana Griswold Van Rensselaer, "American Etchers," pp. 489 and 492.
29. Horatio W. Powers, "Philip Gilbert Hamerton," pp. 196–202.
30. Elizabeth Pennell, *The Life and Letters of Joseph Pennell*, pp. 169–178.
31. Hamerton, "The Unknown River," p. 187.
32. J. R. W. Hitchcock, *Etching in America*, p. 60.
33. Letter from J. M. Falconer to S. R. Koehler, February 28, 1881. Koehler papers, Archives of American Art.
34. Letter from James D. Smillie to S. R. Koehler, May 3, 1881. Koehler papers.
35. The following were elected members. In 1880: Albert F. Bellows. In 1881: O. Bacher, F. S. Church, F. Duveneck, J. M. Falconer, H. Farrer, R. S. Gifford, M. N. Moran, T. Moran, S. Parrish, J. D. Smillie. In

1882: J. Pennell, C. Platt, H. D. Kruseman Van Elten, T. M. Wendel. In 1887: A. L. Merritt. Newbolt, *op. cit.*, pp. 53–56.
36. "Mr. Seymour Haden on Etching," *The Magazine of Art*, 1879, pp. 188–189.
37. Keppel, *op. cit.*, p. 430.
38. *Ibid.*, pp. 134 and 137.
39. *Ibid.*, p. 133.
40. Hamerton, *Etching and Etchers*, p. 66.
41. Keppel, *op. cit.*, p. 136. *See also* "The Decline of the Amateur," *Atlantic Monthly*, June 1894, pp. 859–860: "this elegant, useful, cultivated and appreciative class seems to be in danger of disappearing.... Everyone now demands pay for work, recognition as a worker."
42. Letter from James D. Smillie to S. R. Koehler, February 24, 1890. Koehler papers.
43. Richard Muther, *The History of Modern Painting*, vol. 4, p. 12.
44. Van Rensselaer, *The Union League Club Exhibition Catalogue of the Works of the Women Etchers of America*, p. 5.
45. Van Rensselaer, "American Etchers," p. 491.
46. Alice Gerson Chase, *The Life and Art of William Merritt Chase*, p. 120.
47. Otto Bacher, *With Whistler in Venice*, p. 91.
48. Elizabeth Pennell, *op. cit.*, p. 100.
49. Howard Mansfield, *Whistler as a Critic of His Own Prints*, p. 10.
50. Jonathan Mayne, ed., *Baudelaire: Art in Paris, 1845–1862*, p. 220.
51. Frederick Wedmore, *Whistler's Etchings*, pp. 11 and 13.
52. Thomas R. Way, *Memories of James McNeill Whistler*, p. 56.
53. Robert H. Getscher and Allen Staley, *The Stamp of Whistler*, p. 19.
54. Christopher White, *op. cit.*, p. 11.
55. Way, *op. cit.*, pp. 95–96.
56. E. G. Kennedy, Director of Herman Wunderlich & Company, New York, was a friend and agent for Whistler and began to buy his works in the 1870s when, says Pennell, "scarcely anybody thought of buying them" (Elizabeth R. and Joseph Pennell, *The Life of James McNeill Whistler*, p. 17). The American Society of Painters in Watercolors first included a "Black and White" section in its annual exhibition for the 1874–1875 season. Two etchings by Whistler were shown—*Thames Longshoremen* and *Portrait of a Boy*—which were lent by the collector J. H. Maghee. In 1878 Avery lent several Whistler etchings to the New York Etching Club exhibition. That year the Wunderlich company included Whistler in a group show with Haden, Méryon, Millet, Detaille, Claude Lorrain, Rembrandt and Ostade. In 1879 M. Knoedler & Company included Whistler's prints in the "Modern Etchings and Engravings" section of their general catalogue. In the same year an exhibition at the Boston Museum of Fine Arts was reported in "Notes," *Art Journal*, 1879, p. 95: "... an attractive exhibition of etchings and engravings.... Thirty Rembrandts were shown.... Haden was represented by twenty-five etchings, and sixty-two by J. M. Whistler, mostly Breton scenes and views from the Thames.... Those which attracted the most attention were the Thames scenes by Whistler." In 1880 Avery again lent etchings to the New York Etching Club show. In 1881 Ernest G. Brown of the London Fine Arts Society brought from London the first Venice set of 12 etchings and exhibited them at the Philadelphia Academy of Fine Arts. Private collectors bought sets, Wunderlich Gallery bought six sets and Avery one. James L. Claghorn, President of the Pennsylvania Academy of the Fine Arts, owned Whistler and Haden prints, as well as thousands of others which were studied by artists. The first exhibition of the Philadelphia Society of Etchers, held in 1882–1883, showed Whistlers.
57. Pencil note in the book belonging to Samuel Avery in the New York Public Library: Ralph Thomas, *A Catalogue of the Etchings and Drypoints of James McNeill Whistler*, London, 1874.

58. William Spohn Baker, *The Origin and Antiquity of Engraving: With Some Remarks on the Utility and Pleasure of Prints*, p. 54.

59. Letter from Seymour Haden to Otto Bacher, June 19, 1882, quoted in W. W. Andrews, *Otto Bacher* [n.p.].

60. Hitchcock, *op. cit.*, p. 76.

61. Koehler, *American Art Review*, vol. II, pp. 264 and 143.

62. Hitchcock, *op. cit.*, p. 76.

63. Albert D. Hager, *Report of the Commissioner to the Universal Exposition of 1867 at Paris, France*, p. 4.

64. Maberly, *op. cit.*, p. 285.

65. Koehler, *New York Etching Club* [n.p.]. The New York Etching Club was the only such club to remain active for a period of years. The Etching Club of Cincinnati held an exhibition in 1880 at the Cincinnati Industrial Exhibition consisting of 342 prints. Members included Mary Louise McLaughlin and H. F. Farny. The Philadelphia Society of Etchers held an exhibition at the Pennsylvania Acacemy of Fine Arts during the winter of 1882–1883 (see *Catalogue of the First Annual Exhibition of the Philadelphia Society of Etchers*, Philadelphia, 1882). 1,070 works were exhibited, including 356 etchings by 45 American artists. Among its resident members were Peter Moran, Stephen Parrish, Joseph Pennell and Stephen Ferris. Koehler was an honorary member. The Boston Etching Club held an exhibition of works of its members in 1883. In addition, the New York Etching Club sent traveling exhibitions to other cities; 70 etchings were shown at the Industrial Exposition in Chicago in 1881.

66. Hitchcock, *op. cit.*, p. iv.

67. W. H. Bishop, "Black and White: Second Annual Exhibition of the Salmagundi Sketch Club, New York," and S. G. W. Benjamin, "Black and White."

68. New York Etching Club, *New York Etching Club: Catalogue of the Exhibition Illustrated with Etchings*, 1882 [n.p.].

69. "Watercolors and Etchings," *Harper's Weekly*, vol. xxvi, February 11, 1882, p. 92.

70. Judith K. Brodsky, "Rediscovering Women Printmakers: 1550–1850."

71. Van Rensselaer, *The Union League Club Exhibition Catalogue*, p. 1. The catalogue was illustrated with two small etchings by Mary Moran and Edith Getchell.

72. Emily Faithfull, *Three Visits to America*, p. 312.

73. Christine J. Huber, *The Pennsylvania Academy and Its Women*, *passim*.

74. J. D. Kershaw, "Philadelphia School of Design for Women," pp. 187–200. See also "Schools," *American Art Review*, vol. 1, 1880, p. 43.

75. Anna Lea Merritt, "A Letter to Artists: Especially Women Artists," pp. 466–467.

76. Martha J. Hoppin, "Women Artists in Boston," p. 19.

77. Leader Scott, "Women at Work: Their Functions in Art," p. 99. See also Albert Ten Eyck Gardner, "A Century of Women."

78. Maude Howe Elliott, ed., *Art and Handicrafts in the Women's Building*, pp. 62–63.

79. *American Art Review*, 1880, pp. 1–2, 4.

80. Letter from Dana Estes to S. R. Koehler, March 27, 1879, Koehler papers.

81. Estes to Koehler, March 29, 1879. Koehler papers.

82. Estes to Koehler, March 24, 1879. Koehler papers.

83. Estes to Koehler, March 29, 1879. Koehler papers.

84. Estes to Koehler, April 4, 1879. Koehler papers.

85. Letter from Samuel Colman to S. R. Koehler, July 10, 1880. Koehler papers.

86. Letter from W. M. Chase to S. R. Koehler, July 31, 1880. Koehler papers.

87. Letter from J. F. Cole to S. R. Koehler, spring 1879. Koehler papers.

88. Letter from J. D. Smillie to S. R. Koehler, June 5, 1880. Koehler papers.

89. Smillie to Koehler, June 14, 1880. Koehler papers.

90. F. E. Fryatt, "The Navesink Highlands," p. 541.

91. Charles Moore, "Materials for Landscape Art in America," p. 678.

92. Charles M. Kurtz, *National Academy of Design, American Academy, Notes*, 1881, p. 47.

93. Koehler, *American Etchings and American Art*, pp. 26 and 23.

94. Koehler, *New York Etching Club* [n.p.].

95. Charles Burr Todd, "The American Barbizon," pp. 322–324. From 1891 through 1902 William Merritt Chase ran the first painting school *en plein air* at Shinnecock overlooking Peconic Bay in Long Island.

96. Hamerton, "The Bovines," p. 63.

97. Koehler, *American Etchings and American Art*, pp. 30 and 31.

98. Moore, *op. cit.*, p. 671.

99. Benjamin, "An American Landscape Painter," p. 96.

100. Eugene Benson, "French and English Illustrated Magazines," p. 687.

101. Joseph and Elizabeth R. Pennell, "The Most Picturesque Place in the World," p. 345.

102. Van Rensselaer, "Picturesque New York," pp. 168 and 170.

103. Whistler, quoted in Muther, *op. cit.*, pp. 5–6.

104. John G. Chapman, *The American Drawing Book*, p. 260.

105. Grolier Club of the City of New York, *Catalogue of the Engraved Work of Asher B. Durand*, pp. 101–103.

106. Hitchcock, *op. cit.*, p. 40.

107. Lloyd Goodrich, *The Graphic Art of Winslow Homer*, p. 17.

108. Letter from J. D. Smillie to S. R. Koehler, March 7, 1886. Koehler papers.

109. Keppel, *op. cit.*, pp. 27–28.

110. J. D. Smillie, *New York Etching Club*, 1891, p. xv.

111. Koehler, *Etching*, p. 190.

112. Andrew Robison, *Paper in Prints*, pp. 16 and 17.

113. Keppel, *op. cit.*, p. 278.

114. Alfred Trumble, "To Subscribers"; "All Around the Clock"; "As the World Wags," *The Collector*, May 1, 1891, p. 199.

115. Van Rensselaer, *The Union League Club Exhibition*, pp. 5 and 6.

116. Koehler, *Etching*, p. 160.

117. Smillie, "Etching and Painter-Etching," p. 263.

118. Frank Weitenkampf, *American Graphic Art*, p. 25.

119. Frank Weitenkampf, "Some Women Etchers," p. 736.

120. S. R. Koehler, *American Etchings*. [n.p.].

121. Frank Weitenkampf, "Some Women Etchers," p. 732.

122. Letter from Getchell to George Washington Stevens, George Washington Stevens Papers, Archives of American Art.

123. Leigh Harrison Hunt, *On the Making of Etchings*, p. 16.

124. F. Newlin Price, "The Art of W. L. Lathrop," p. 32.

125. Alfred Trumble, quoted in Thurman Thomas Wilkins, *Moran: Artist of the Mountains*, p. 140.

126. Weitenkampf, *American Graphic Art*, p. 20.

127. John Sloan, quoted in Peter Morse, *John Sloan's Prints, A Catalogue Raisonné of the Etchings, Lithographs and Posters*, p. 62.

128. Koehler, *New York Etching Club* [n.p.].

129. Weitenkampf, *American Graphic Art*, p. 25.

130. *Ibid.*, p. 8.

BIBLIOGRAPHY

The American Art Review. Vols. I, II. Boston, 1880–1881.

American Society of Painters in Water Color. Catalogues of Annual Exhibitions, 1874–1881.

ANDREWS, WILLIAM W. *Otto Bacher.* Madison, Wis., 1973.

"Art and Artists, The Academy Exhibition," *The Galaxy* (June 1868), pp. 795–796.

Art and Commerce: American Prints of the Nineteenth Century. Boston, 1975.

ARTS COUNCIL OF GREAT BRITAIN. *The Shock of Recognition: The Landscape of English Romanticism and the Dutch Seventeenth Century School,* London, 1971.

ATKINSON, J. BEAVINGTON. "Etching, Its Relation to the Artist, the Amateur and the Collector," *Art Journal* (London, 1880), pp. 129–132, 197–199.

———. "Etchings of Rembrandt," *The Portfolio* (1877), pp. 114–116.

AUSTIN, GEORGE LOWELL. "With Acid and Needle," *The Galaxy* (vol. 18, 1874), pp. 639–646; 768–777.

AUSTIN, HENRY WILLARD. "Monks and His Work," *The Connoisseur* (autumn 1887), pp. 3–14.

BACHER, OTTO. *With Whistler in Venice.* New York, 1908.

BAER, W. J. "Robert Frederick Blum," *Book Buyer* (vol. 10, 1893), pp. 353–355.

BAKER, WILLIAM SPOHN. *The Origin and Antiquity of Engraving: With Some Remarks on the Utility and Pleasure of Prints.* Philadelphia, 1872.

BASKETT, MARY WELCH. "John Henry Twachtman: Prints." In Cincinnati Art Museum, *John Twachtman: A Retrospective Exhibition.* Cincinnati, 1966.

BEAUFORT, MADELEINE FIDELL, HERBERT L. KLEINFIELD and JEANNE K. WELCHER. Introduction. *The Diaries 1871–1882 of Samuel P. Avery, Art Dealer.* New York, 1979.

BENJAMIN, S. G. W. "An American Landscape Painter," *The Magazine of Art* (vol. 7, 1884), pp. 94–98.

———. "Black and White," *American Art Review* (vol. 2, 1881), pp. 116–122.

———. "Fifty Years of American Art, III." *Harper's Monthly Magazine* (Oct. 1879), pp. 673–688.

———. *Our American Artists, 1879 and 1881.* (Facsimile of 1879 and 1881 eds.) New York, 1977.

———. "Practice and Patronage of French Art," *Atlantic Monthly* (Sept. 1875), pp. 251–269.

BENSON, EUGENE. "French and English Illustrated Magazines," *The Atlantic Monthly* (June 1870), pp. 681–687.

BERMINGHAM, PETER. *American Art in the Barbizon Mood,* Washington, D.C., 1975.

BINYON, LAURENCE. "Rembrandt's Landscape Etchings." In Carrington, Fitzroy, ed. *Prints and Their Makers,* New York, 1912, pp. 94–111.

BISHOP, W. H. "Black and White: Second Annual Exhibition of the Salmagundi Sketch Club, New York," *American Art Review* (vol. 1, 1880), pp. 206–208.

BOIME, ALBERT. *The Academy and French Painting in the Nineteenth Century.* London, 1971.

BOSTON MUSEUM OF FINE ARTS. *Catalogue of Etchings Exhibited at the Museum of Fine Arts,* 1879.

BRADLEY, WILLIAM ASPENWALL. *French Etchers of the Second Empire.* New York, 1911.

BREESKIN, ADELYN DOHME. *Mary Cassatt: A Catalogue Raisonné of the Graphic Work.* Washington, D.C., 1979.

BRODSKY, JUDITH K. "Rediscovering Women Printmakers: 1550–1850," *Counterproof* (vol. 1, no. 3, summer 1979), pp. 1ff.

BROWNELL, WILLIAM C., "The Younger Painters of America," *Scribner's Monthly* (vol. XX, 1880), pp. 1–15.

CAFFIN, CHARLES H. "Robert Frederick Blum," *The International Studio* (vol. 21, Nov. 1903–Feb. 1904), pp. clxxvii–cxcii.

CAMPBELL, WILLIAM P. *John Gadsby Chapman.* Washington, D.C., 1963.

CARRINGTON, FITZROY. *Engravers and Etchers.* Chicago, 1917.

CARY, ELIZABETH LUTHER. "Frank Duveneck's Etchings," *Art in America* (vol. 13, 1925), pp. 274–276.

Catalogue of the Collection of Paintings and Sculpture Belonging to Mr. James H. Stebbins. New York, 1889.

CHAPMAN, JOHN G. *The American Drawing Book.* New York, 1870.

CHASE, ALICE GERSON. *The Life and Art of William Merritt Chase.* New York, 1917.

CHURCH, F. S. "An Artist Among Animals," *Scribner's Magazine* (vol. 14, 1893), pp. 749–752.

CINCINNATI ART MUSEUM. *A Retrospective Exhibition: Robert F. Blum, 1857–1903.* Cincinnati, 1966.

CLARK, ROBERT JUDSON, ed. *The Arts and Crafts Movement in America 1876–1916.* Princeton, 1972.

CLEMENT, CLARA ERSKINE and LAURENCE HUTTON. *Artists of the Nineteenth Century and Their Works.* Boston and New York, 1894.

COOK, JOEL. *An Eastern Tour at Home.* Philadelphia, 1889.

CORTISSOZ, ROYAL. "The Field of Art," *Scribner's Magazine* (vol. 81, 1927), pp. 216–224.

COXE, REGINALD CLEVELAND. "In Gloucester Harbor," *Century Magazine* (Aug. 1892), pp. 518–522. Illustrations by Coxe.

CRAVEN, WAYNE. "Albion Harris Bicknell 1837–1915, *Antiques* (Sept. 1974), pp. 443–449.

CURTI, MERLE. *The Growth of American Thought.* New York, 1943.

DAWSON, WILLIAM FORREST. *A Civil War Artist at the Front: Edwin Forbes' Life Studies of the Great Army.* New York, 1957.

DELABORDE, LE VICOMTE HENRI. *Engraving: Its Origin, Processes and History.* Trans. by R. A. M. Stevenson. New York, 1886.

"The Deserted Village: Illustrated by the Etching Club," *Blackwood's Magazine* (Jan. 1842), pp. 122–129.

"The Elements of Etching," *The American Architect and Building News* (Apr. 22, 1882), pp. 185–186.

ELLIOTT, MAUDE HOWE. *Art and Handicrafts in the Women's Building of the World's Columbian Exposition.* Chicago, 1893.

"Etched Thoughts by the Etching Club," *Blackwood's Magazine* (Aug. 1844), pp. 153–163.

EVERETT, MORRIS T. "The Etchings of Mrs. Mary Nimmo Moran," *Brush and Pencil* (vol. 8, 1901), pp. 3–16.

FAITHFULL, EMILY. *Three Visits to America.* New York, 1884.

Famous Etchers. Boston, 1889.

FAWCETT, TREVOR, and CLIVE PHILLPOT, eds. *The Art Press.* London, 1976.

FERBER, LINDA. "Our Mr. Falconer," *Brooklyn Before the Bridge: American Paintings from the Long Island Historical Society* (exhib. cat.). Brooklyn Museum, 1982.

FINKE, ULRICH. *German Painting: From Romanticism to Expressionism.* London, 1974.

FISHE, MARY WAGER. "The Claghorn Collection of Prints," *The Art Journal* (1879–1880), pp. 153–156.

FLINT, JANET A. *J. Alden Weir, An American Printmaker, 1852–1919.* Provo, Utah, 1972.

FRYATT, F. E. "The Navesink Highlands," *Harper's Monthly Magazine* (Sept. 1879), pp. 541–553.

GARDNER, ALBERT TEN EYCK. "A Century of Women," *Bulletin of the Metropolitan Museum of Art* (vol. 7, 1948–1949), pp. 110–118.

GARRATY, JOHN ARTHUR. *The Transformation of American Society: 1870–1890.* Columbia, S.C., 1968.

GETCHELL, MARGARET C. "A Little Print Shop," *Philadelphia Public Ledger,* magazine section (July 27, 1919).

GETSCHER, ROBERT H. and ALLEN STALEY. *The Stamp of Whistler.* Oberlin College, Ohio, 1977.

GODFREY, RICHARD T. *Printmaking in Britain.* New York, 1978.

GOLDBERG, NORMAN L. *John Crome the Elder*. New York, 1968.

GOLDWATER, ROBERT, and MARCO TREVES. *Artists on Art*. New York, 1945.

GOODRICH, LLOYD. *The Graphic Art of Winslow Homer*. New York, 1968.

GROLIER CLUB OF THE CITY OF NEW YORK. *Catalogue of a Collection of Engravings, Etchings and Lithographs by Women*. New York, 1901.

———. *Catalogue of the Engraved Work of Asher B. Durand*. New York, 1895.

———. *Exhibition of the Etched Work of C. A. Platt*. New York, 1925.

HAGER, ALBERT D. *Report of the Commissioner to the Universal Exposition of 1867 at Paris, France*. Vermont, Oct. 20, 1867.

HALE, ELLEN DAY. Intro. by Alanna Chesebro. *Ellen Day Hale, 1855–1940*. (exhib. cat.). Richard York Gallery, New York, 1981.

HALL, ELTON W. *R. Swain Gifford*. Old Dartmouth Historical Society Whaling Museum, New Bedford, 1974.

HAMERTON, PHILIP GILBERT. "The Bovines," *The Portfolio* (1871), pp. 59–64.

———. *Etching and Etchers*. London, 1868.

———. *Painting in France*. Boston, 1895.

———. "Seymour Haden's Etchings," *Century Magazine* (vol. 20, 1880), pp. 586–600.

———. "The Unknown River, An Etcher's Voyage of Discovery," *The Portfolio*, 1870, pp. 7ff.

HARRIS, G. W. "Mielatz, American Etcher," *International Studio* (July 1922), pp. 293–298.

HARRIS, NEIL, *The Artist in American Society*. New York, 1966.

HEATON, MARY M. "John Crome," *The Portfolio* (Feb. 1879), pp. 32–33, 48–51.

HENDERSON, M. STURGE. *Constable*. London, 1905.

HERBERT, ROBERT. *Barbizon Revisited*. New York, 1962.

HERZBERG, JANINE BAILLY. *L'Eau-forte de Peintre au Dix-Neuvième Siècle: La Société des Aqua-fortistes, 1862–67*. 2 vols. Paris, 1972.

HITCHCOCK, J. R. W. *Etching in America*, New York, 1886.

———. *Important New Etchings*. New York, 1888.

———. *Notable Etchings by American Artists*. New York, 1886.

———. *Representative Etchings of Artists Today in America*. New York, 1887.

———. *Some Modern Etchings*. New York, 1884.

HOBSBAWM, E. J. *The Age of Revolution: 1789–1848*. New York, 1962.

HOPPIN, MARTHA J. "Women Artists in Boston (1870–1900), The Pupils of William Morris Hunt," *The American Art Journal* (winter 1981), pp. 17–46.

HUBER, CHRISTINE J. *The Pennsylvania Academy and Its Women: 1850–1920*. Philadelphia, 1974.

HUNT, LEIGH HARRISON. *On the Making of Etchings: Also a Few Characteristics of Some Great Etchers*. New York, 18–.

HUSSEY, CHRISTOPHER. *The Picturesque: Studies in a Point of View*. London, 1927.

INGERSOLL, ERNEST. *A Week in New York*. New York, 1891.

"The International Exhibition: French Art II," *The Nation* (vol. 23, Oct. 12, 1876), pp. 224–226.

The International Studio (Whistler issue, vol. 21, Nov. 1903–Feb. 1904).

ISHAM, SAMUEL. *History of American Painting*. New York, 1922.

JAMES, HENRY. "London," *Century Magazine* (1888), pp. 220–239.

———. "Venice," *The Century Magazine* (Nov. 1882), pp. 3–23.

JUNIOR ETCHING CLUB. *Passages from Modern English Poets*. London, 1862.

KENNEDY, EDWARD G. *The Etched Work of Whistler*. New York, 1910.

KENNEDY AND CO. *Catalogue of Miscellaneous Etchings Formerly Belonging to Sir Francis Seymour Haden*. New York, 1911.

KEPPEL, FREDERICK. *The Golden Age of Engraving*. New York, 1910.

———. "Personal Sketches of Some Famous Etchers," *Transactions: Grolier Club of the City of New York*, Part 11. New York, 1894.

KERSHAW, J. D. "Philadelphia School of Design for Women," *The Sketch Book* (Apr. 1905), pp. 187–200.

KLACKNER, CHRISTIAN. *Klackner's American Etchings* (sale cat.). New York, 1888.

———. *Proofs and Prints. Engravings, Etchings; How They are Made, Their Grades, Qualities, and Values and How to Select Them*. New York, 1884.

KOEHLER, SYLVESTER ROSA. *American Etchings and American Art*. (Facsimile of Boston 1886 and New York 1886 editions.) Garland Press, New York, 1978.

———. *Etching: An Outline of Its Technical Processes and Its History, With Some Remarks on Collections and Collecting*. New York, 1885.

———. *Exhibition of American Etchings*. Boston Museum of Fine Arts, 1881.

———. *New York Etching Club: Twenty Original American Etchings*. 2 vols. New York, 1885.

———. *Exhibition of the Etched Work of Rembrandt and of the Artists of His Circle*. Boston Museum of Fine Arts, 1887.

———. *Exhibition of the Work of the Women Etchers of America*. Boston, 1887.

———. *The Technical Methods of the Reproductive Arts, from the XV Century with Special Reference to the Photo-Mechanical Processes*. Boston Museum of Fine Arts, 1892.

———. *Twenty American Etchings*. New York, 1887.

KURTZ, CHARLES M. *National Academy of Design, American Academy: Notes with Illustrations of Many of the Principal Pictures in the Exhibition*. New York, 1881–1889.

"Lady Art Students in Paris," *International Studio* (vol. 21, 1903–1904), pp. 225–233.

LA FOLLETTE, SUZANNE. *Art in America*. New York, 1929.

LALANNE, MAXIME. *Treatise on Etching*. 2nd ed. trans. by S. R. Koehler, London, 1880. (Reprinted by Dover Publications, Inc., 1981.)

LAVER, JAMES. *A History of British and American Etching*. London, 1929.

———. "Seymour Haden and the Old Etching Club," *Bookman's Journal and Print Collector* (vol. 10, 1924), pp. 87–91.

LEYMARIE, JEAN. *The Graphic Works of the Impressionists*. New York, 1971.

LISTER, RAYMOND. *Samuel Palmer and His Etchings*. New York, 1969.

LORING, CHARLES G. "Sylvester R. Koehler," *Boston Museum of Fine Arts Annual Report* (vol. 25, 1900), pp. 11–14.

MABERLY, JOSEPH. *The Print Collector*. New York, 1880.

MANDEL, PATRICIA C. F. "A Look at The New York Etching Club, 1877–1894." *Imprint* (winter 1980), pp. 31–35.

MANSFIELD, HOWARD. *Whistler as a Critic of His Own Prints*. New York, 1935.

MAYNE, JONATHAN, ed. and trans. *Baudelaire: Art in Paris, 1845–1862*. London, 1965.

MERRITT, ANNA LEA. "A Letter to Artists: Especially Women Artists," *Lippincott's Monthly Magazine* (March 1900), pp. 466–467.

MIELATZ, CHARLES F. W. *Etchings of New York by Charles F. W. Mielatz*. New York, 1934.

MILLER, JOHN R. "The Art of Making Monotypes," *Brush and Pencil* (vol. 11, March 1903), pp. 445–450.

MONTGOMERY, WALTER, ed. *American Art and American Art Collections*. 2 vols. (Facsimile of Boston, 1889 ed.) New York, 1978.

MOORE, CHARLES. "Materials for Landscape Art in America." *Atlantic Monthly* (Nov. 1889), pp. 670–679.

MOORE, EDWARD HOWARD. "The Art of Joseph Pennell," *Brush and Pencil* (May 1903), pp. 81–94.

MORAN, PETER. *Catalogue of the Etched Work of Peter Moran*. New York, 1888.

MORAN, THOMAS and MARY NIMMO. *A Catalogue of the Complete Etched Works of Thomas Moran and Mary Nimmo Moran*. New York, 1889.

MORSE, PETER. *John Sloan's Prints, A Catalogue Raisonné of the Etchings, Lithographs, and Posters*. New Haven and London, 1969.

MUMFORD, LEWIS. *The Brown Decades*. New York, 1931. (Reprinted by Dover Publications, Inc., New York, 1971.)

———. *The Golden Day*. New York, 1926.

MUTHER, RICHARD. *The History of Modern Painting*. 4 vols., New York, 1907.

NEWBOLT, FRANCIS GEORGE. *History of the Royal Society of Painter-Etchers and Engravers: 1880–1930*. London, 1930.

NEW YORK ETCHING CLUB. *New York Etching Club: Catalogue of the Exhibition Illustrated with Etchings*. 1882–1889.

———. *A Publication by the New York Etching Club . . . With Catalogue of Etching Proofs Exhibited at the National Academy of Design, New York, 1891–1893*.

———. *Twenty Original Etchings*. 2 vols. New York, 1885.

NEW YORK PUBLIC LIBRARY. Art Division and Prints Division. Clipping files on individual artists.

NORTON, CHARLES ELIOT. "The Lack of Old Homes in America," *Scribner's Magazine* (vol. V, 1889), pp. 636–640.

The Painterly Print. Monotypes from the Seventeenth to the Twentieth Century. Metropolitan Museum of Art, New York, 1980.

Painters-Etchings. London, 1884.

PARRISH, STEPHEN. *A Catalogue of Etchings by Stephen Parrish: 1879–1883.* Philadelphia, 188–.

PENNELL, ELIZABETH. *The Life and Letters of Joseph Pennell,* Boston, 1929.

PENNELL, ELIZABETH R. and JOSEPH. *The Life of James McNeill Whistler.* Philadelphia, 1908.

PENNELL, JOSEPH. *Etchers and Etching.* New York, 1924.

——. *Pen Drawing and Pen Draughtsmen.* New York, 1920.

PENNELL, JOSEPH and ELIZABETH R. "The Most Picturesque Place in the World," *The Century Magazine* (July 1893), pp. 345–351.

——. *The Whistler Journal.* Philadelphia, 1921.

PHILADELPHIA SOCIETY OF ETCHERS. *Catalogue of the First Annual Exhibition.* Philadelphia, 1882.

PILGRIM, DIANNE H. "The Revival of Pastels in Nineteenth Century America: The Society of Painters in Pastel," *American Art Journal* (Nov. 1978), pp. 43–62.

POOLE, EMILY. "The Etchings of Frank Duveneck," *The Print Collector's Quarterly* (Oct. 1938), pp. 312–331.

——. "Catalogue of the Etchings of Frank Duveneck," *The Print Collector's Quarterly* (Dec. 1938), pp. 447–463.

POWERS, HORATIO W. "Philip Gilbert Hamerton," *Old and New* (August 1873), pp. 196–202.

PRICE, F. NEWLIN. "The Art of W. L. Lathrop," *International Studio* (Nov. 1923), pp. 32–38.

"Printer and Artist," *The Collector* (Nov. 1, 1891), p. 234.

RANDALL, LILIAN M. C. *The Diary of George A. Lucas; An American Art Agent in Paris: 1857–1909.* 2 vols. New Jersey, 1979.

REYNOLDS, GRAHAM. *Victoria and Albert Museum: Catalogue of the Constable Collection.* London, 1960.

RICE RICHARD A. *A Descriptive Catalogue of the Etched Work of C. A. Platt,* New York, 1889.

RICH, HIRAM. "Around Cape Ann, Annisquam to Marblehead," *Century Magazine* (Nov. 1881), pp. 49–57.

RICHARDSON, E. P. *A Short History of Painting in America,* New York, 1963.

ROBBINS, ELIZABETH. "A Ramble in Old Philadelphia," *Century Magazine* (vol. 1, Jan. 1882), pp. 655–665.

ROBINSON, FRANK T. *Living New England Artists.* Boston, 1888.

ROBISON, ANDREW. *Paper in Prints.* Washington, D.C., 1977.

ROGER-MARX, CLAUDE. *French Original Etchings from Manet to the Present Time.* New York, 1939.

ROWLANDS, WALTER. *American Painter-Etchings.* Boston, 1888.

RYERSON, MARGERY A. "John H. Twachtman's Etchings, Including Catalogue," *Art in America* (1920), pp. 92–96.

SAINT-GAUDENS, HOMER. *The American Artist and His Time.* New York, 1941.

SANDBERG, JOHN. "Whistler's Early Work in America, 1834–1855," *The Art Quarterly* (1966), pp. 46–58.

SCHAPIRO, MEYER. "Nature of Abstract Art," *Modern Art.* New York, 1978.

SCOTT, LEADER. "Women at Work: Their Functions in Art," *The Magazine of Art* (vol. 7, 1884), pp. 98–99.

"Mr. Seymour Haden on Etching," *The Magazine of Art* (1879), pp. 188ff.

SHELDON, GEORGE WILLIAM. "F. S. Church," *Harper's Monthly Magazine* (Dec. 1888), pp. 52–58.

SHESTACK, ALAN. "Some Thoughts on Méryon and French Printmaking in the Nineteenth Century," in *Charles Méryon: Prints and Drawings,* (exhib. cat., ed. by James D. Burke). New Haven, 1974.

SHILLING, ALEXANDER. *The Book of Alexander Shilling.* New York, 1937.

SLOAN, JOHN. *New York Etchings* (1905–1949). New York, 1978.

SMILLIE, JAMES D. "Etching and Painter-Etching," *The Quarterly Illustrator* (vol. II, no. 7, 1894), pp. 260–263.

——. *Manuscript Catalogue of Etchings, Engravings and Drawings by James D. Smillie.* New York 18–. New York Public Library, Prints Department.

——. *Some Works by James D. Smillie, N.A. 1833–1909.* New York, 1910.

SPARROW, WALTER SHAW. *A Book of British Etchers from Francis Barlow to Francis Seymour Haden.* London, 1926.

STORY, WILLIAM WETMORE. *Reports of the U.S. Commissioners to the Paris Universal Exposition, 1878.* Washington, D.C., 1880.

STRAHAN, EDWARD E. *The Masterpieces of the Centennial Exhibition.* Philadelphia, 1877.

THEOBALD, HENRY STUDDY. *Crome's Etchings.* London, 1906.

THOMAS, RALPH. *A Catalogue of the Etchings and Drypoints of James Abbott McNeill Whistler.* London (privately printed), 1874.

TODD, CHARLES BURR. "The American Barbizon," *Lippincott's Magazine* (Apr. 1883), pp. 321–328.

TRUMBLE, ALFRED. "All Around the Clock," *The Collector* (June 1, 1891), p. 174.

——. "Some Etchers and their Etchings," *The Collector* (Apr. 15, 1890), p. 98.

——. "The Prints of the Season," *The Collector* (Oct. 15, 1892), pp. 314–315.

——. "To Subscribers," *The Collector* (Sept. 1, 1890), p. 145.

UNION LEAGUE CLUB. *Catalogue of Etchings and Dry Points at the Gallery of the Union League Club.* New York, Oct. 1881.

VAN RENSSELAER, MARIANA GRISWOLD [Mrs. Schuyler Van Rensselaer]. "American Etchers," *The Century Magazine* (Feb. 1883), pp. 483–499.

——. "Picturesque New York," *The Century Magazine* (Dec. 1892), pp. 164–175.

——. *Rembrandt's "Gilder."* New York, ca. 1884.

——. *The Union League Club Exhibition Catalogue of the Works of the Women Etchers of America.* New York, 1888.

VINTON, FREDERIC P. *Memorial Exhibition of the Works of J. Foxcroft Cole.* Boston Museum of Fine Arts, 1893.

"Watercolors and Etchings," *Harper's Weekly* (Feb. 11, 1882), p. 92.

WAY, THOMAS R. *Memories of James McNeill Whistler.* New York, 1912.

WEDMORE, FREDERICK. *Etching in England.* London, 1895.

——. *Whistler's Etchings.* London, 1886.

WEIBE, R. H. *The Search for Order: 1877–1920.* New York, 1967.

WEIMANN, JEANNE MADELINE. *The Fair Women.* Chicago, 1981.

WEISBERG, GABRIEL P. *The Etching Renaissance in France: 1850–1880* (exhib. cat.). Utah Museum of Fine Arts, Salt Lake City, 1971.

WEITENKAMPF, FRANK. *American Graphic Art.* New York, 1924.

——. "Charles Adams Platt," *Print Connoisseur* (vol. 7, 1927), pp. 87–91.

——. "Mielatz, An Etcher of New York," *The International Studio* (Sept. 1911), pp. xxxix–xlvi.

——. "Some Women Etchers," *Scribner's Magazine* (Dec. 1909), pp. 731–739.

WHISTLER, JAMES MCNEILL. *The Gentle Art of Making Enemies.* London, 1890. (Reprinted by Dover Publications, Inc., New York, 1967.)

"Whistler as an Etcher," *The Art Amateur* (Oct. 1879), pp. 90–91.

WHITCOMB, CHARLOTTE. "Robert Koehler, Painter," *Brush and Pencil* (Dec. 1901), pp. 144–153.

WHITE, CHRISTOPHER. *Rembrandt as an Etcher.* University Park, Pa., 1969.

WHITE, ROBERT RANKIN. "Whistler and the Junior Etching Club," *Print Review* (no. 4, 1975), pp. 38–39.

WICKENDEN, ROBERT JOHN. *The Art and Etching of John Henry Twachtman.* New York, n.d.

——. "Charles Jacque," *Print Collector's Quarterly* (Feb. 1912), pp. 74–101.

WILKINS, THURMAN THOMAS. *Moran: Artist of the Mountains.* Norman, Oklahoma, 1966.

WILLIAMS, RAYMOND. *Culture and Society: 1780–1950.* New York, 1958.

WRAY, HENRY RUSSELL. *A Review of Etching in the United States.* Philadelphia, 1893.

WUERTH, LOUIS A. *Catalogue of the Etchings of Joseph Pennell.* Boston, 1928.

WUNDERLICH, H. *Catalogue of S. Parrish's Complete Etched Work on Exhibition at the Gallery.* New York, 1886.

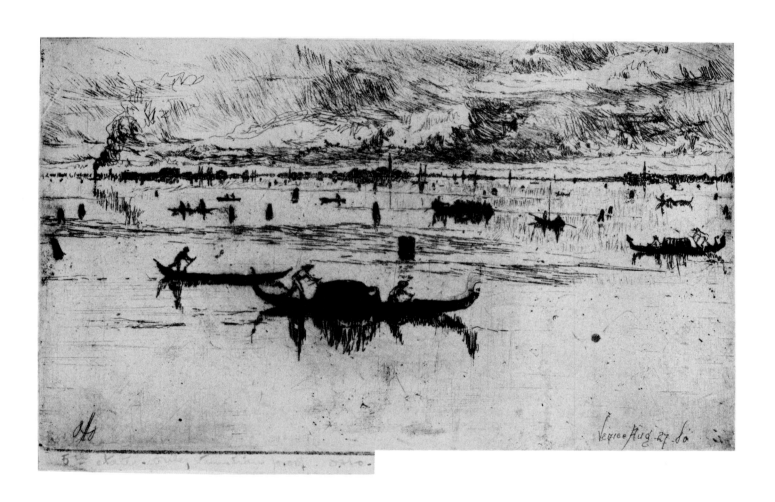

1. Otto Bacher. *Laguna Veneta* (No. 22, Venetian Series), August 27, 1880. Etching (Andrews V/ VI). 4¾ x 7¼″.

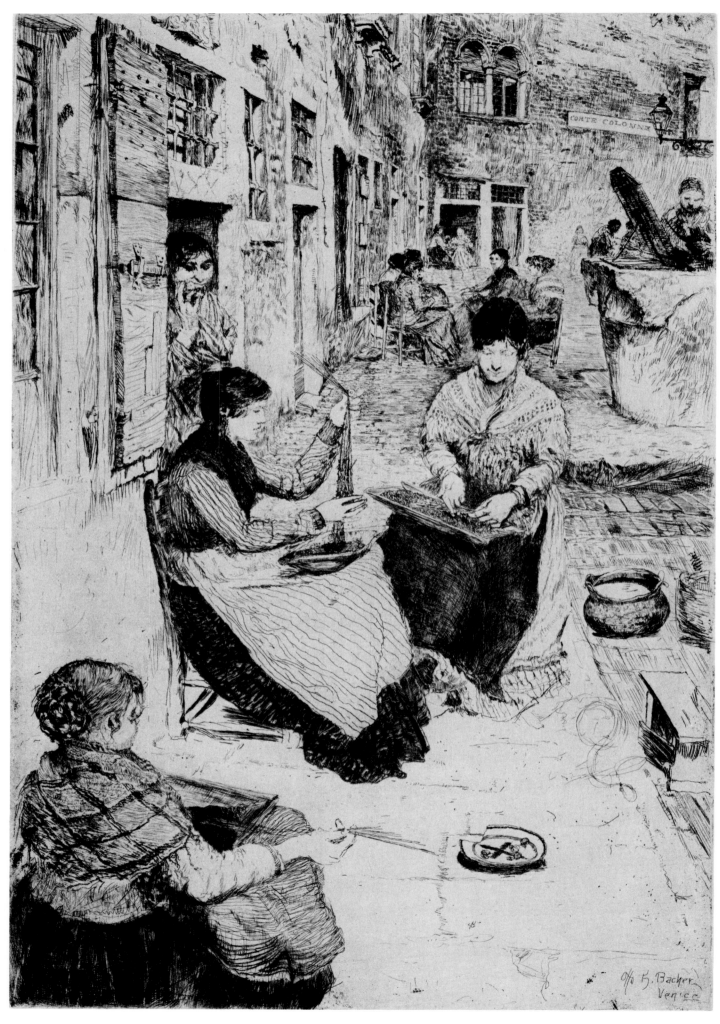

2. OTTO BACHER. *Perlaie or Bead Stringers, Venice* (No. 7, Venetian Series), 1882. Etching. 13⅛ x 8⅞″.

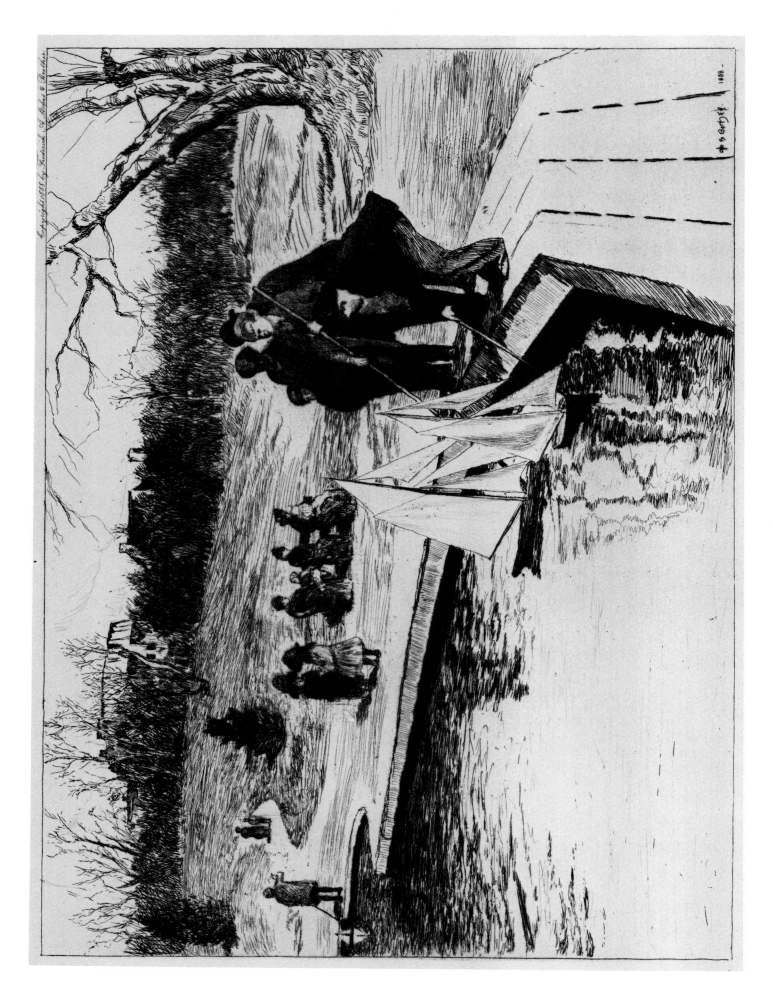

3. OTTO BACHER. *Sailing Toy Yachts in Central Park*, 1888. Etching. 7¼ x 9¾".

4. ALBION HARRIS BICKNELL. *Landscape*, n.d. Monotype. 5⅛ x 11".

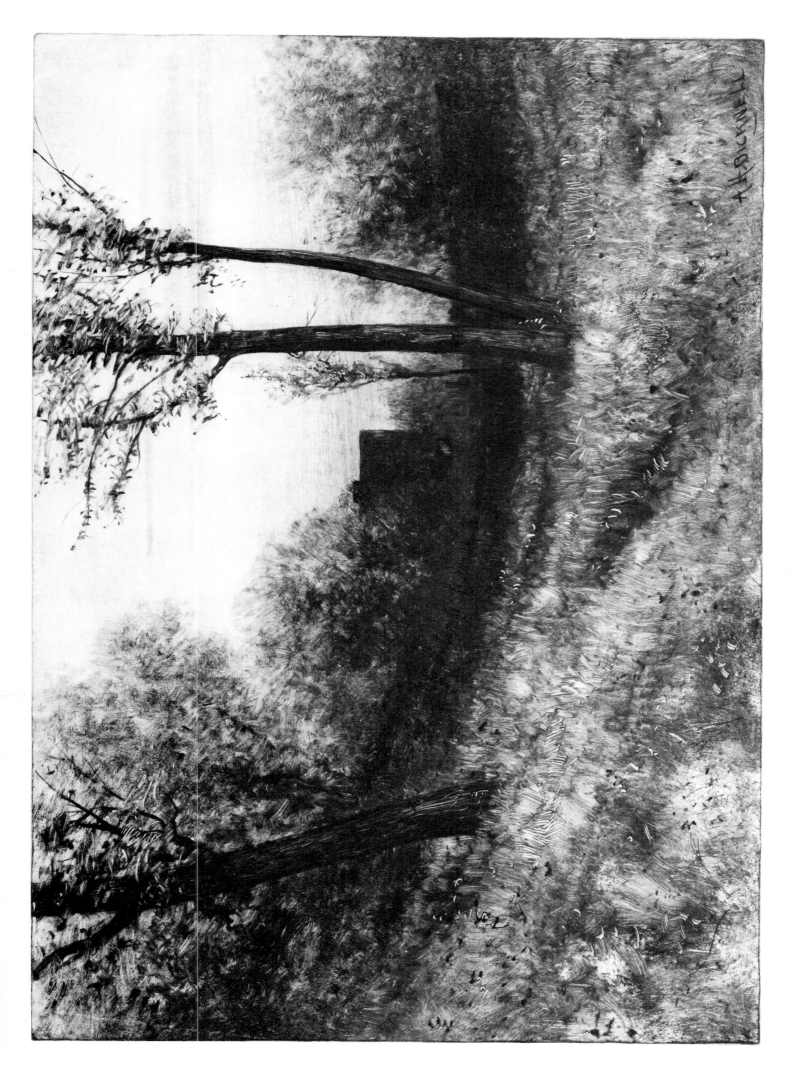

5. ALBION HARRIS BICKNELL. *The Farm*, ca. 1881. Monotype. 15 x 21″.

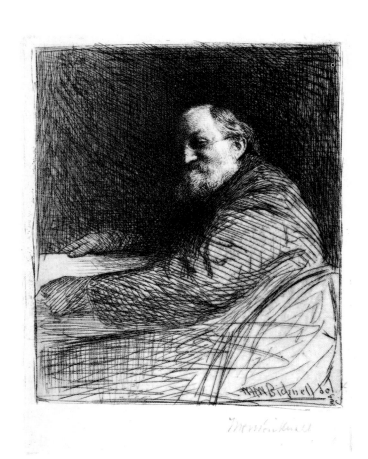

6. William Henry Warren Bicknell. *Portrait of S. R. Koehler*, n.d. Etching. 4¹¹⁄₁₆ x 3½″.

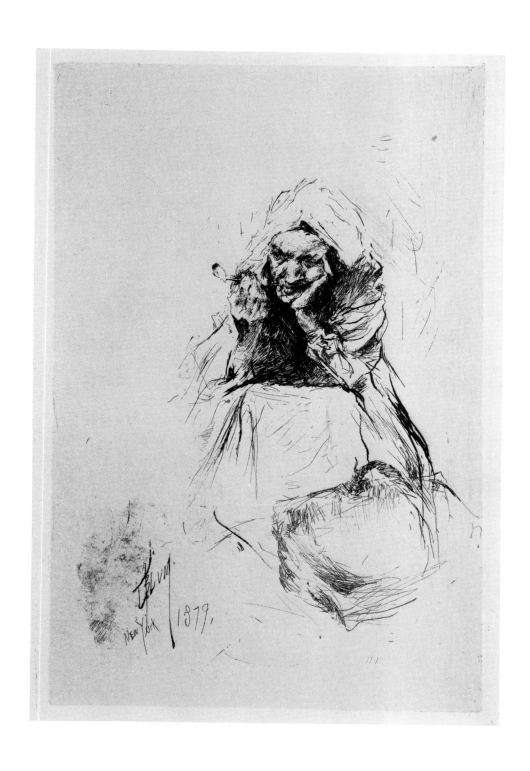

7. ROBERT FREDERICK BLUM. *The Hag*, 1879. Etching and drypoint (Cincinnati Art Museum 120). 7⅜ x 4⅞″.

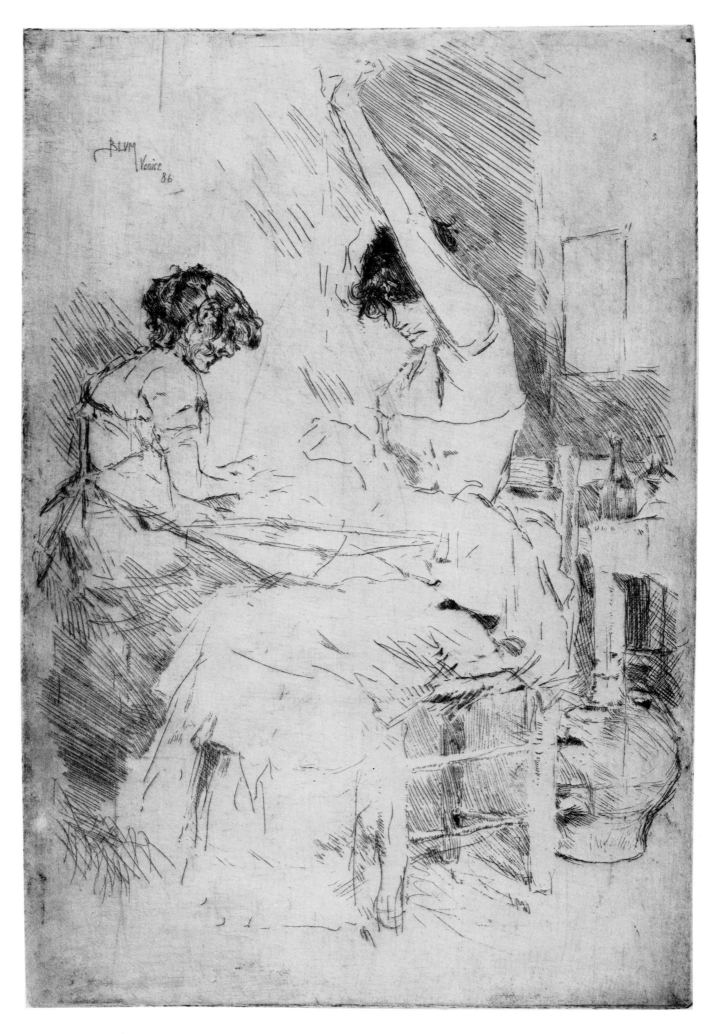

8. ROBERT FREDERICK BLUM. *Bead Stringers, Venice,* 1886. Etching (Cincinnati Art Museum 105). 12¼ x 8″.

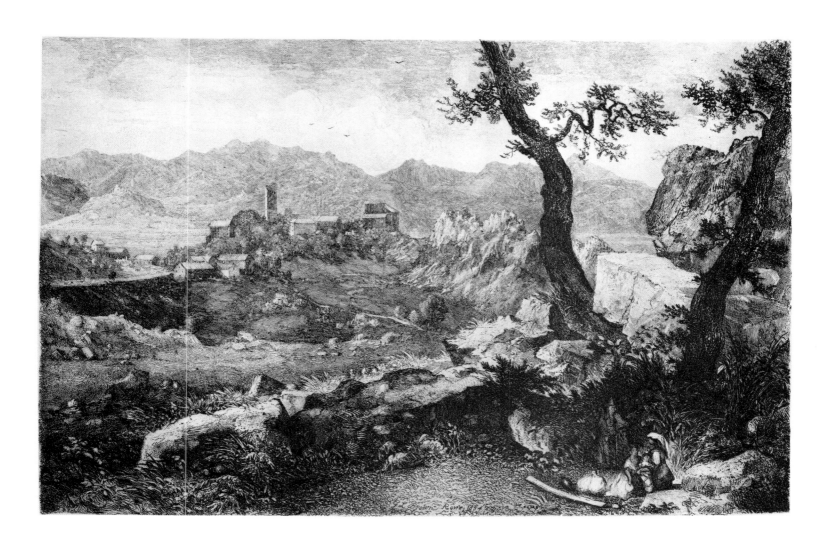

9. GEORGE LORING BROWN. *View Near Rome*, 1854. Etching. Plate 6 x 8½″.

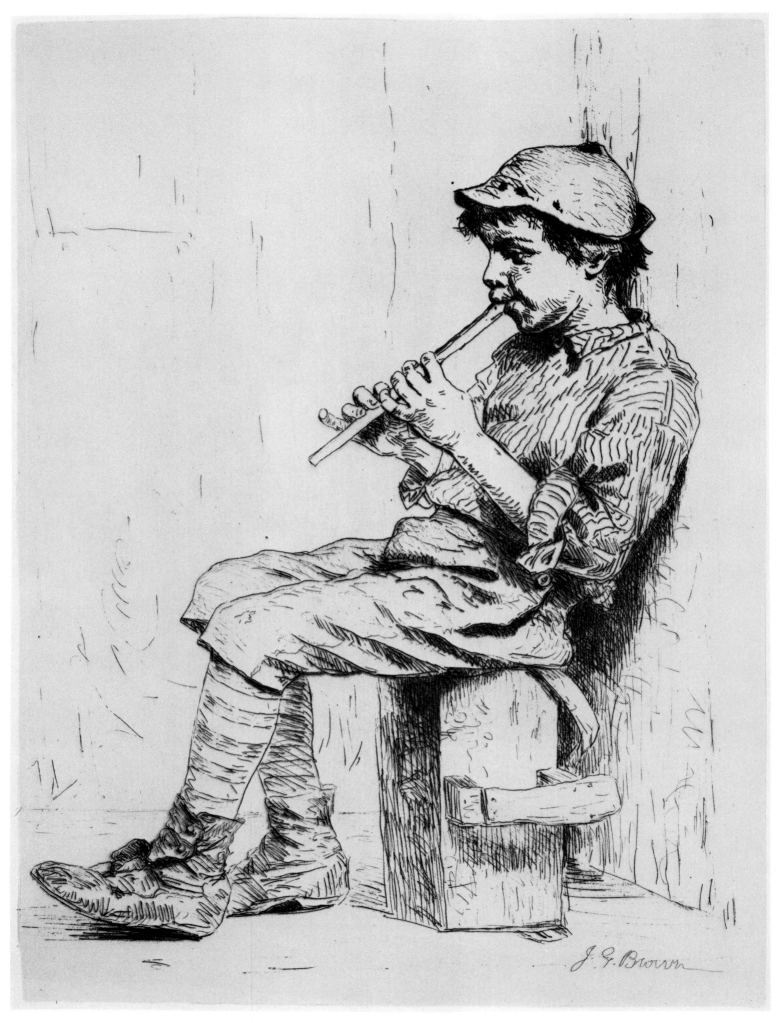

10. JOHN GEORGE BROWN. *Business Neglected*, ca. 1884. Etching. 13¾ x 9½".

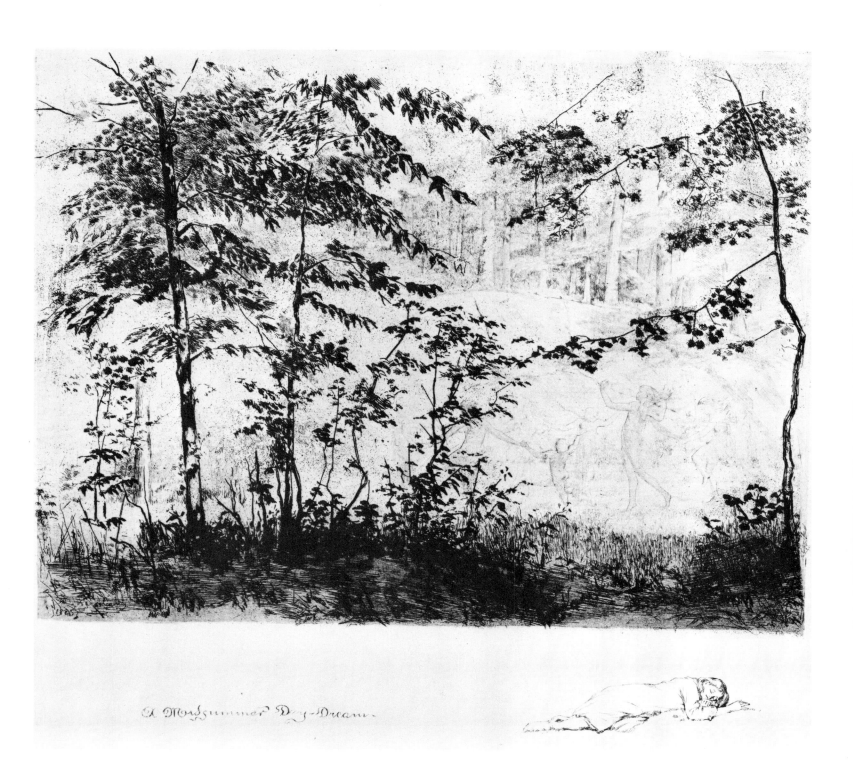

11. MARGARET W. LESLEY BUSH-BROWN. *A Midsummer Day-Dream*, 1885. Etching. 8⅝ x 11⅛″, with remarque.

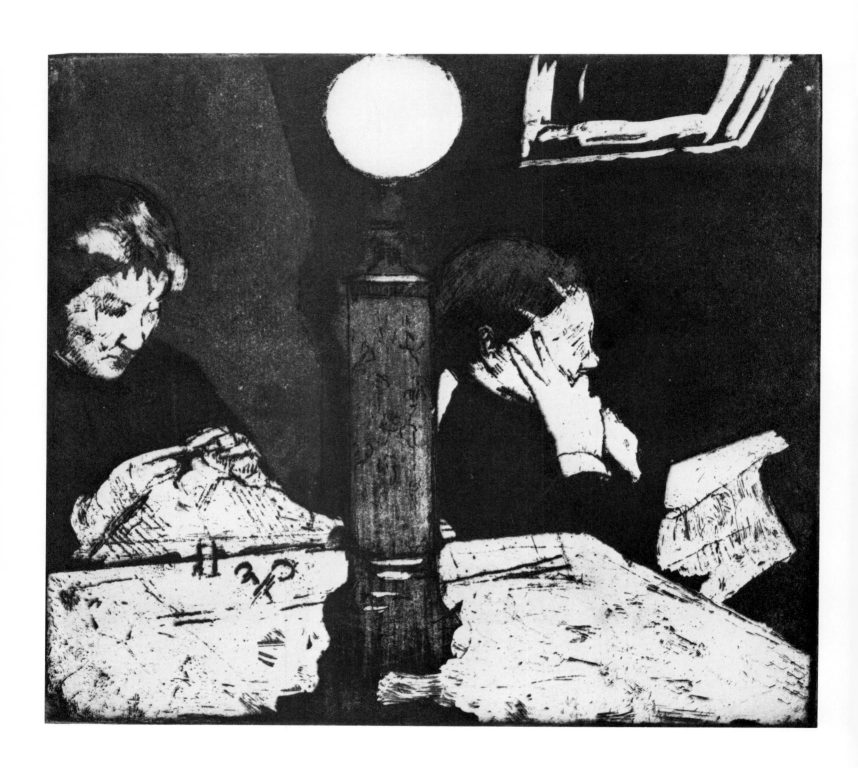

12. MARY CASSATT. *Under the Lamp*, ca. 1882. Soft-ground etching (Breeskin 71, I/II). 7¾ x 8¹¹/₁₆″.

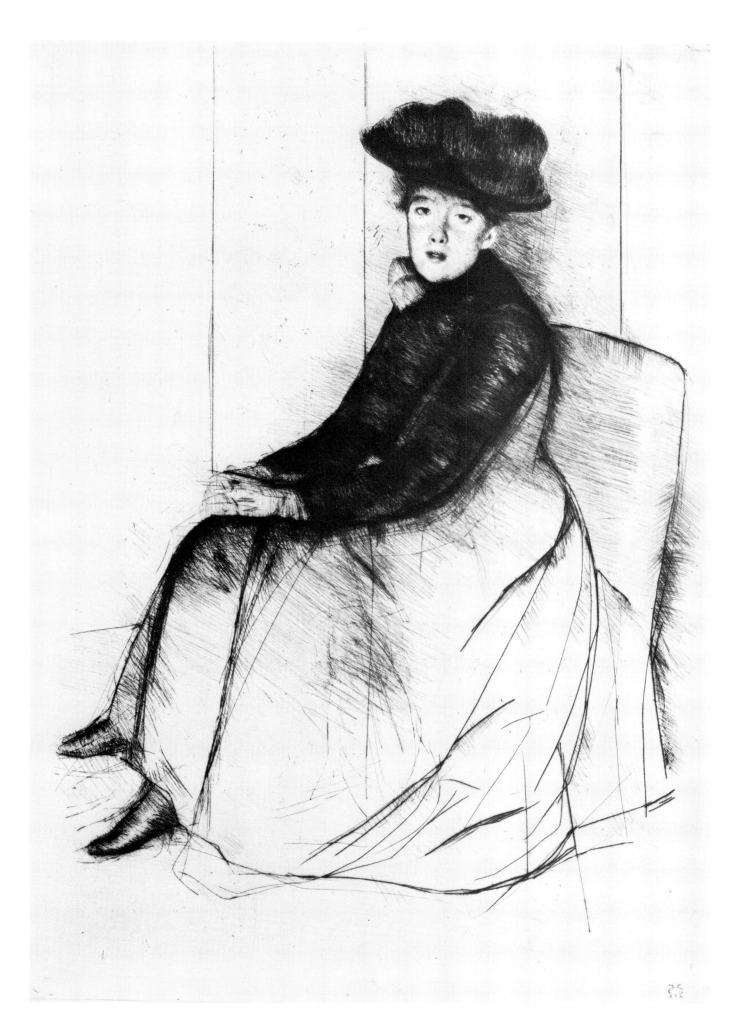

13. MARY CASSATT. *Reflection*, ca. 1890. Drypoint (Breeskin 131, V/IV). 10³⁄₁₆ x 6⁷⁄₈″.

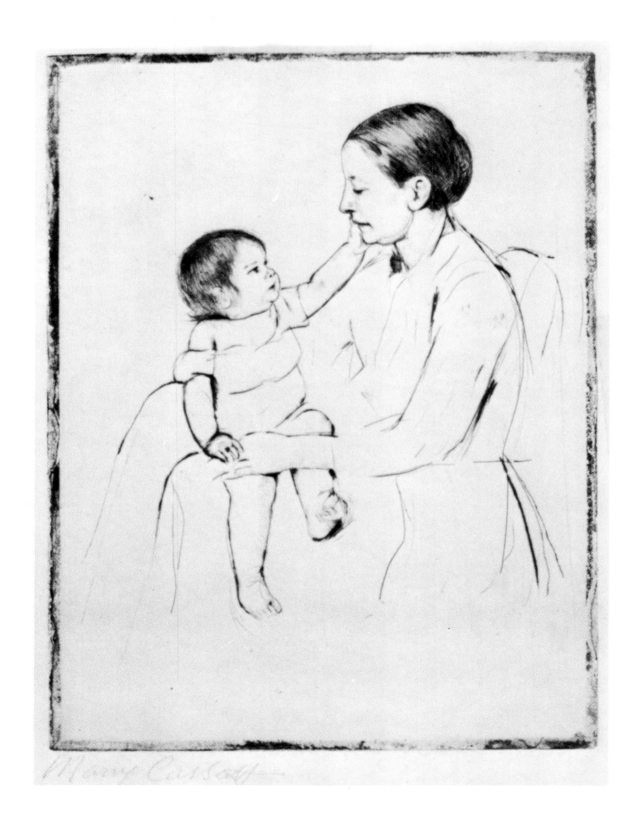

14. MARY CASSATT. *The Caress,* ca. 1891. Drypoint (Breeskin 140, V/V). 7¾ x 5¾".

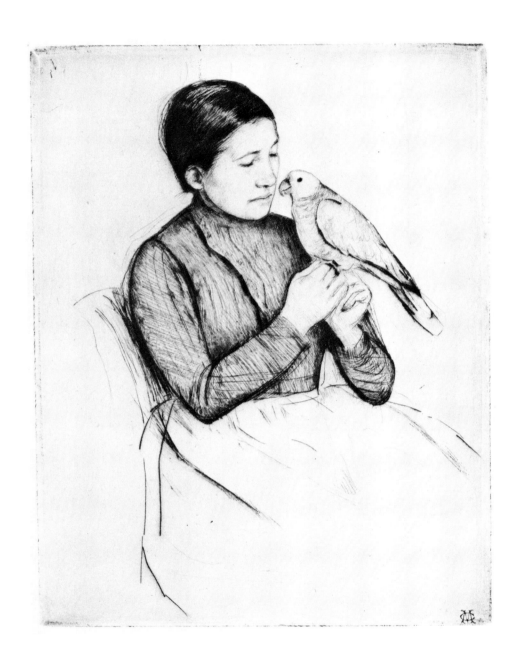

15. MARY CASSATT. *The Parrot*, ca. 1891. Drypoint (Breeskin 138, V/VII). 6⅜ x 4¹¹⁄₁₆″.

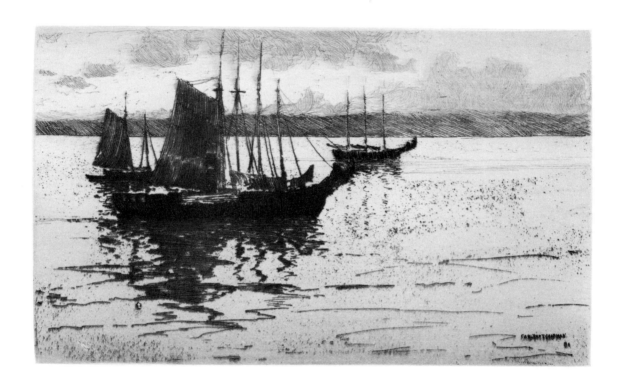

16. CARLTON THEODORE CHAPMAN. *Sundown, Gloucester Harbor*, 1891. Etching. Plate 3¾ x 5¾″.

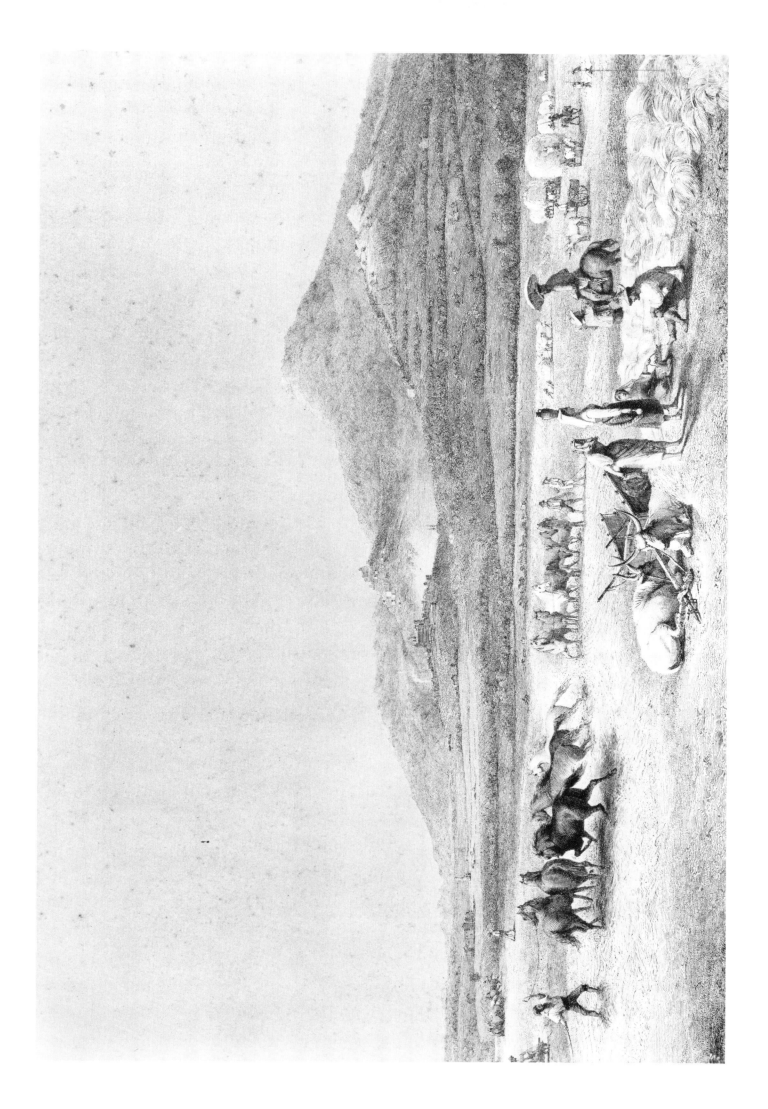

17. JOHN GADSBY CHAPMAN. *Harvest in the Roman Campagna,* 1871. Etching. 9 x 19¾".

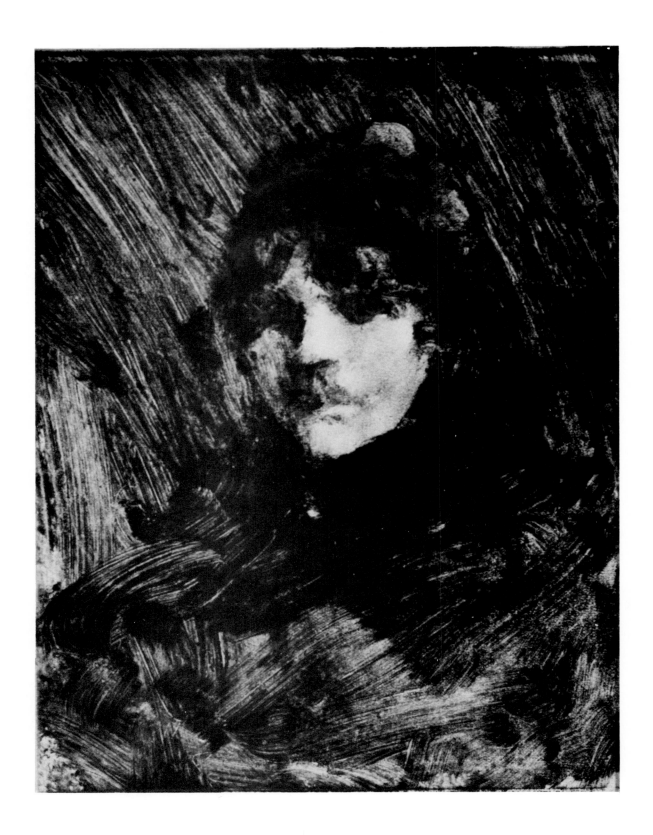

18. WILLIAM MERRITT CHASE. *Portrait of the Artist's Wife,* ca. 1890. Monotype. 8 x 6″.

19. FREDERICK STUART CHURCH. *The Snow Image,* 1884. Etching. Plate 5¼ x 2⅝″.

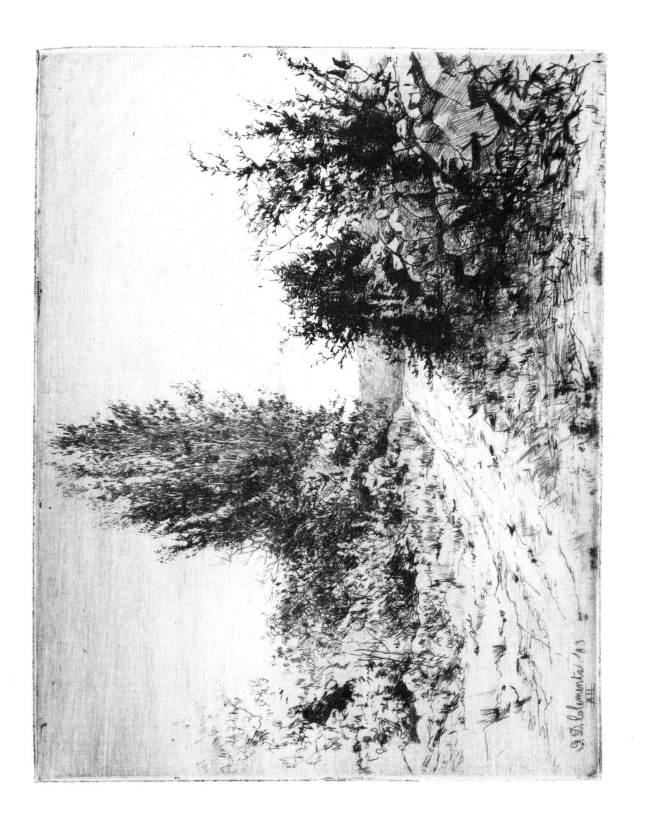

20. Gabrielle de Veaux Clements. [A country road], 1883. Etching. Plate 5⅞ x 7¹⁵⁄₁₆″.

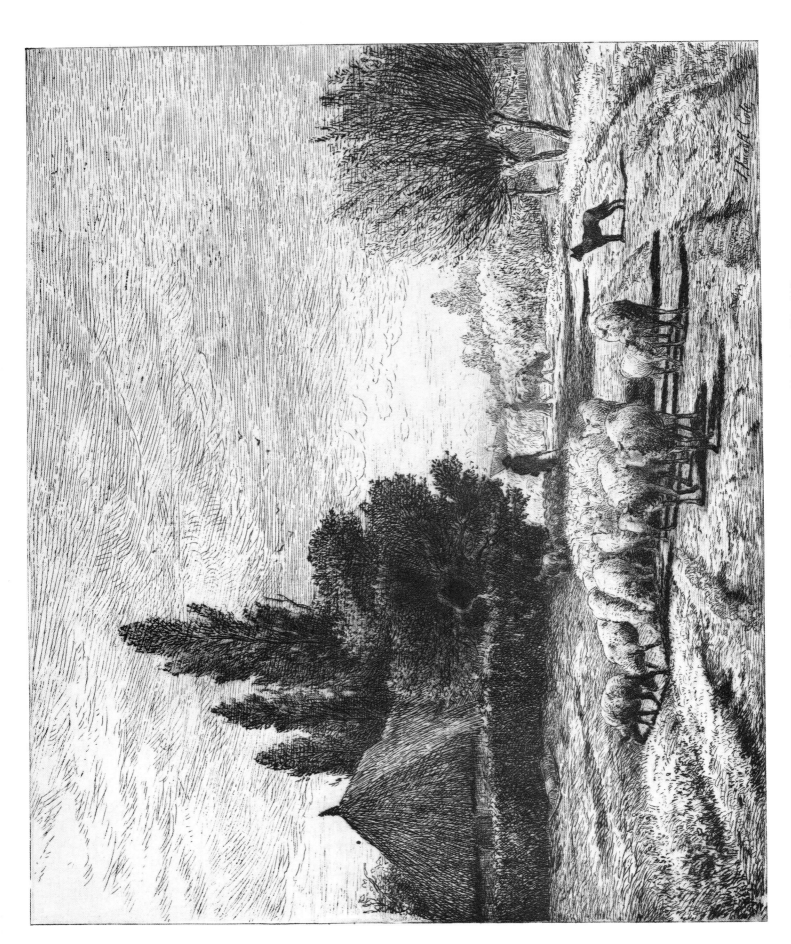

21. Joseph Foxcroft Cole. *Village Street in France*, ca. 1866. Etching. 9¼ x 11″.

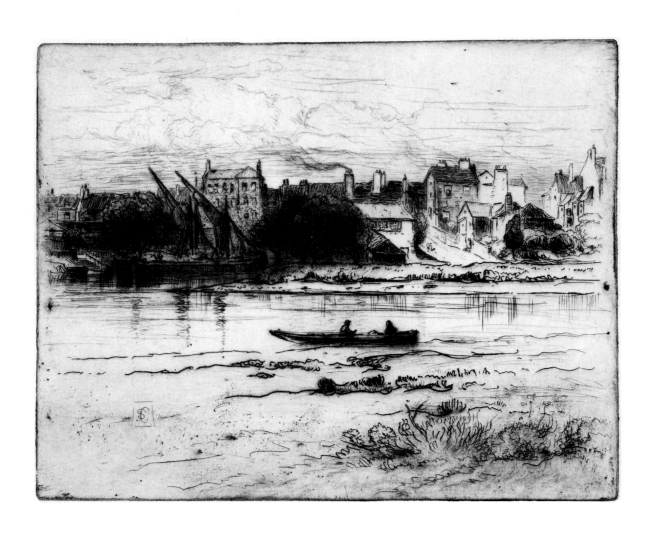

22. SAMUEL COLMAN. *Kew, England*, 1891. Etching. Plate 5 x 6″.

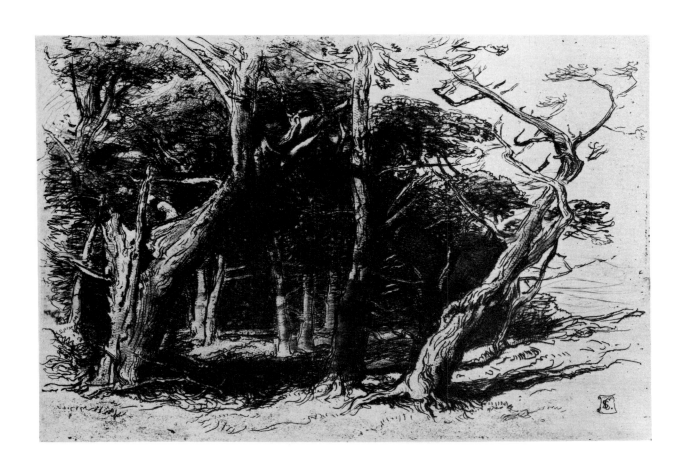

23. SAMUEL COLMAN. *Old Cedars, Pike's Peak*, 1900. Etching. Plate 4½ x 6⅜″.

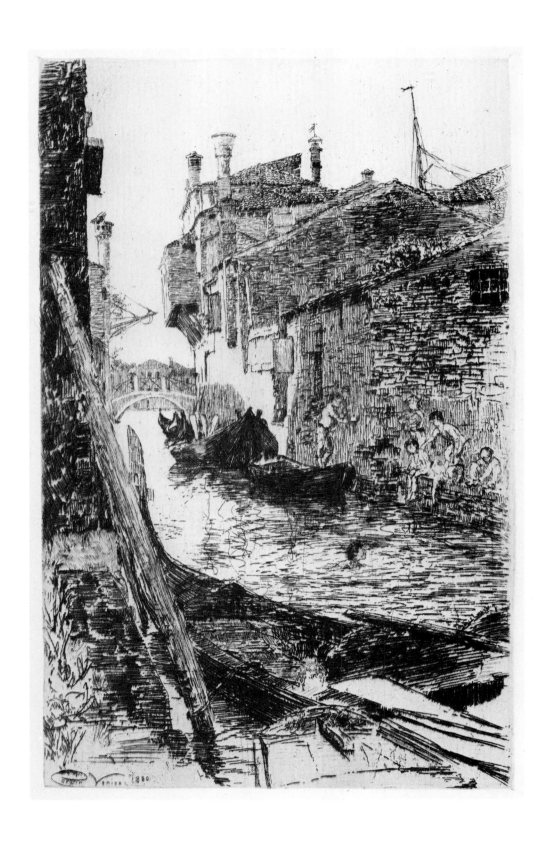

24. CHARLES ABLE CORWIN. *Scene Along Venetian Canal*, 1880. Etching. Plate 8³⁄₁₆ x 5³⁄₁₆″.

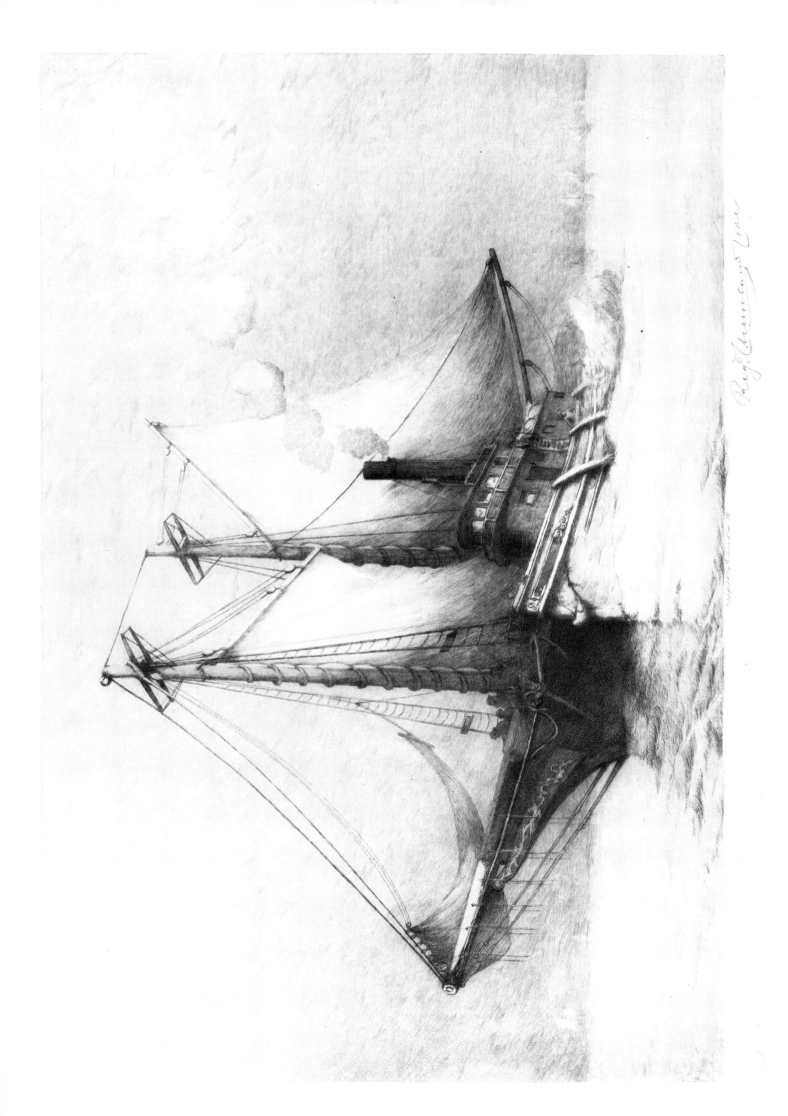

25. REGINALD CLEVELAND COXE. *Tug and Sailing Ship*, 1887. Etching. Plate 13¹⁵⁄₁₆ x 21¹¹⁄₁₆″.

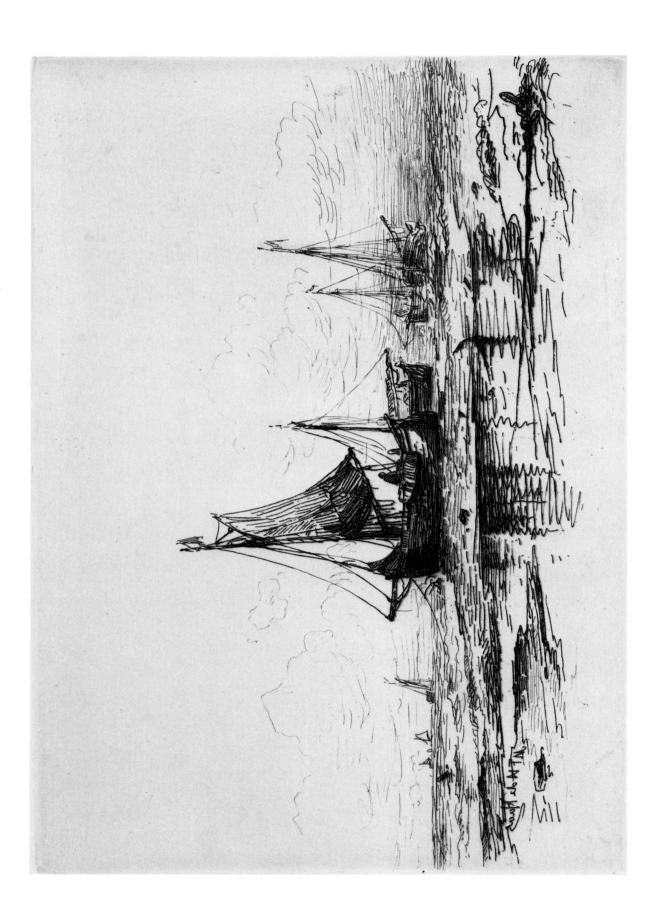

26. MAURITZ FREDERIK HENDRIK DE HAAS. *Fishing Boats on the Beach at Scheveningen*, ca. 1883. Etching. Plate 6³⁄₁₆ x 9¹⁄₁₆".

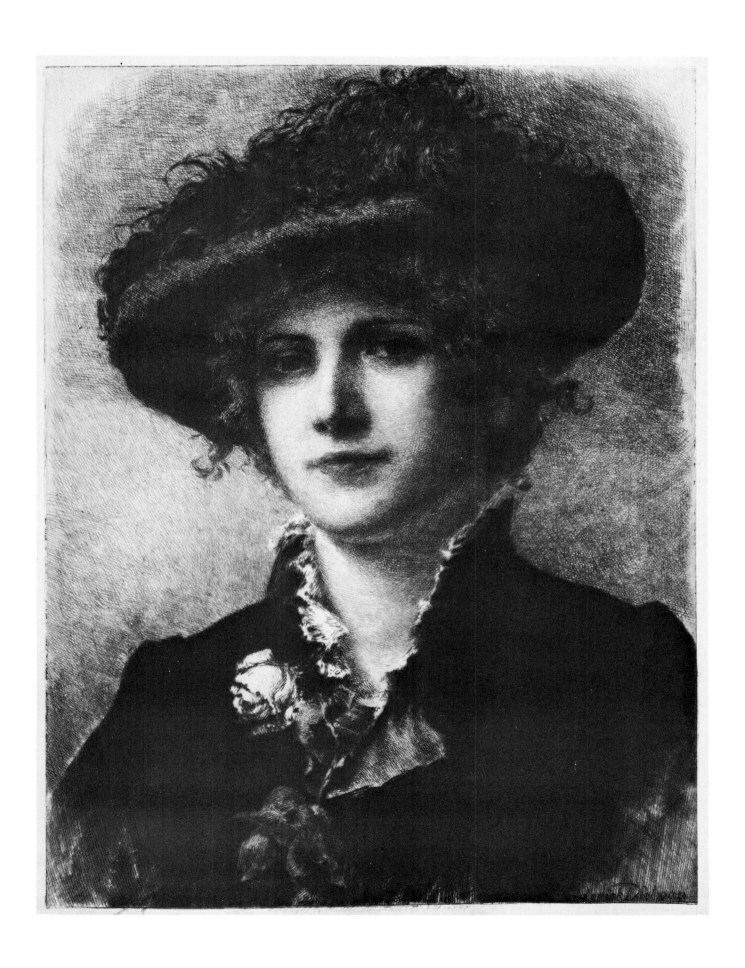

27. FREDERICK DIELMAN. *Portrait of a Young Woman*, 1891. Hand-colored drypoint. 9¾ x 6¾".

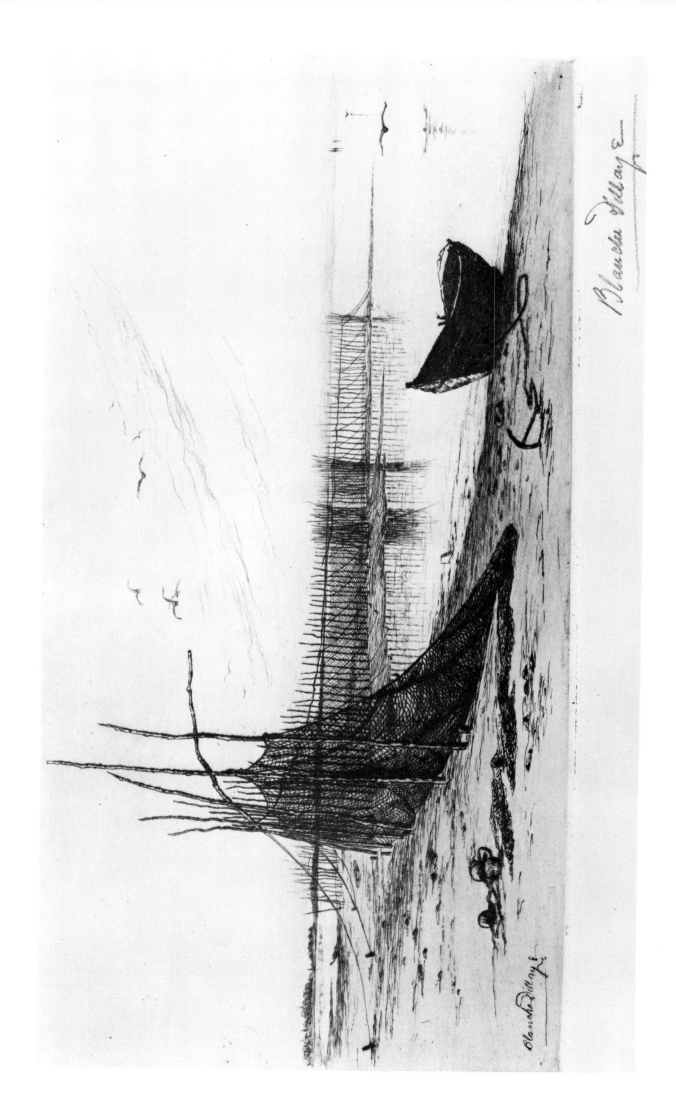

28. BLANCHE DILLAYE. *Fishing Weirs, Bay of Fundy*, n.d. Etching, 6⅜ x 12¾".

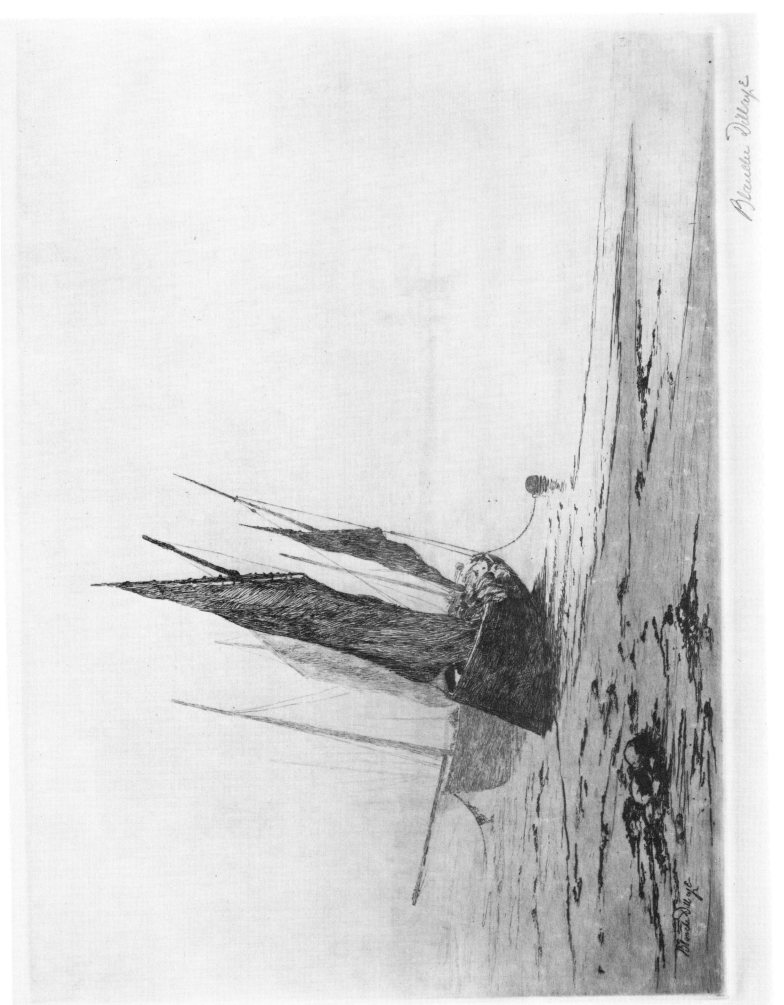

29. BLANCHE DILLAYE. *Mist on the Cornish Coast*, n.d. Etching. 10¾ x 16″.

30. Blanche Dillaye. *A Winding Stream*, n.d. Drypoint. 7 x 10⅜".

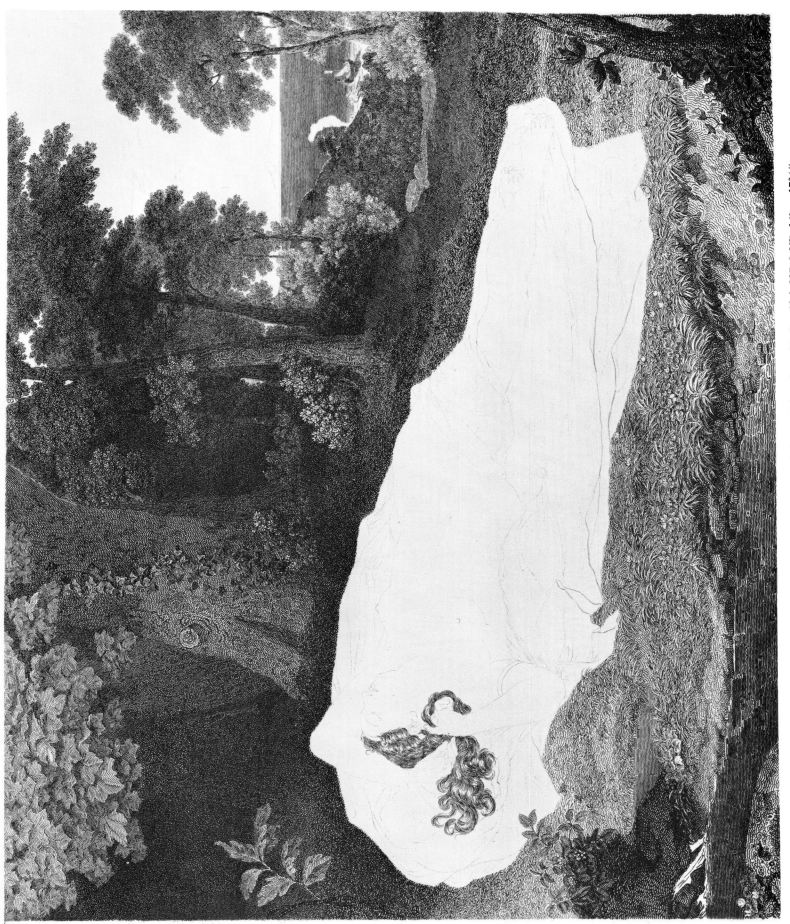

31. ASHER B. DURAND. *Ariadne* (after a painting by John Vanderlyn), 1835. Etching (Grolier Club 237, I/XI). 14⁷⁄₁₆ x 17³⁄₄″.

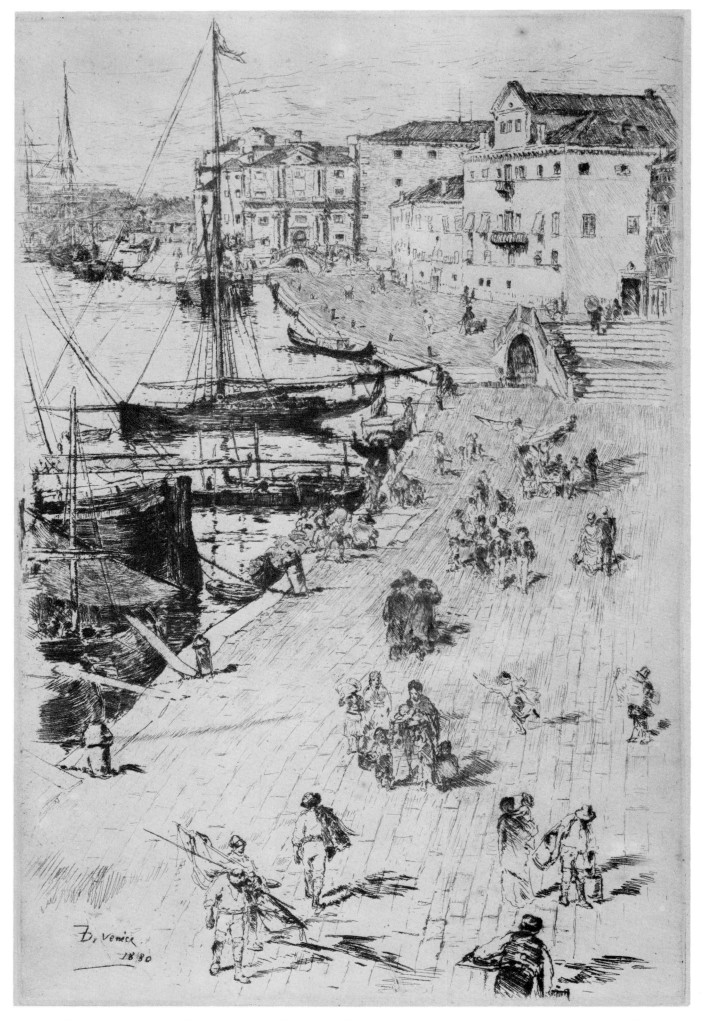

32. FRANK DUVENECK. *The Riva, Looking Towards the Grand Ducal Palace*, 1880. Etching (Poole 13). 13⅛ x 8½″.

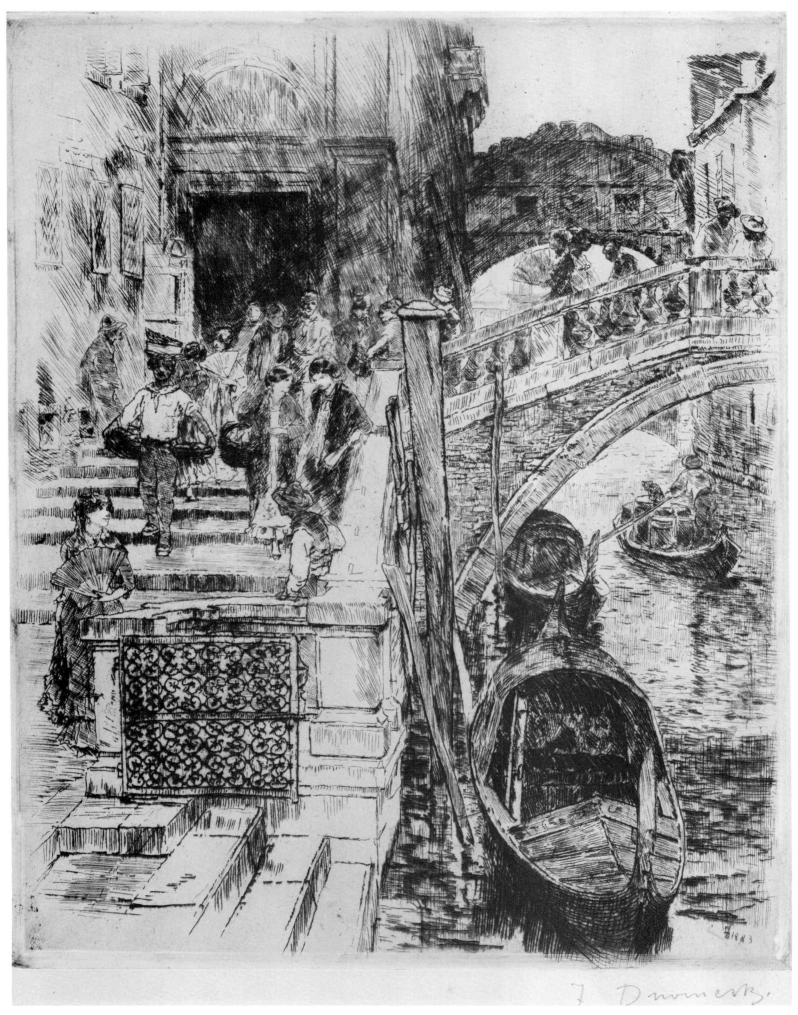

33. FRANK DUVENECK. *The Bridge of Sighs*, 1883. Etching (Poole 14). 10 x 8⅝″.

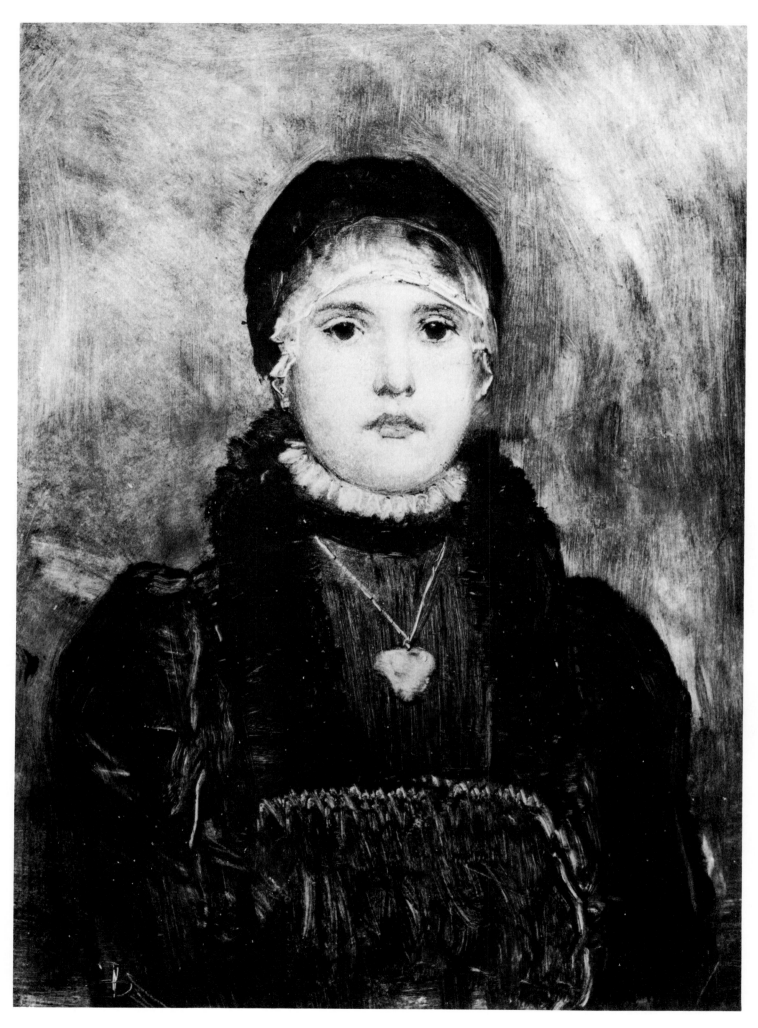

34. FRANK DUVENECK. *Portrait of a Girl*, ca. 1880–1883. Monotype retouched with pencil. 16¹⁵⁄₁₆ x 12³⁄₁₆".

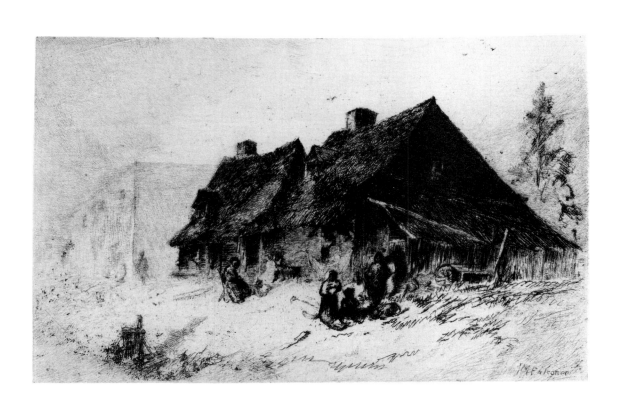

35. JOHN MACKIE FALCONER. *Negro Huts in Wilmington, N.C.,* ca. 1880. Etching. Plate 3¾ x 5¾″.

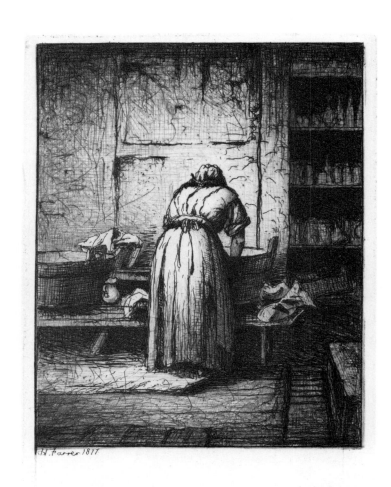

36. HENRY FARRER. *A Washerwoman*, 1877. Etching. 4¾ x 3⅜″.

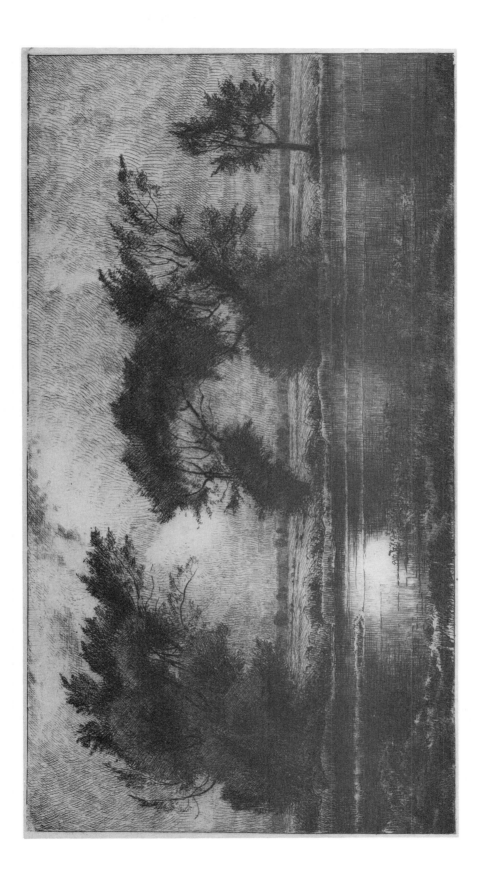

37. HENRY FARRER. A *Stormy Day*, n.d. Etching. 4½ x 8½″.

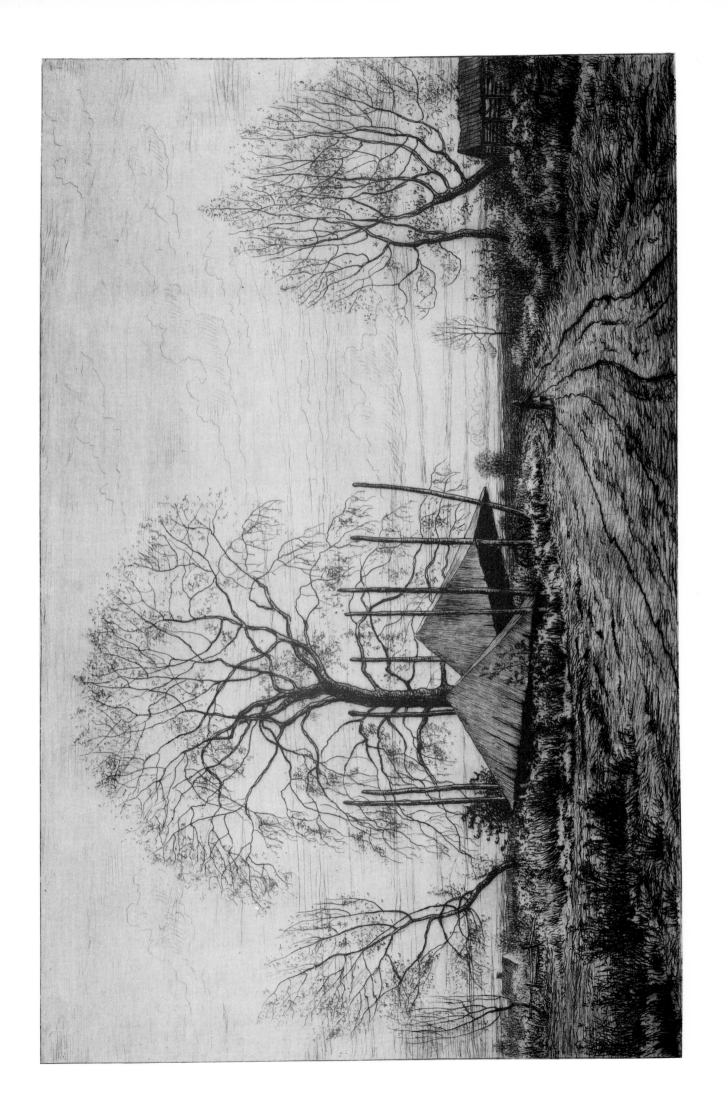

38. HENRY FARRER. *October*, 1878. Etching. 6⅝ x 10⅞″.

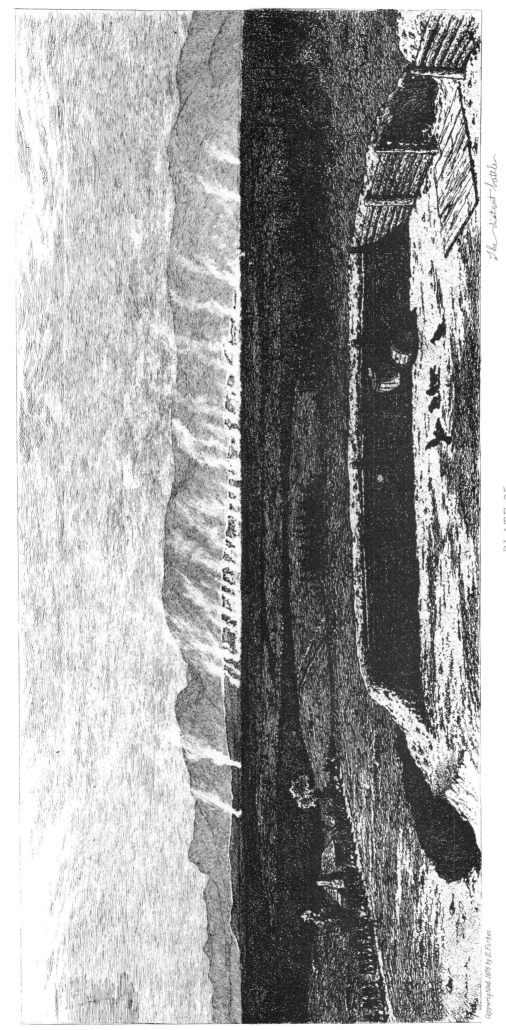

The Distant Battle

PLATE 25

39. EDWIN FORBES. *The Distant Battle*, 1876. Etching. 7 x 15¾".

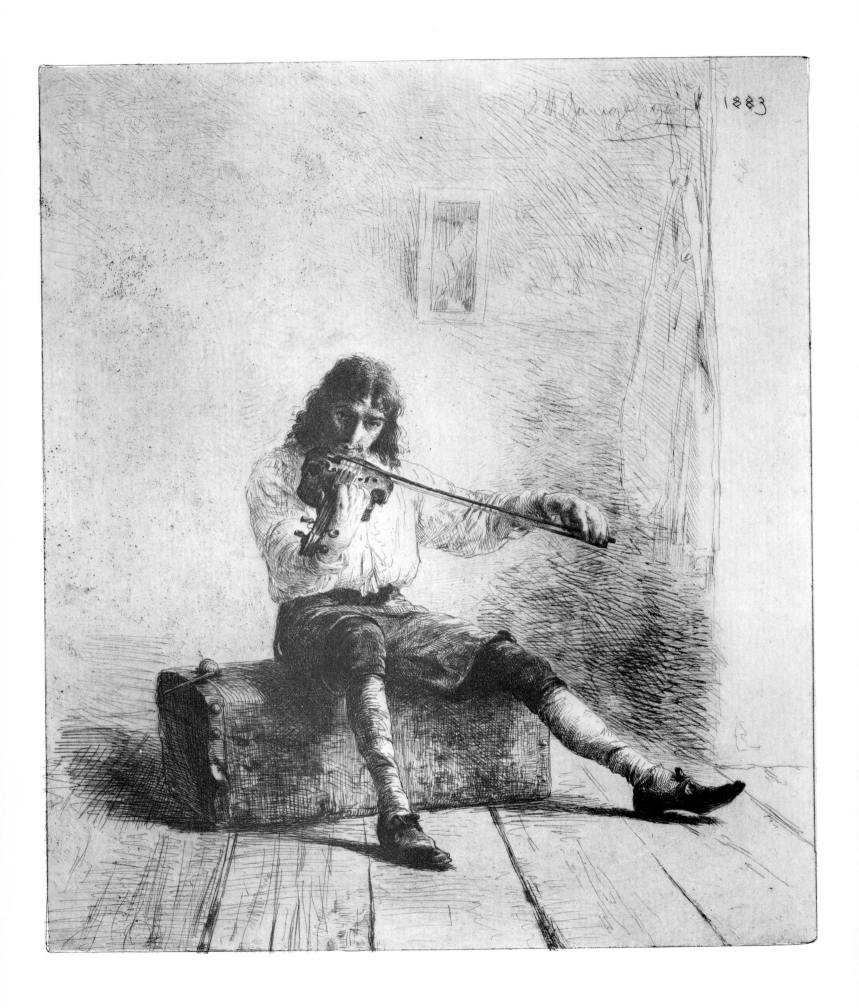

40. IGNAZ MARCEL GAUGENGIGL. *And Drive Dull Cares Away*, 1883. Etching. 10⅝ x 8⅞″.

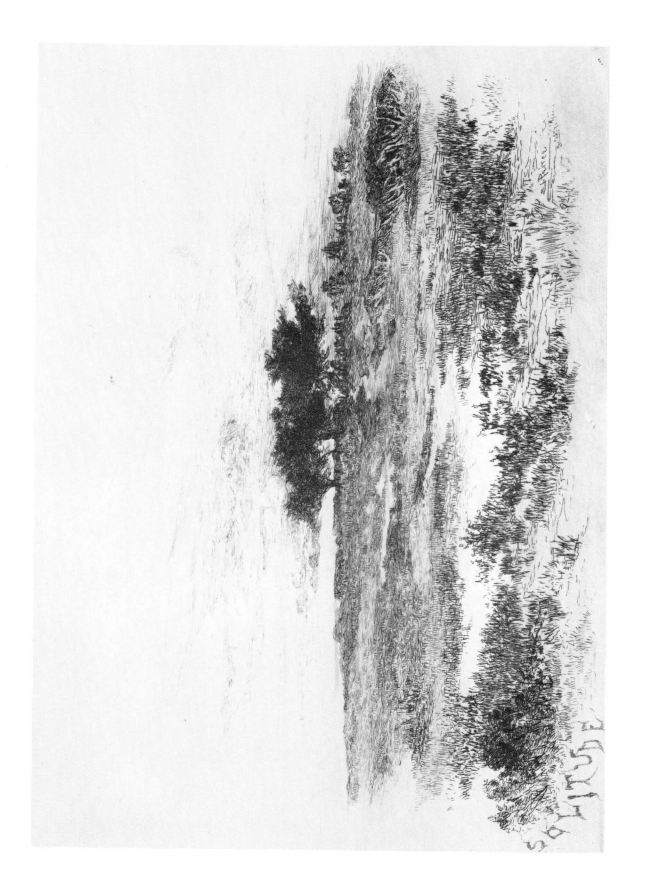

41. Edith Loring Peirce Getchell. *Solitude*, 1884. Etching. 6 x 8⅞".

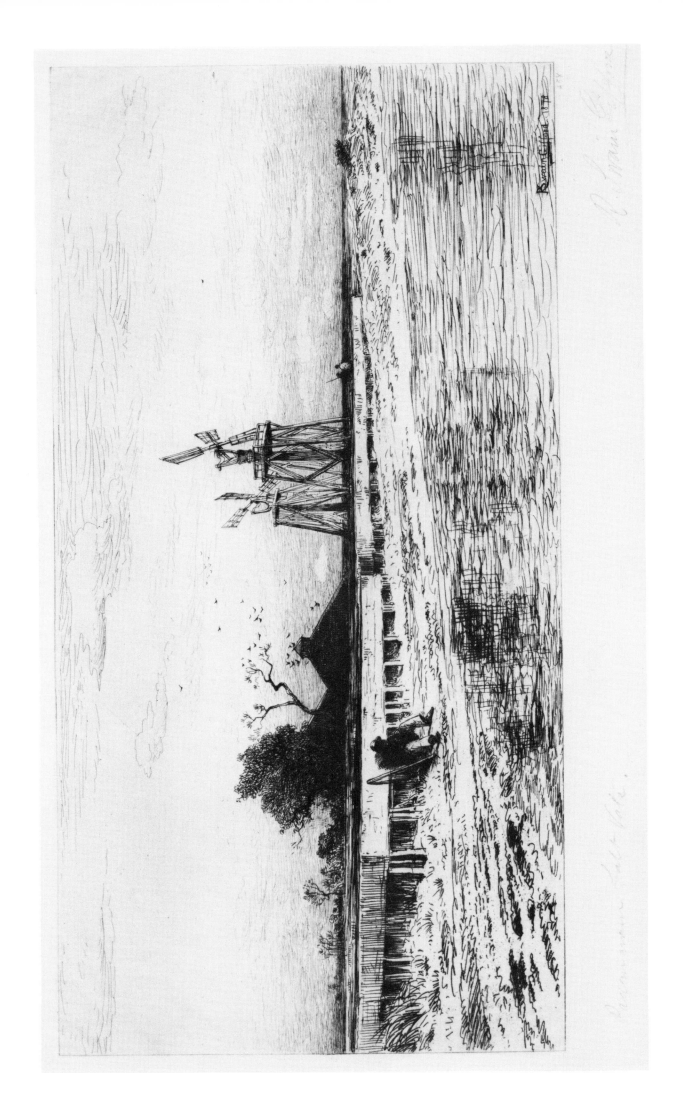

42. ROBERT SWAIN GIFFORD. *Padanaram, Dartmouth Salt Works*, 1878. Etching. 6⅝ x 13¼".

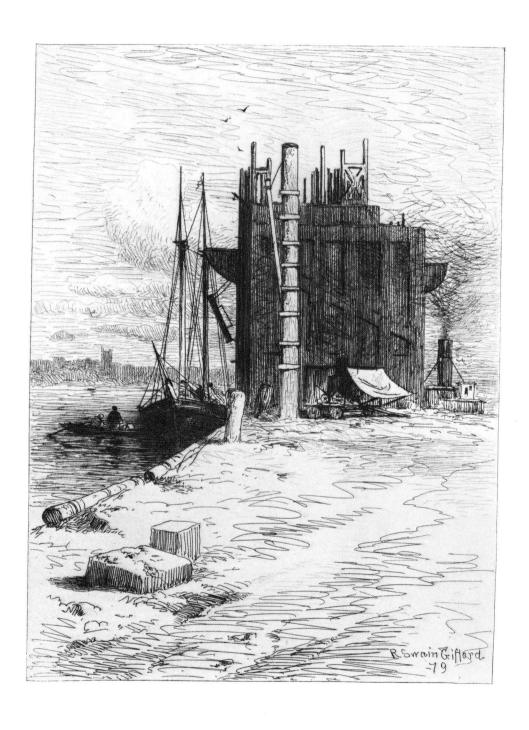

43. Robert Swain Gifford. *Coal Pockets at New Bedford*, 1879. Etching. Plate 8¼ x 5⅞".

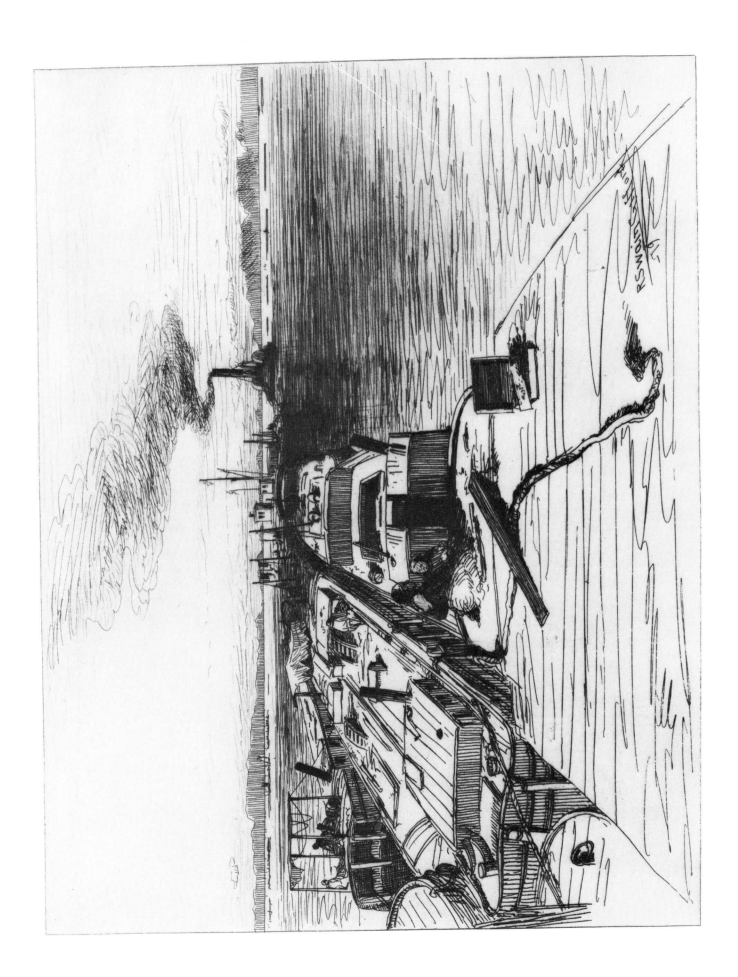

44. ROBERT SWAIN GIFFORD. *A Hudson River Tow*, 1879. Etching. 7 x 9¾".

45. ROBERT SWAIN GIFFORD. *Summer Storm*, 1879. Etching. 4¹⁄₁₆ x 8⁷⁄₁₆".

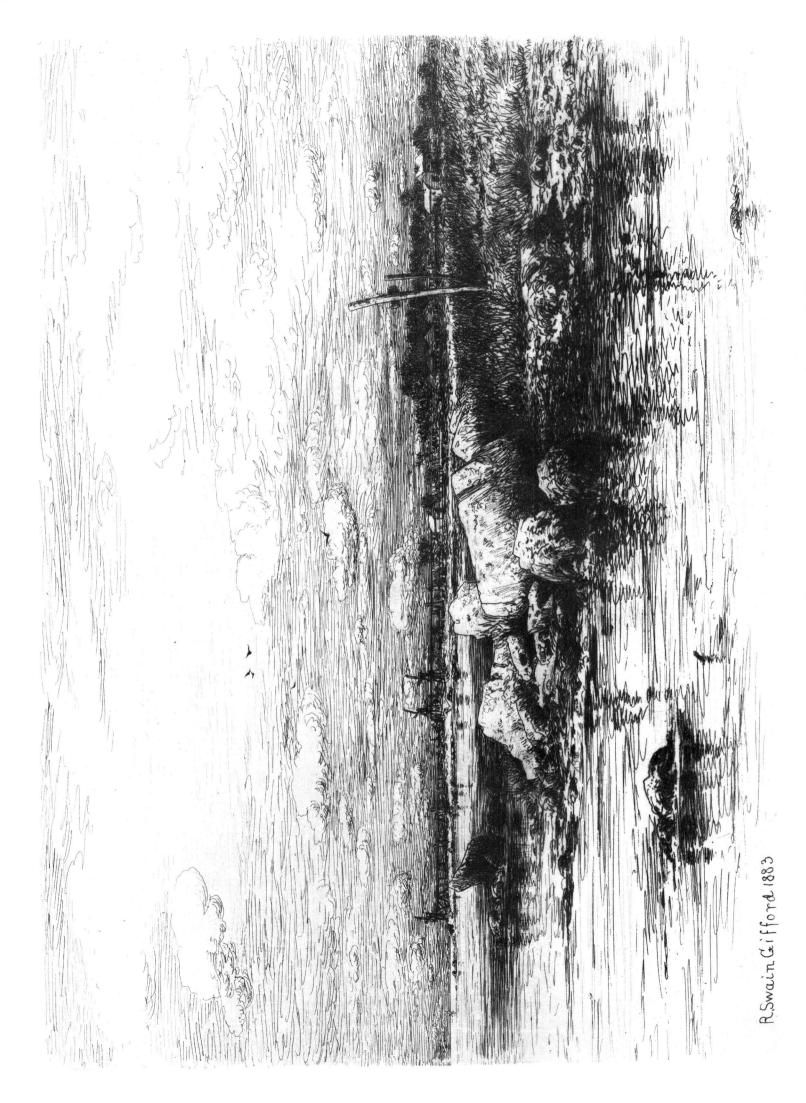

R. Swain Gifford 1883

46. ROBERT SWAIN GIFFORD. *The Mouth of the Apponigansett, Dartmouth, Mass.,* 1883. Etching. 7⅞ x 11⅛″.

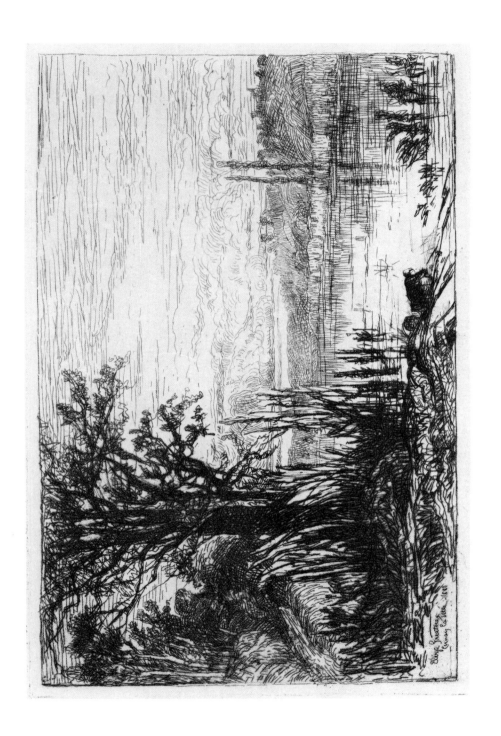

47. ELIZA PRATT CREATOREX. *Pond at Cernay-la-Ville,* 1880. Etching. 4½ x 7".

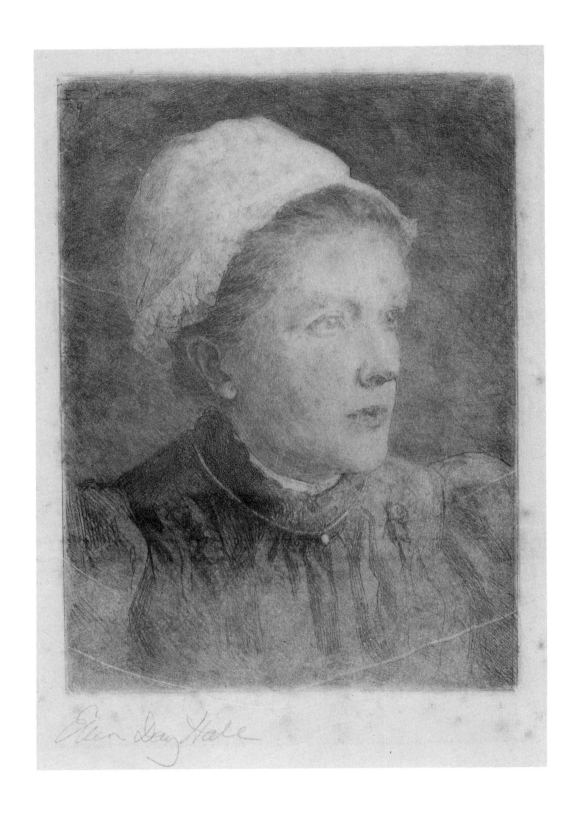

48. ELLEN DAY HALE. *A Woman from Normandy*, 1889. Drypoint printed in colors *à la poupée*. 6⅝ x 4¾″.

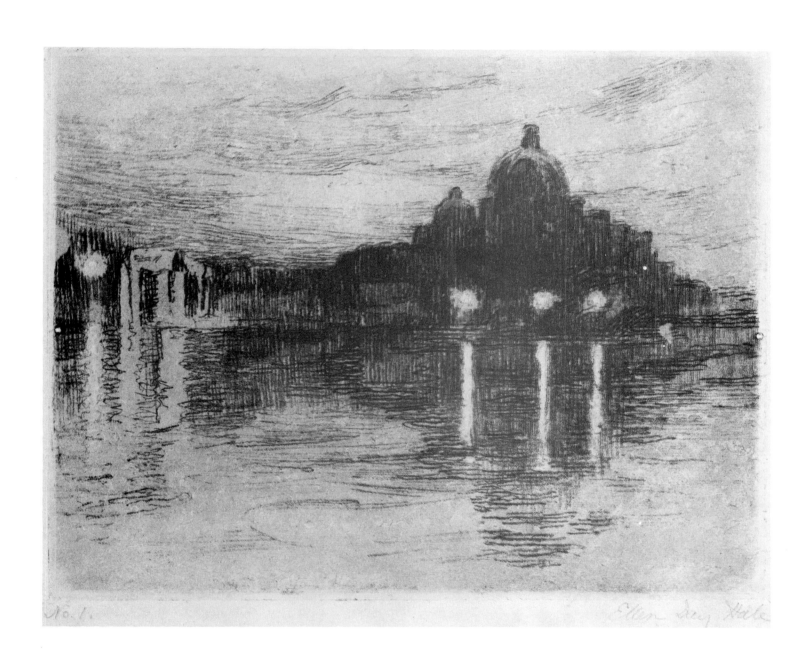

49. ELLEN DAY HALE. *First Night in Venice,* 1890. Soft-ground etching printed in colors from a single plate. 5⅞ x 7⅜″.

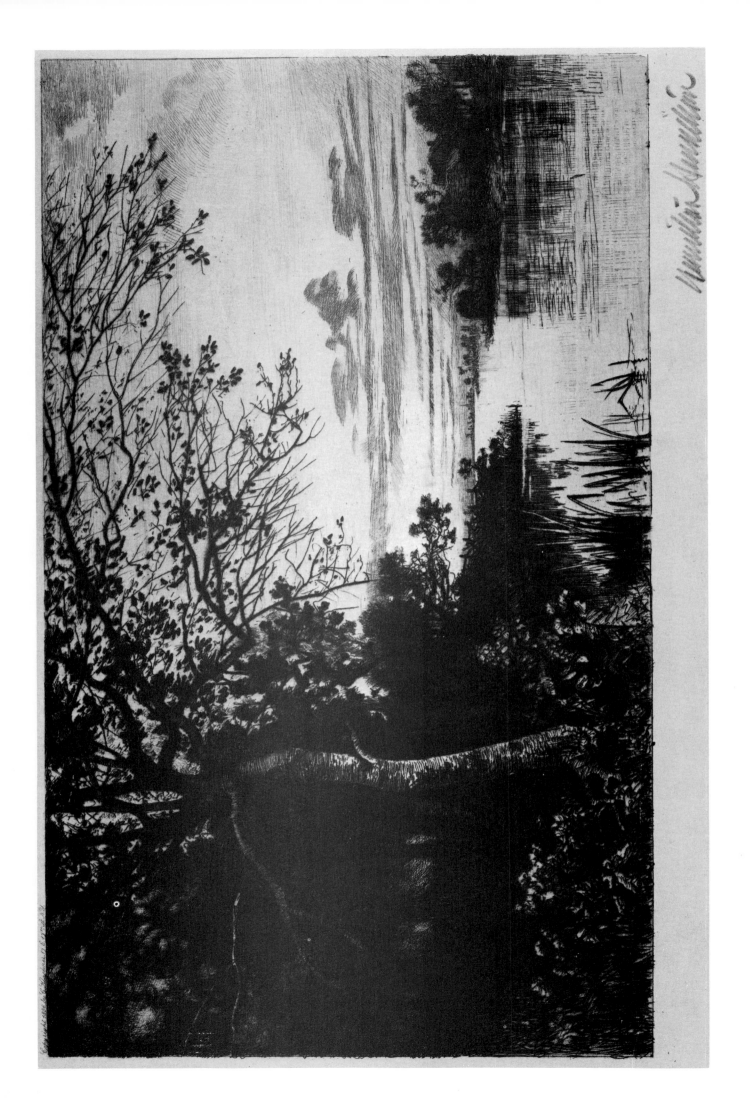

50. HAMILTON HAMILTON. [River scene], ca. 1886. Etching. 6⅜ x 10⅞".

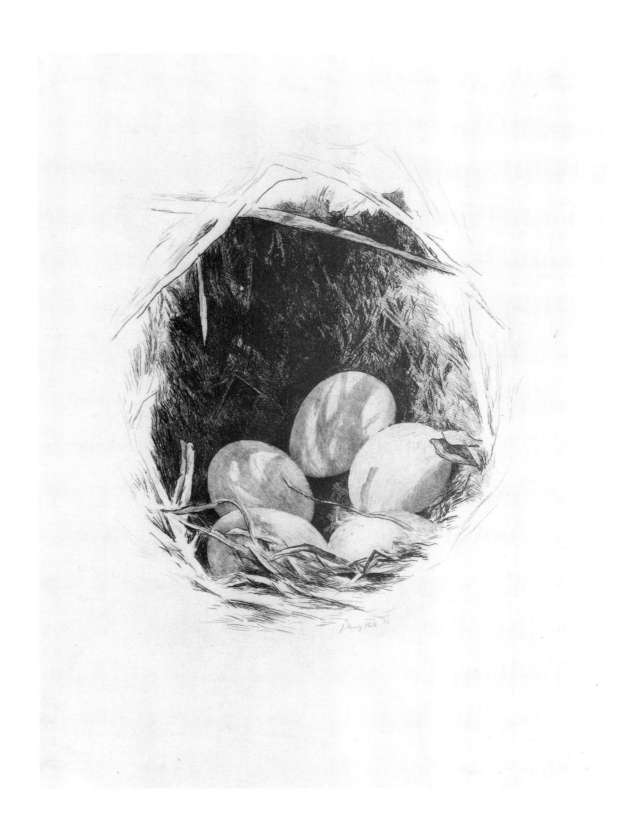

51. JOHN HENRY HILL. *Meadow Lark's Nest*, 1876. Etching. 8 x 6⅛″.

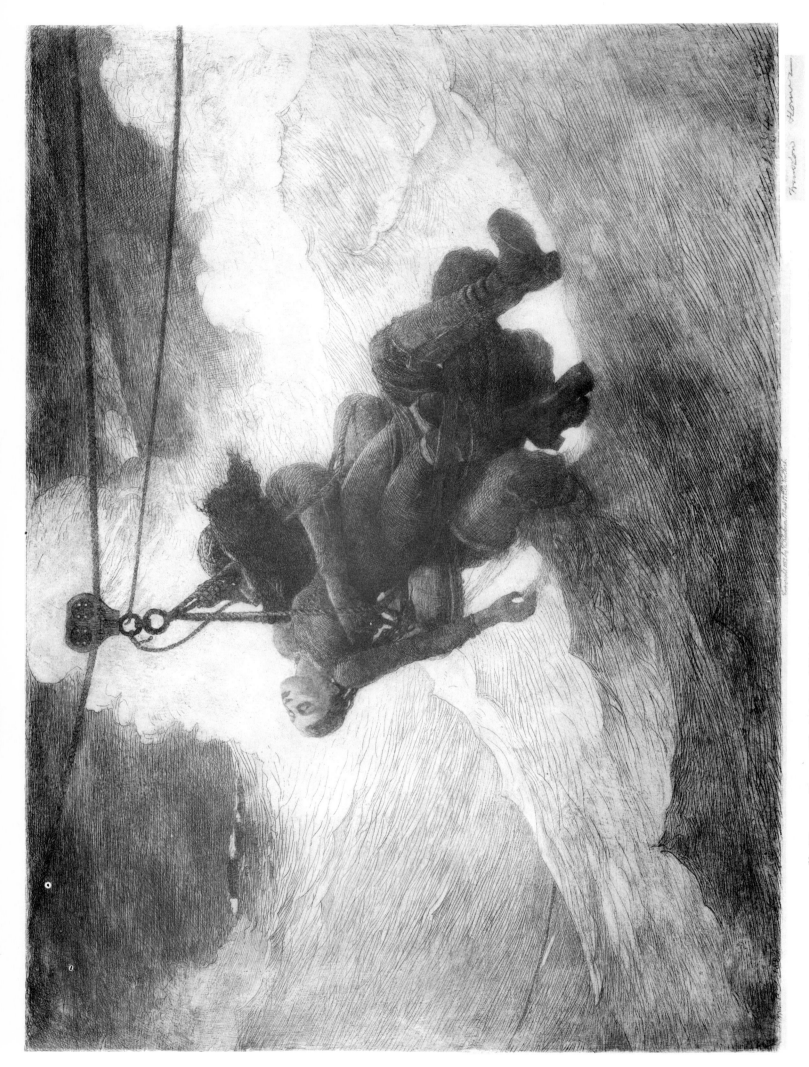

52. WINSLOW HOMER. *The Life Line*, 1884. Etching printed in dark green ink (Goodrich 91, only state). 12⅞ x 17¾", with remarque.

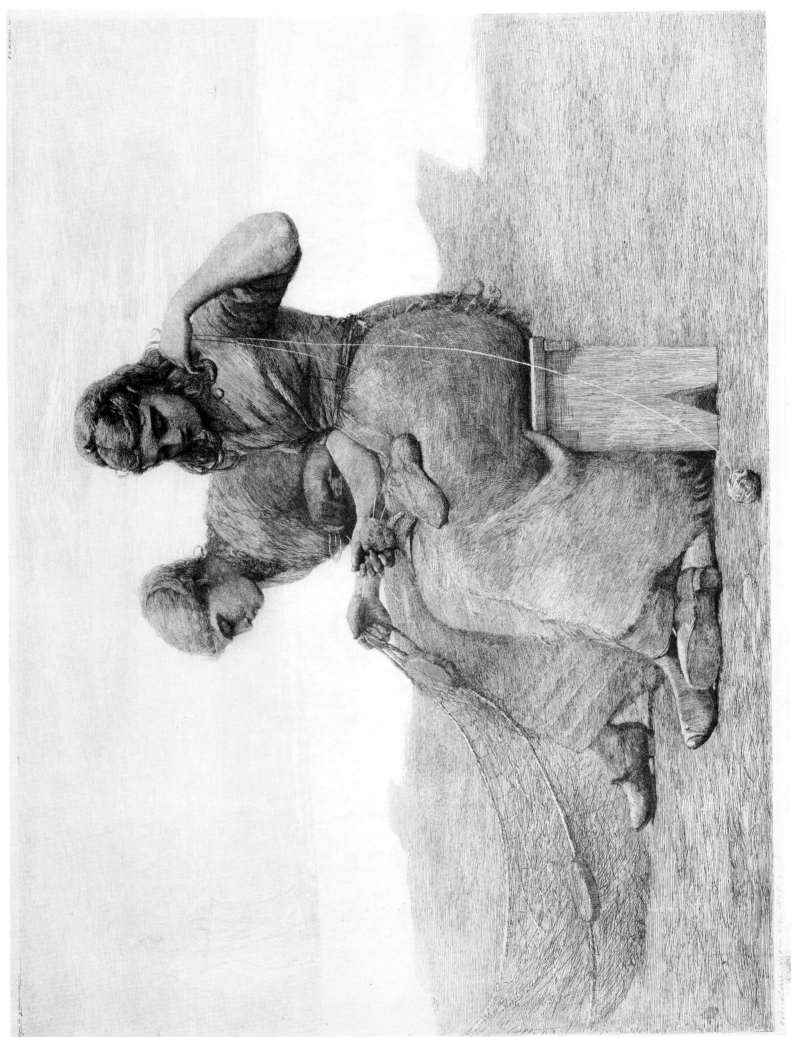

53. WINSLOW HOMER. *Mending the Tears*, 1888. Etching (Goodrich 97, only state). 17⅜ x 23″, with remarque.

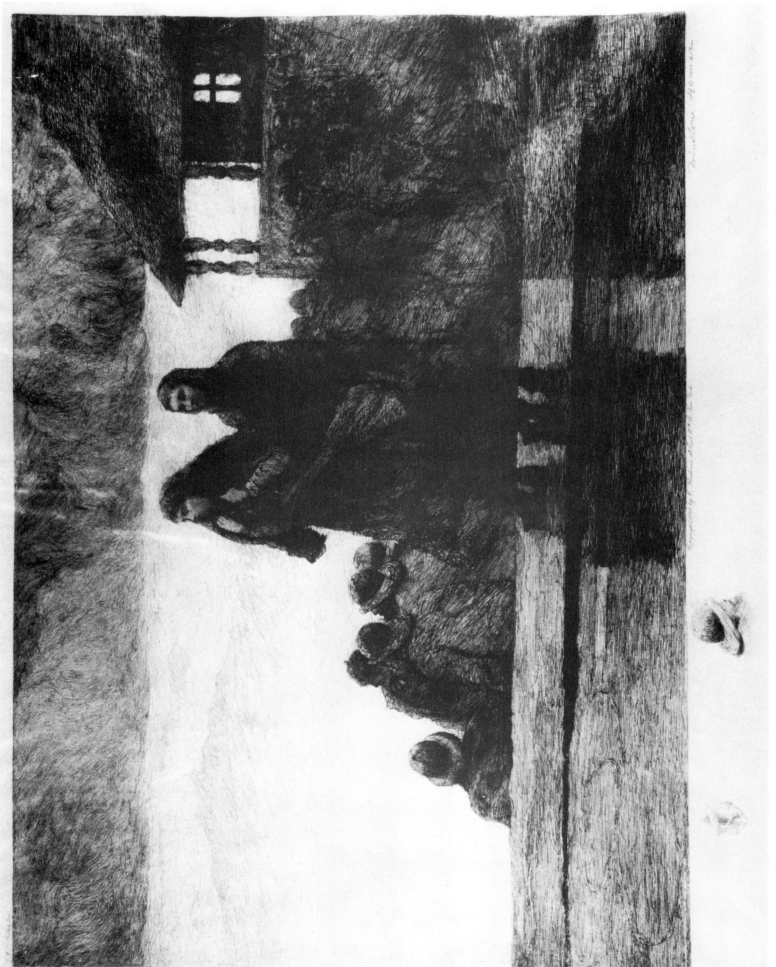

54. WINSLOW HOMER. *Perils of the Sea*, 1888. Etching (Goodrich 98). 16½ x 22″, with remarque.

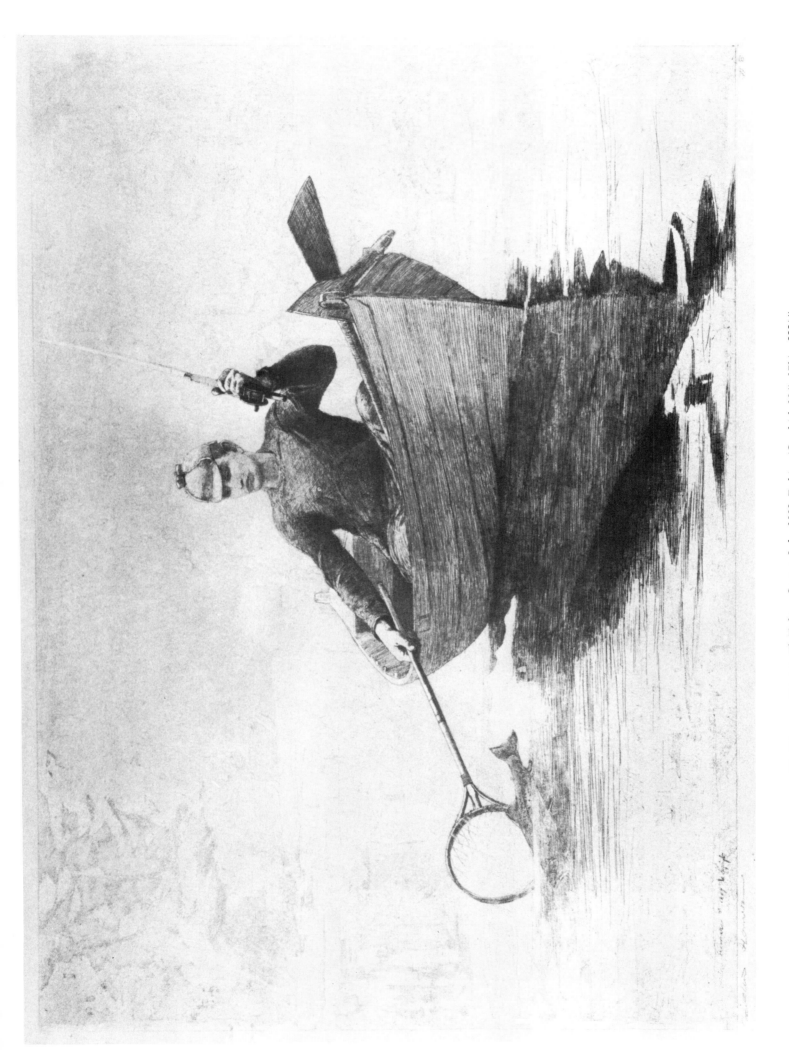

55. WINSLOW HOMER. *Fly Fishing, Saranac Lake*, 1889. Etching (Goodrich 104). 17½ x 22⅝".

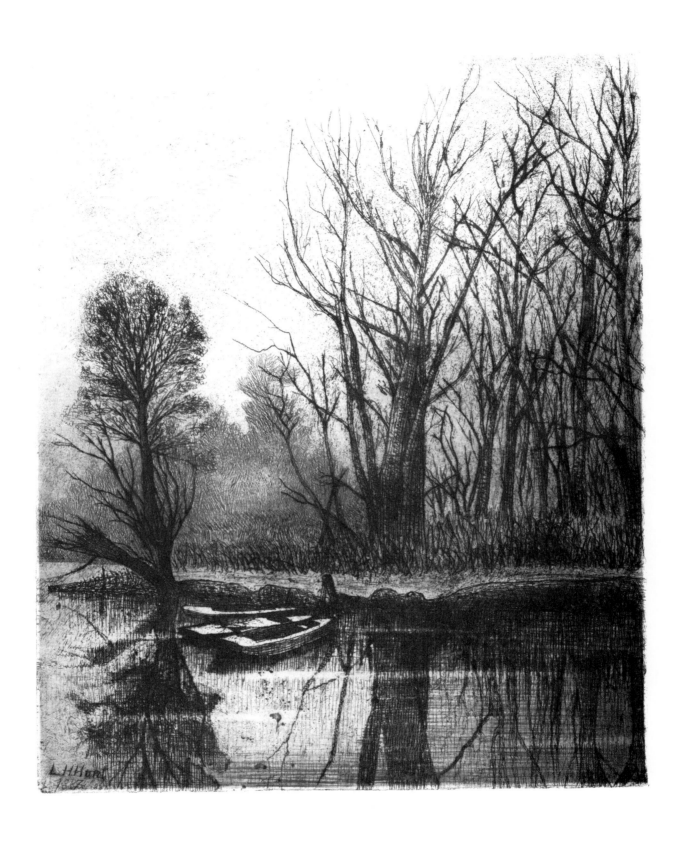

56. LEIGH HARRISON HUNT. [Peaceful woods], 1887. Etching. Plate 7⅞ x 6¹⁵⁄₁₆″.

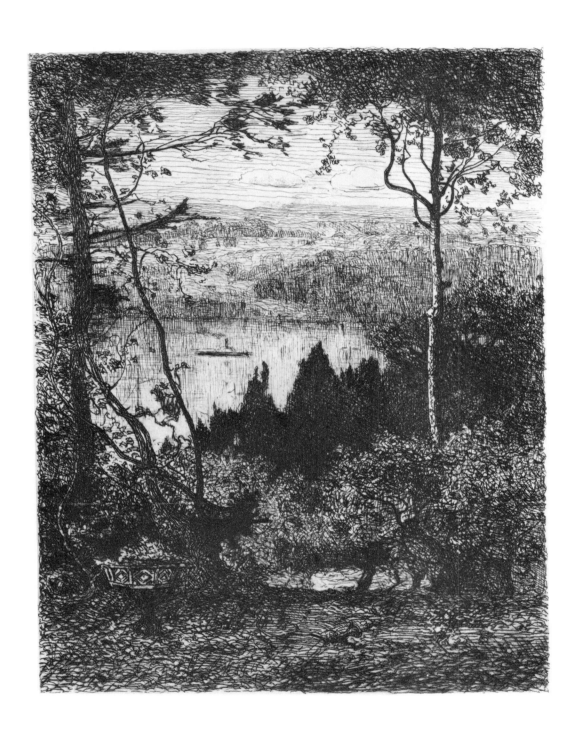

57. GEORGE INNESS. *On the Hudson*, 1879. Etching. 7⅛ x 5⅜″.

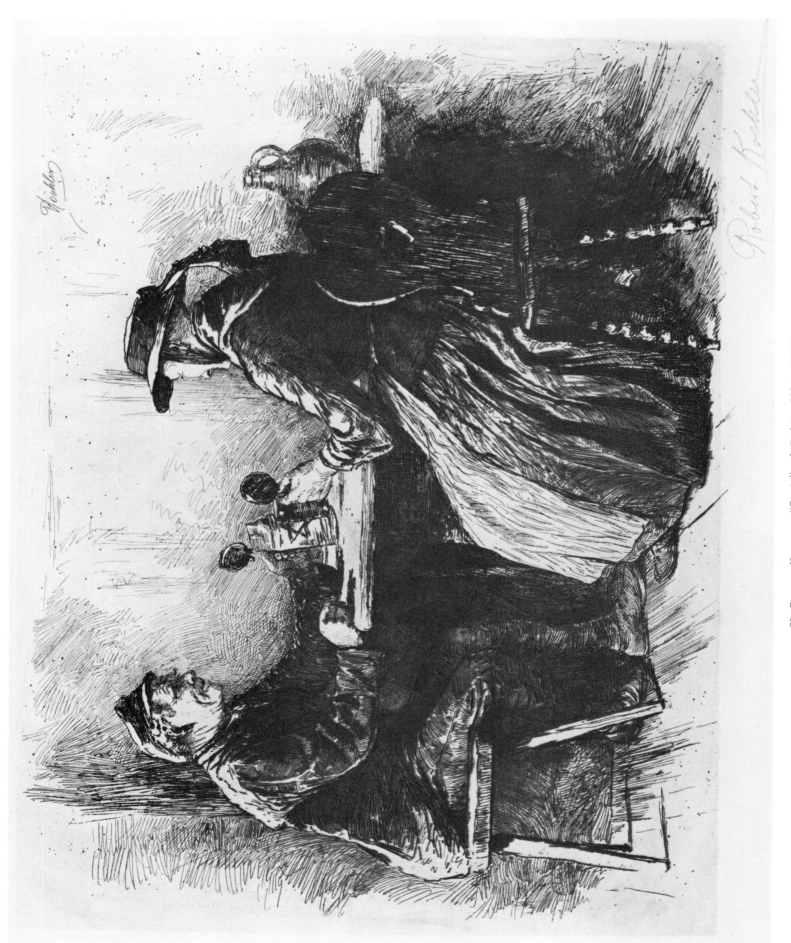

58. ROBERT KOEHLER. "*Prosit,*" n.d. Etching. 10⅝ x 14¼".

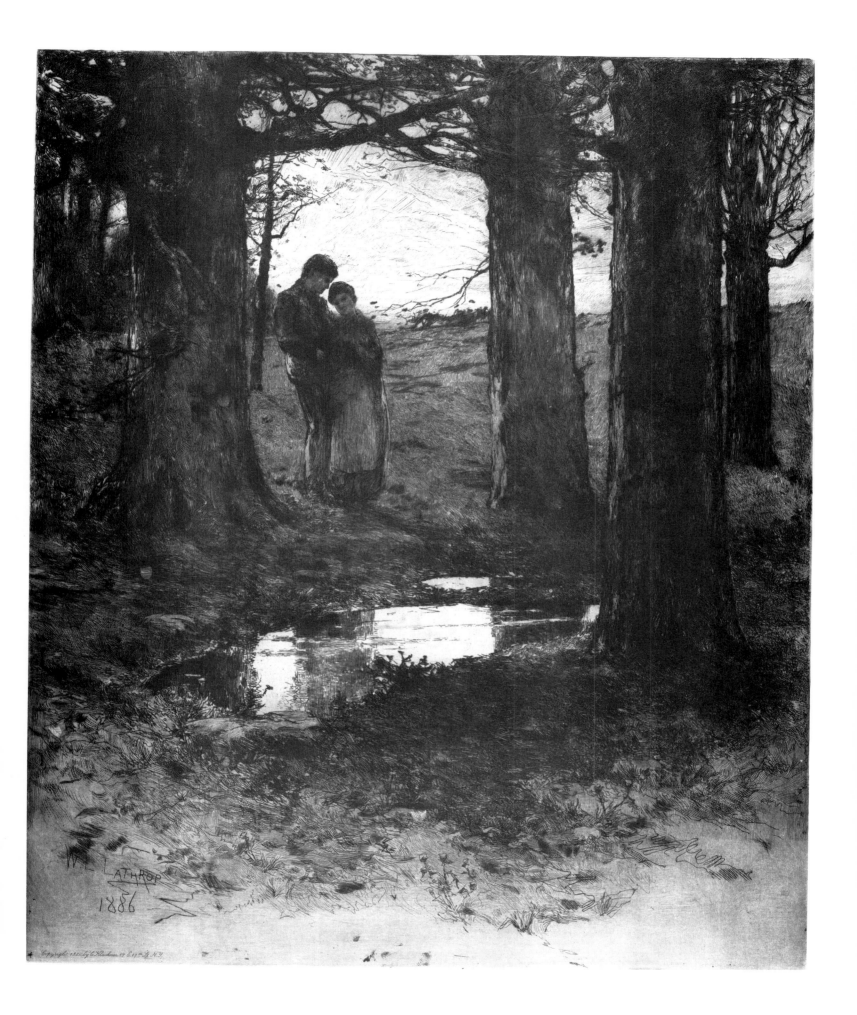

59. WILLIAM LANGSON LATHROP. [Lovers in a wood], 1886. Etching. Plate 17⅞ x 14¹⁵⁄₁₆″.

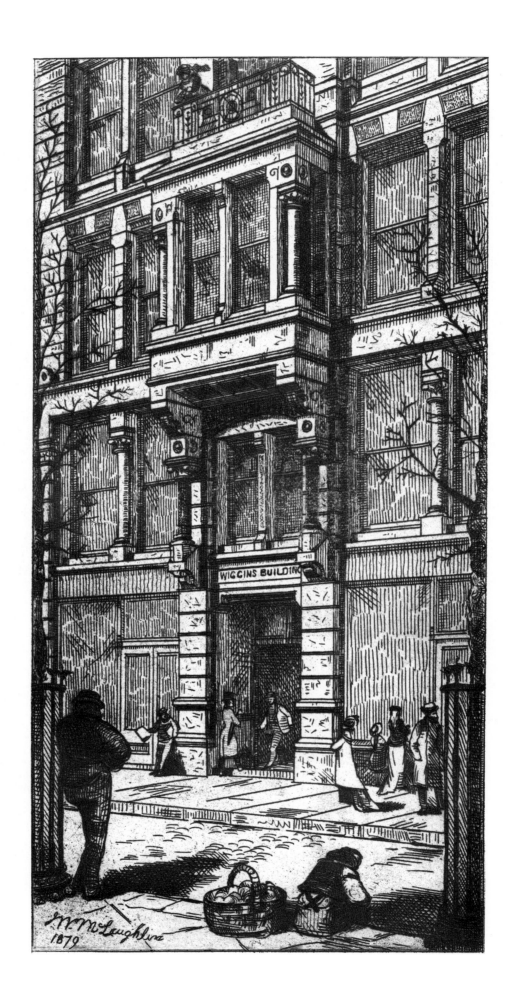

60. James W. McLaughlin. *A Street Scene, Wiggins Building,* 1879. Etching. Plate 10⅞ x 5¹⁵⁄₁₆″.

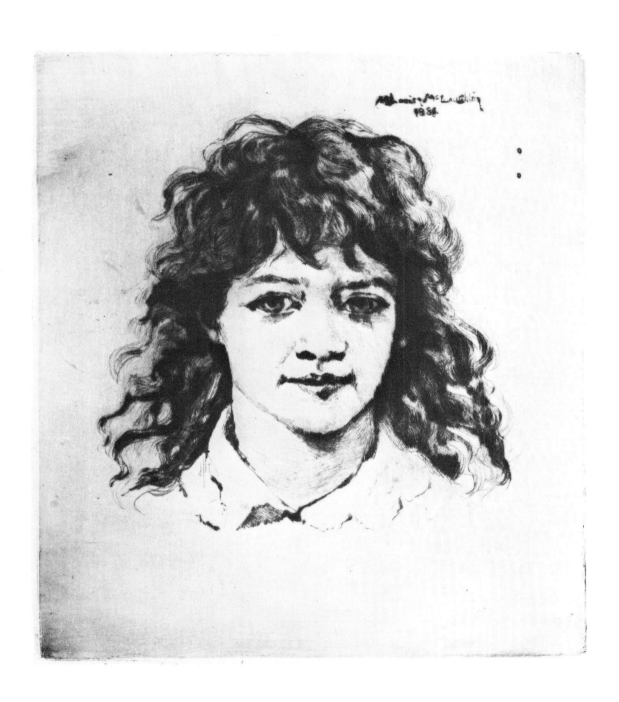

61. MARY LOUISE MCLAUGHLIN. *Girl with Flying Hair*, 1884. Drypoint. 6¹³⁄₁₆ x 5⅞".

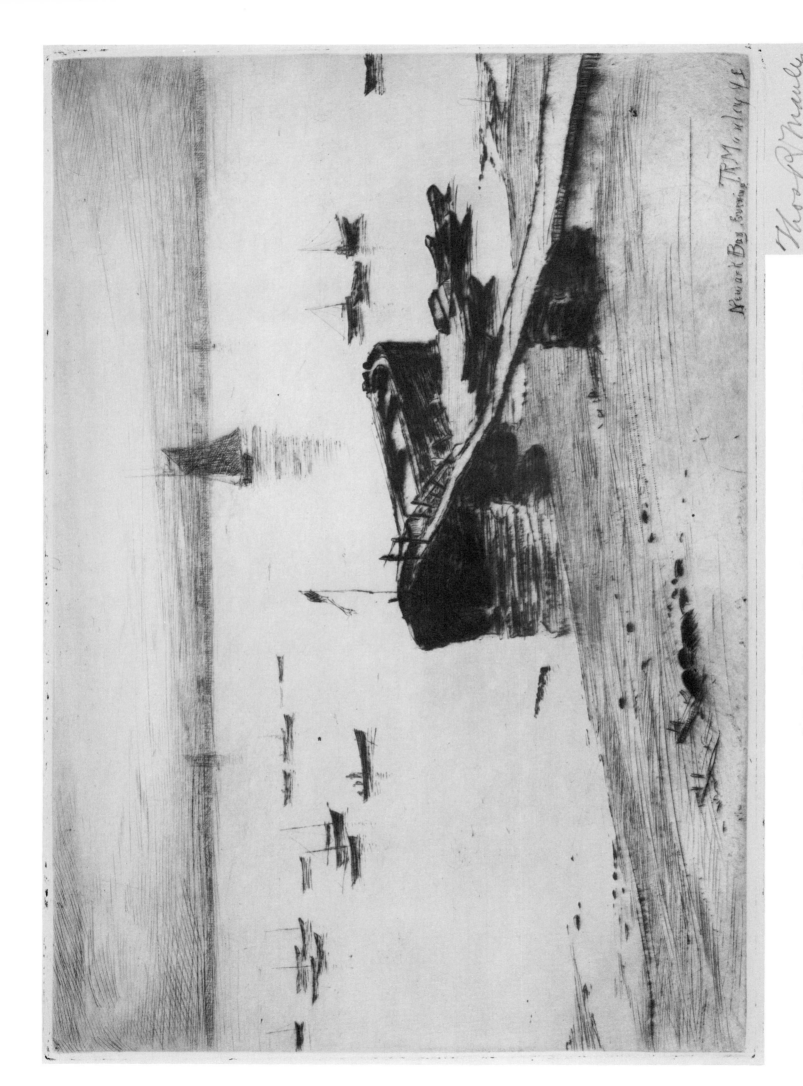

62. THOMAS R. MANLEY. *Newark Bay, Evening.* 1892. Drypoint. 7¼ x 10¾″.

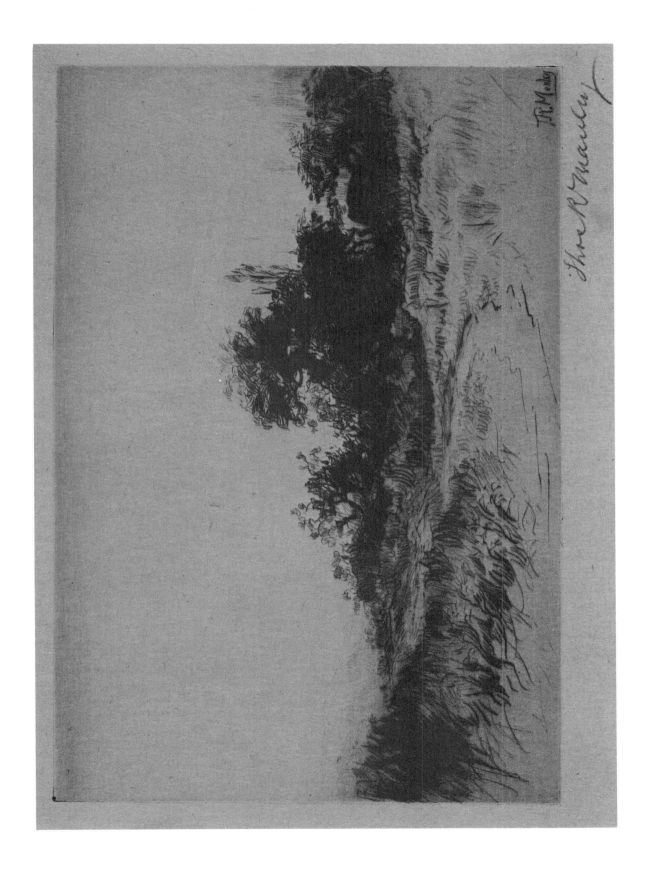

63. THOMAS R. MANLEY. *Morning in the Uplands*, n.d. Drypoint. 8 x 5¼".

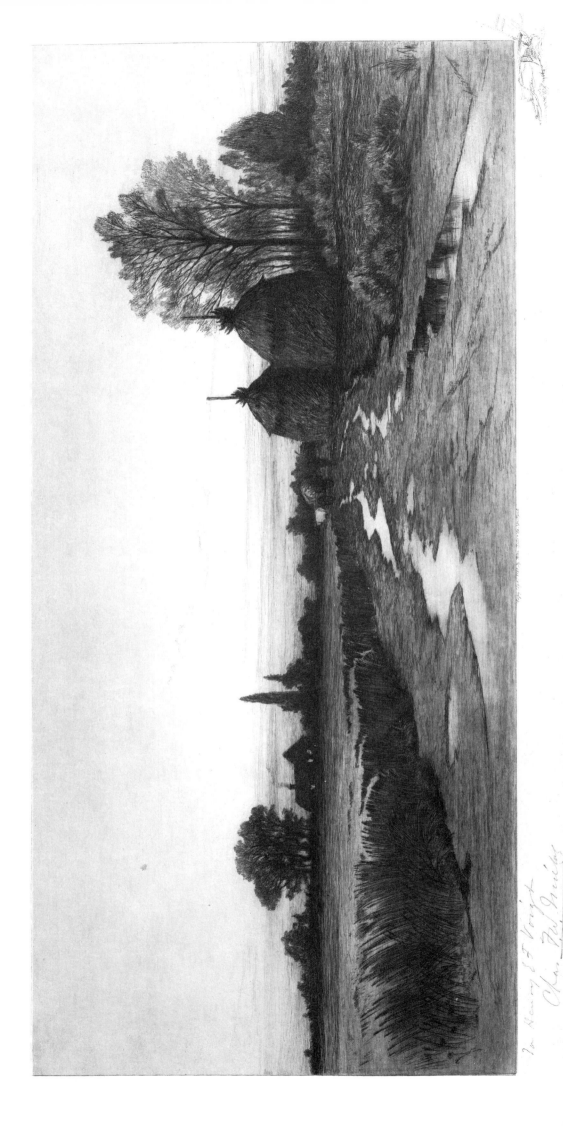

64. Charles Frederick William Mielatz. [Haystacks], 1888. Etching. Plate 7¾ x 17".

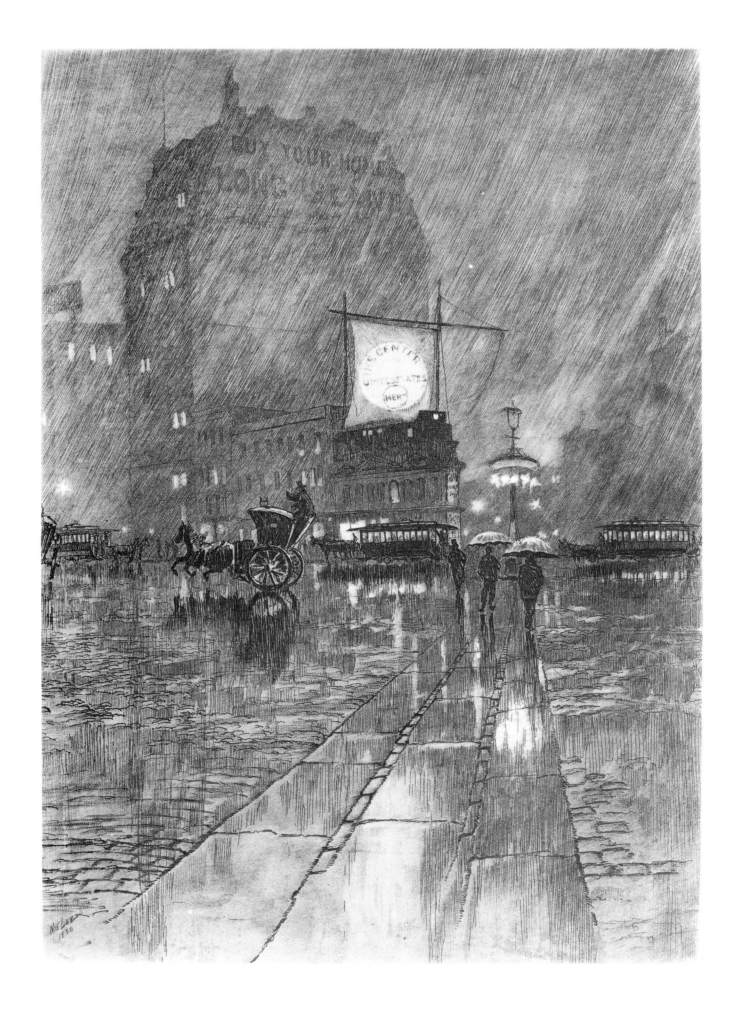

65. CHARLES FREDERICK WILLIAM MIELATZ. *Rainy Night, Madison Square,* 1890. Etching printed in blue ink. 9⅞ x 6¾″.

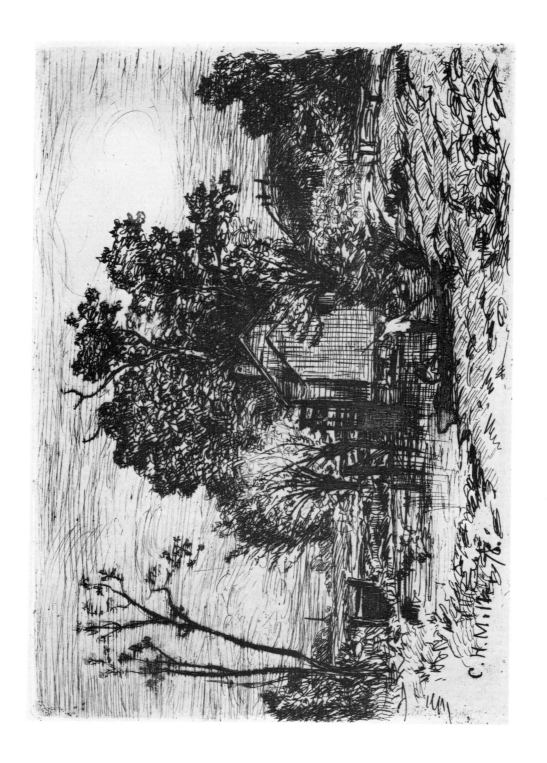

66. Charles Henry Miller. *Old Mill at Valley Stream*, 1878. Etching. 5 x 7¼".

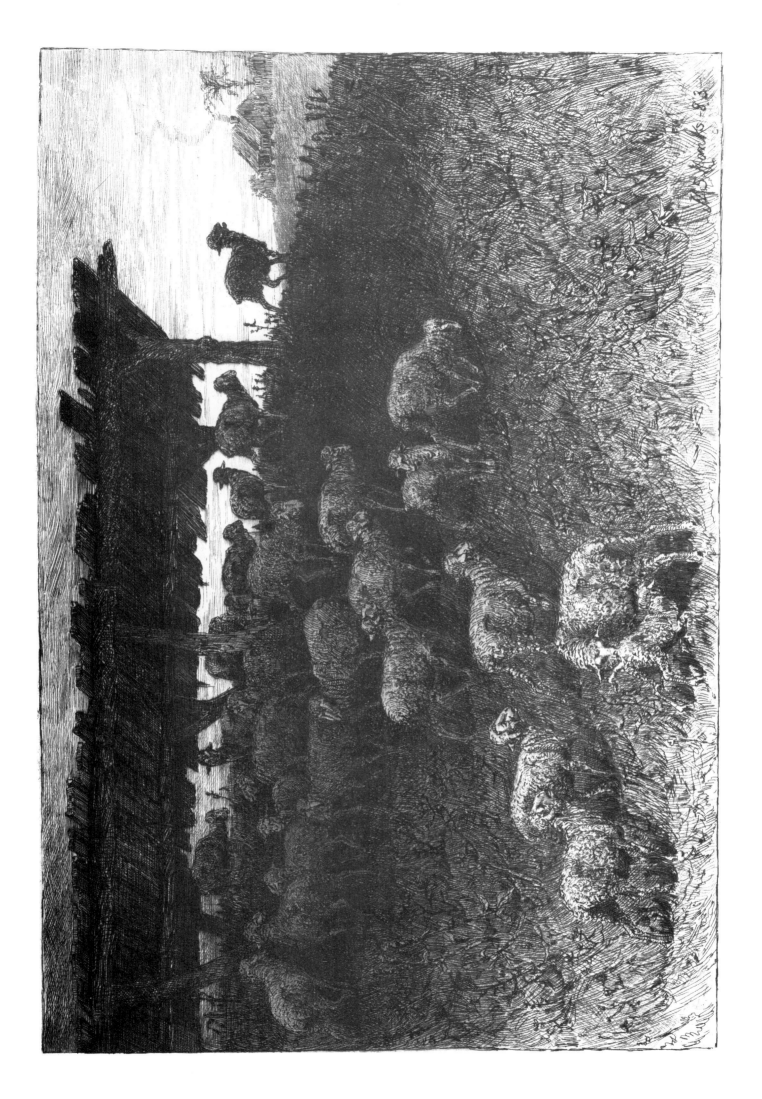

67. John Austin Sands Monks. *Twilight*, 1883. Etching. Plate 7⁷⁄₁₆ x 10¾".

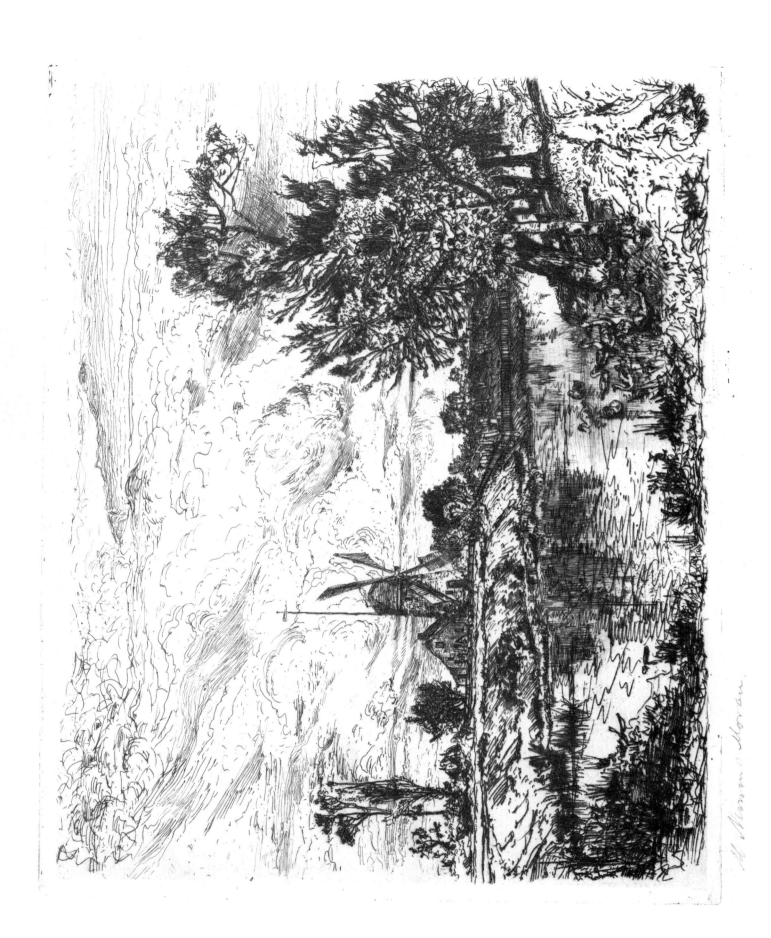

68. MARY NIMMO MORAN. *The Goosepond, East Hampton*, 1881. Etching (Klackner 16). 7 x 9″.

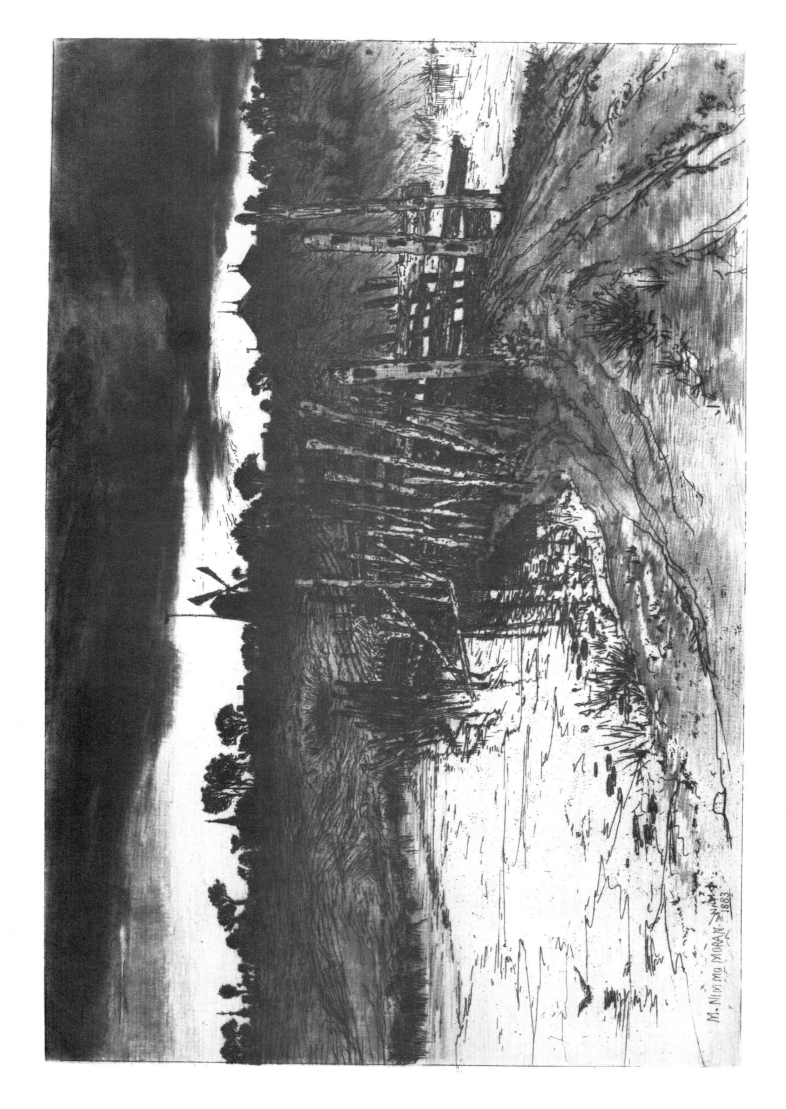

69. MARY NIMMO MORAN. *'Tween the Gloaming and the Mirk*, 1883. Etching (Klackner 29). 7½ x 11½".

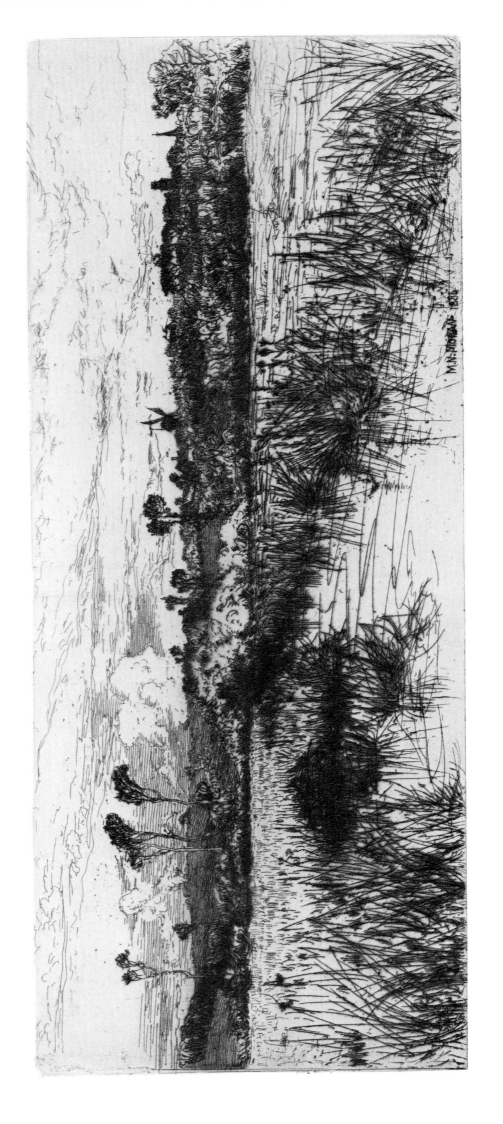

70. MARY NIMMO MORAN. *Home of the Muskrat*, 1884. Etching (Klackner 38). Plate 4⅞ x 11⅜″.

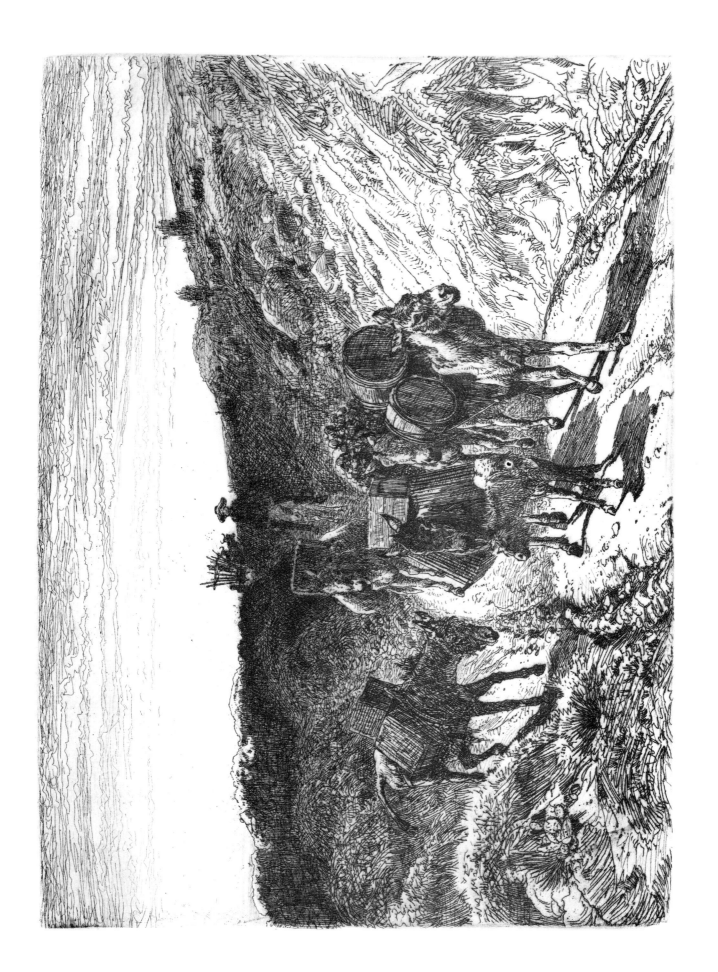

71. PETER MORAN. *Burro Train, New Mexico,* ca. 1880. Etching. Plate 6½ x 9½".

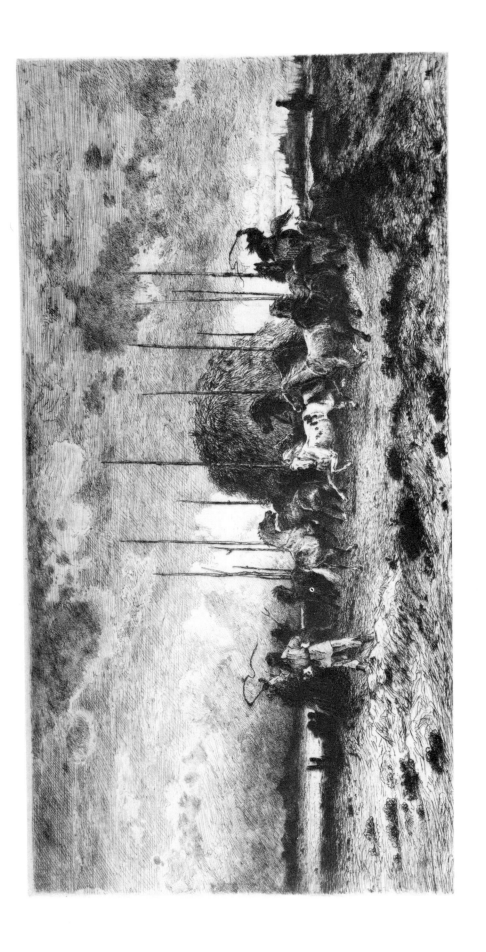

72. PETER MORAN. *Harvest, San Juan,* n.d. Etching. 4½ x 9″.

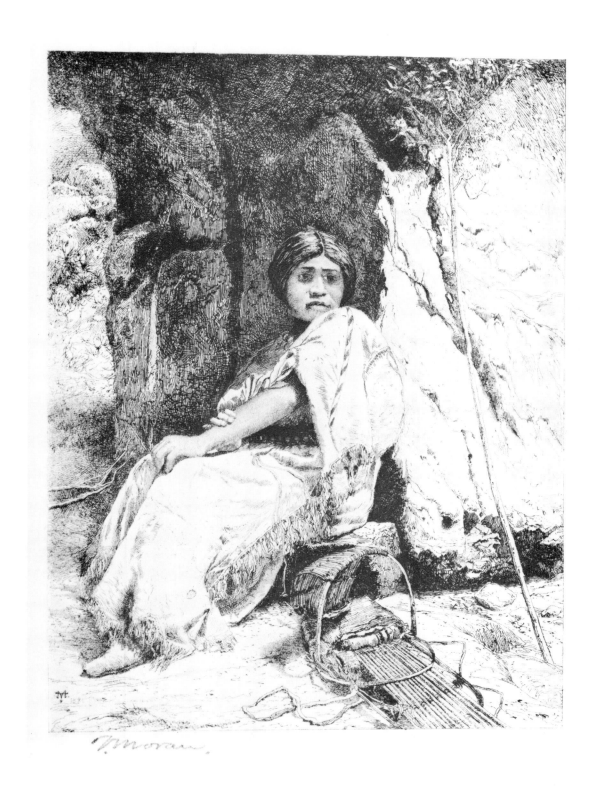

73. THOMAS MORAN. *The Empty Cradle*, 1878. Etching (Klackner 9). 7¾ x 5¾″.

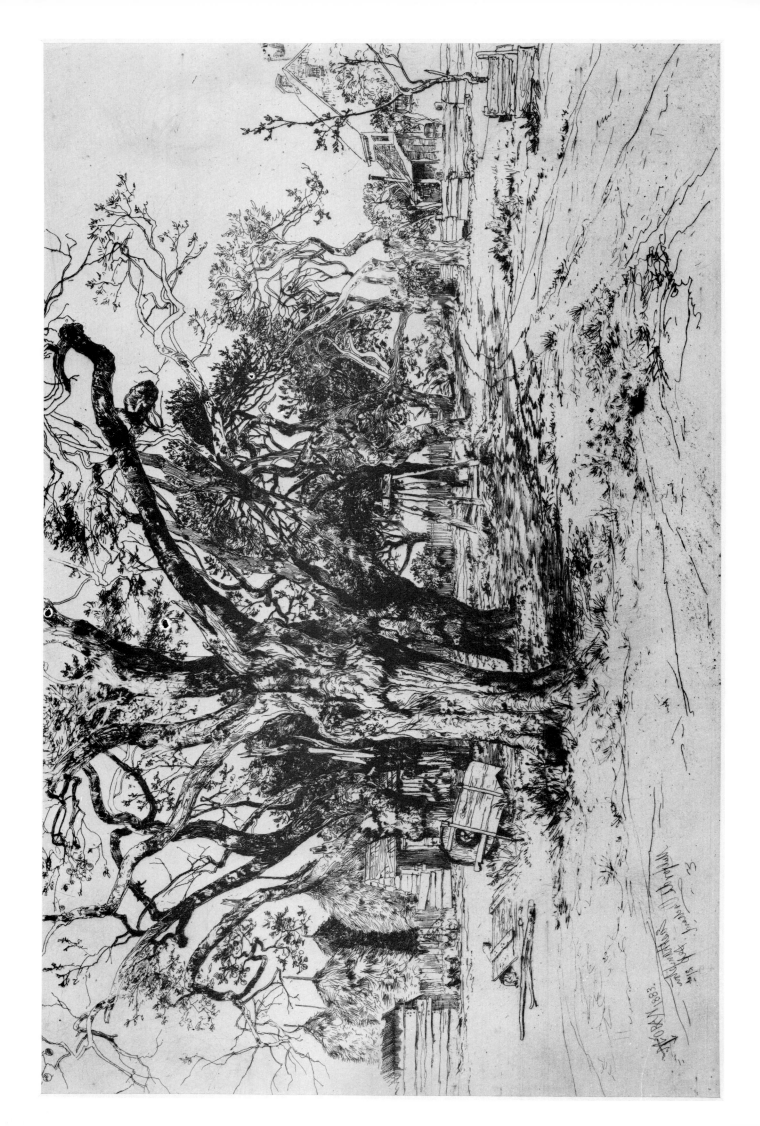

74. THOMAS MORAN. *An Apple Orchard—East Hampton, L.I.*, 1883. Etching (Klackner 36). 11¾ x 17½".

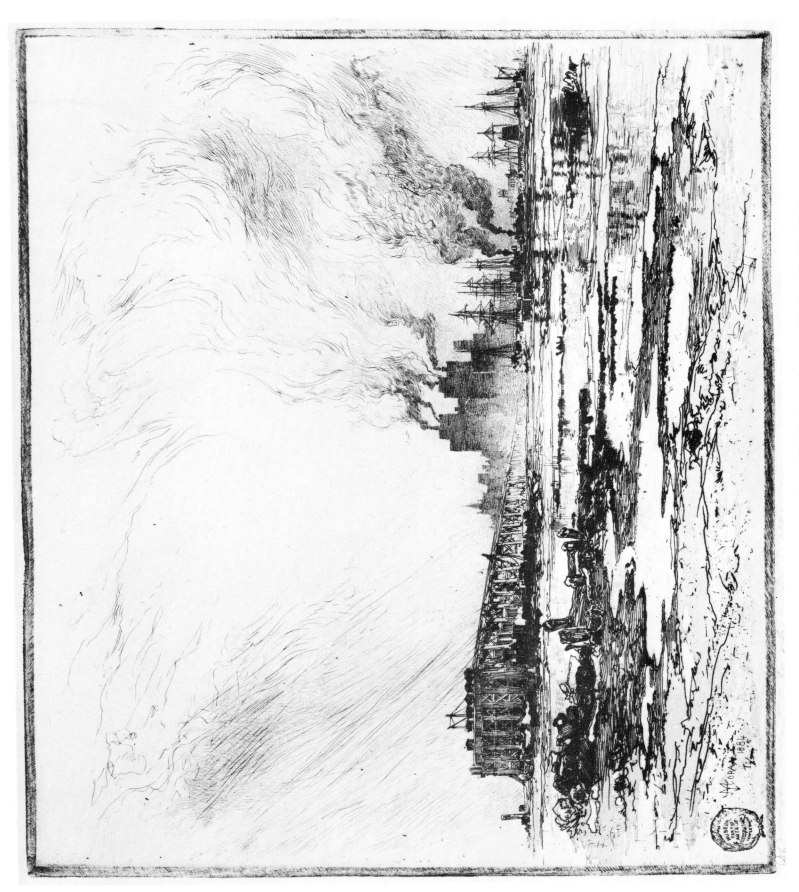

75. THOMAS MORAN. *Communipaw, New Jersey*, 1884. Etching and aquatint (Klackner 42). 10 x 11½″.

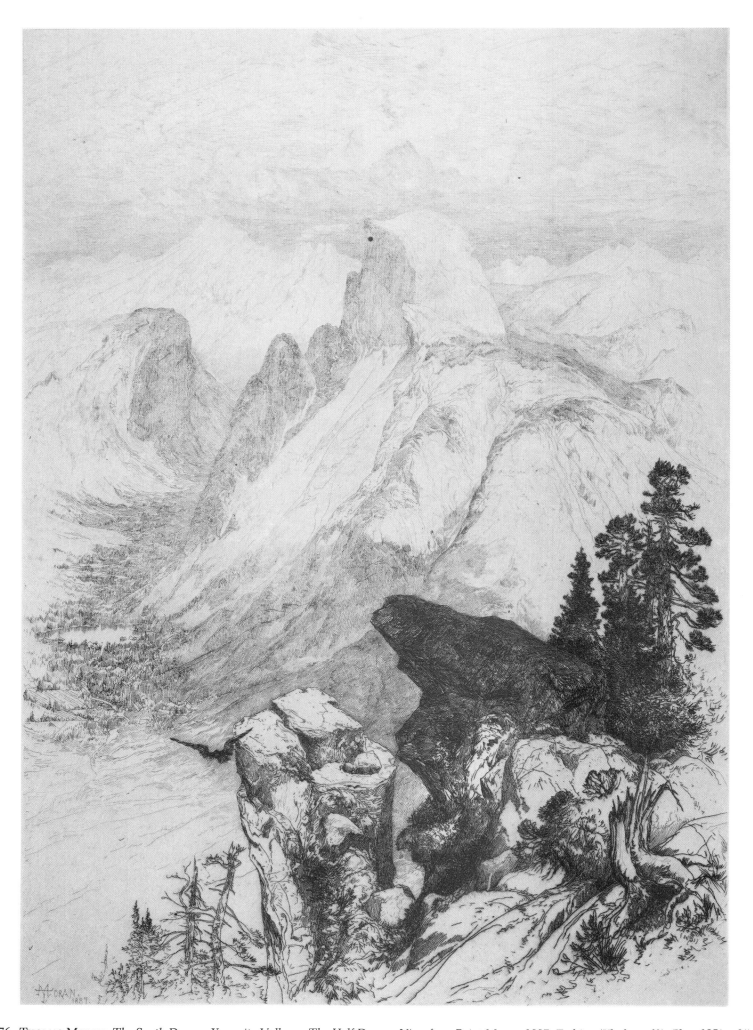

76. THOMAS MORAN. *The South Dome—Yosemite Valley* or *The Half Dome—View from Point Moran*, 1887. Etching (Klackner 60). Plate 12⅞ x 9″.

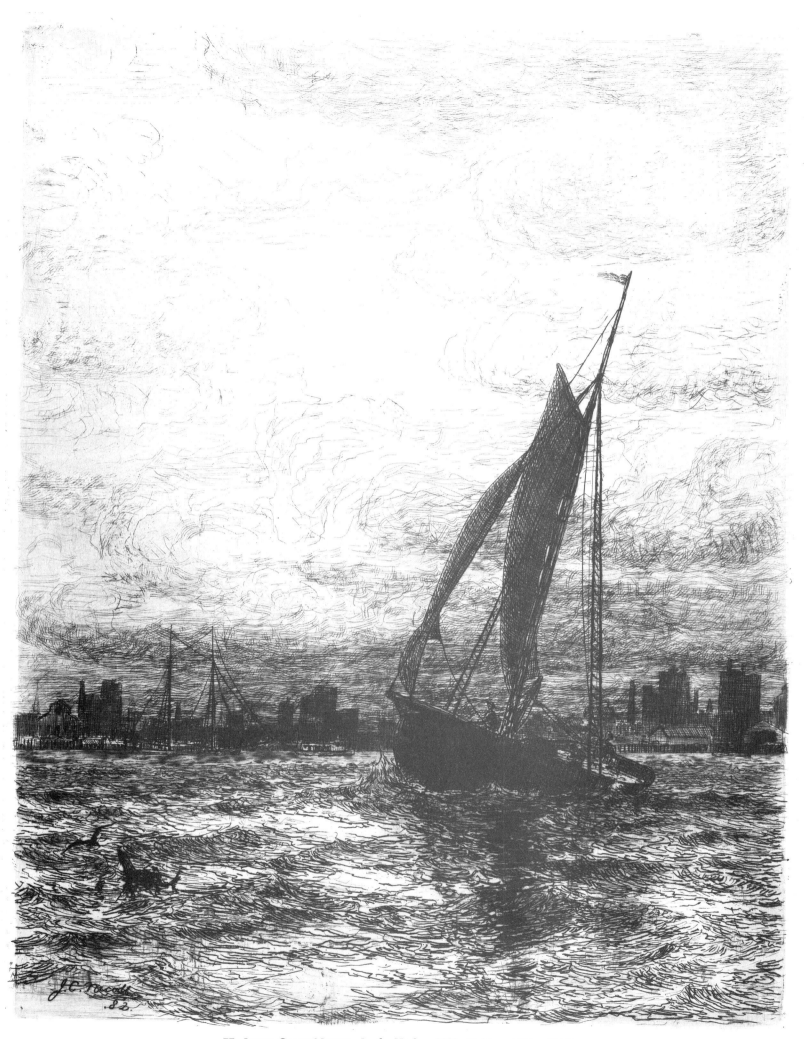

77. JAMES CRAIG NICOLL. *In the Harbor*, 1882. Etching. 12¼ x 9¾".

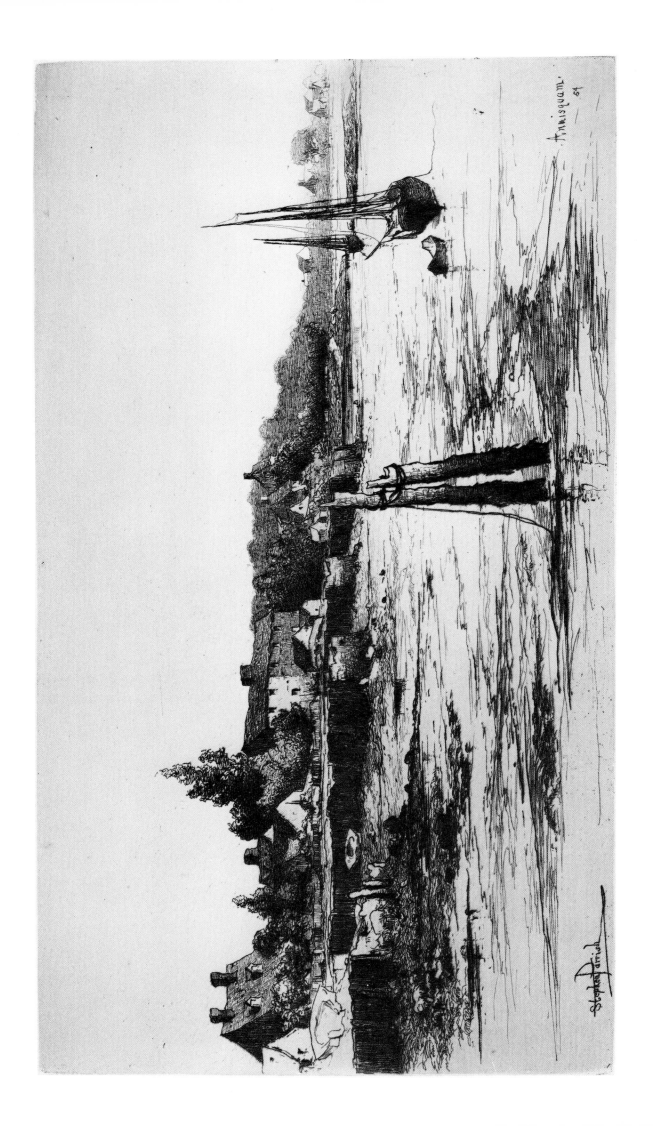

78. STEPHEN PARRISH. *Annisquam*, summer 1881. Etching (Parrish 54). 6⅜ x 11⅝".

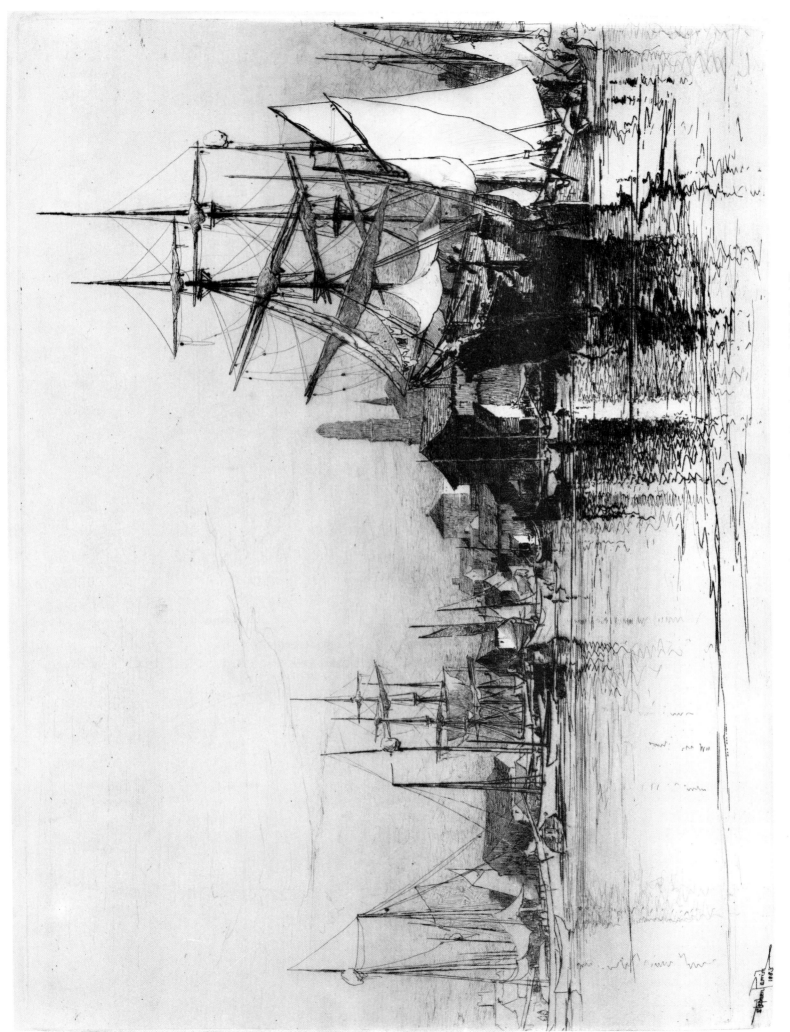

79. STEPHEN PARRISH. *The Inner Harbor, Gloucester, Mass.*, March 1883. Etching (Parrish 79). 10 x 14".

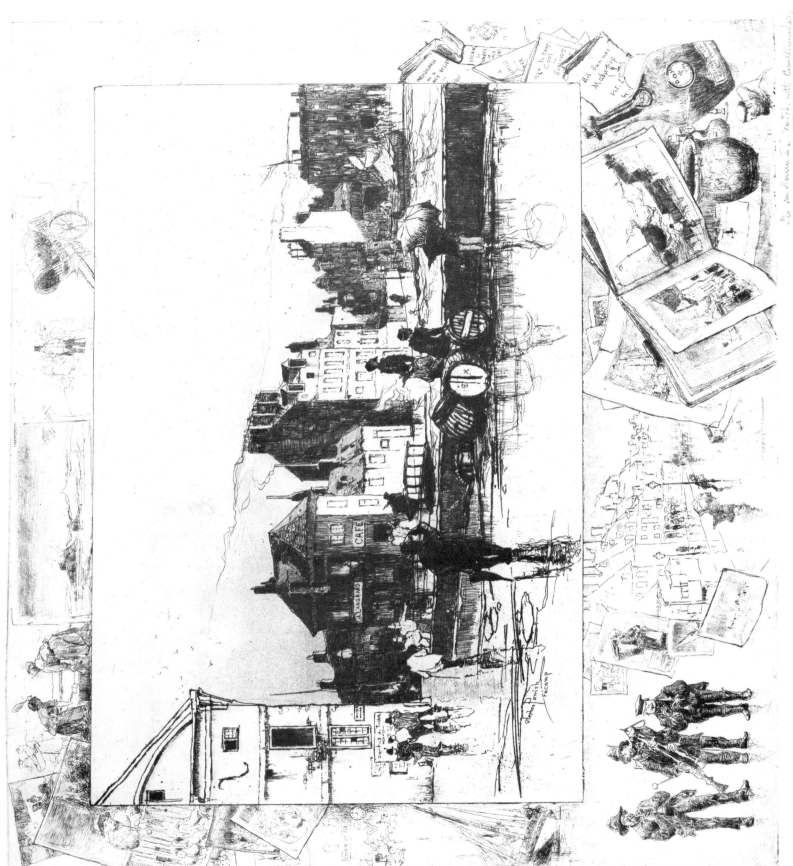

80. Stephen Parrish. *A Gale at Fécamp, Normandy*, n.d. Etching. 13¾ x 15⅞".

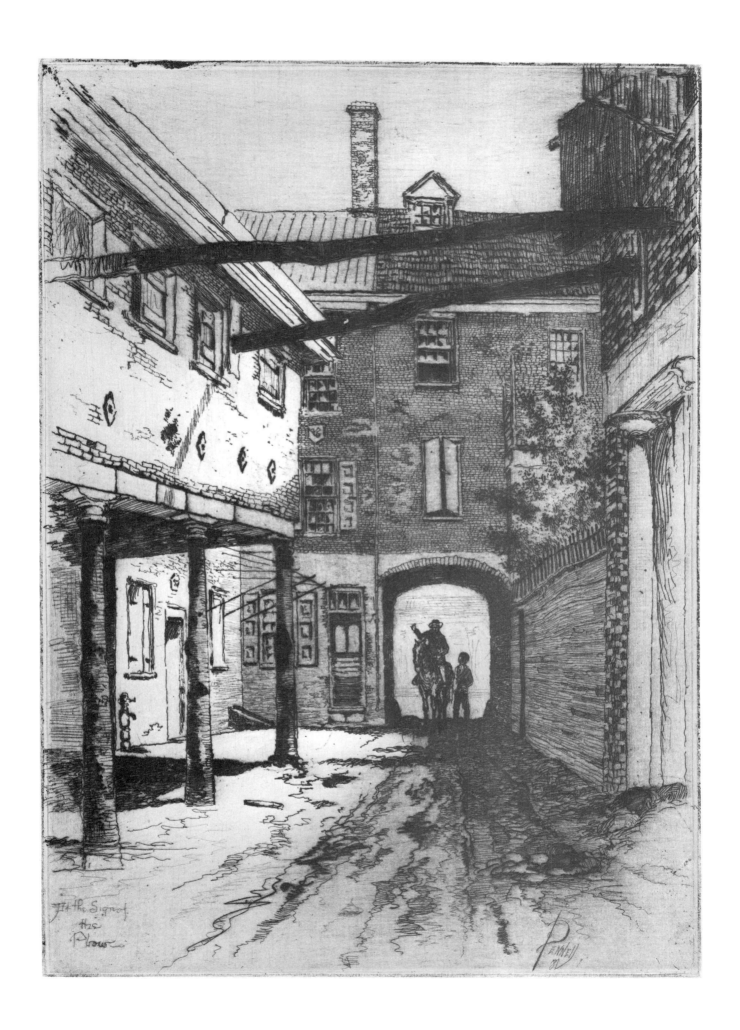

81. JOSEPH PENNELL. *Plow Inn Yard*, 1881. Etching (Wuerth 35). 9¾ x 6⅞".

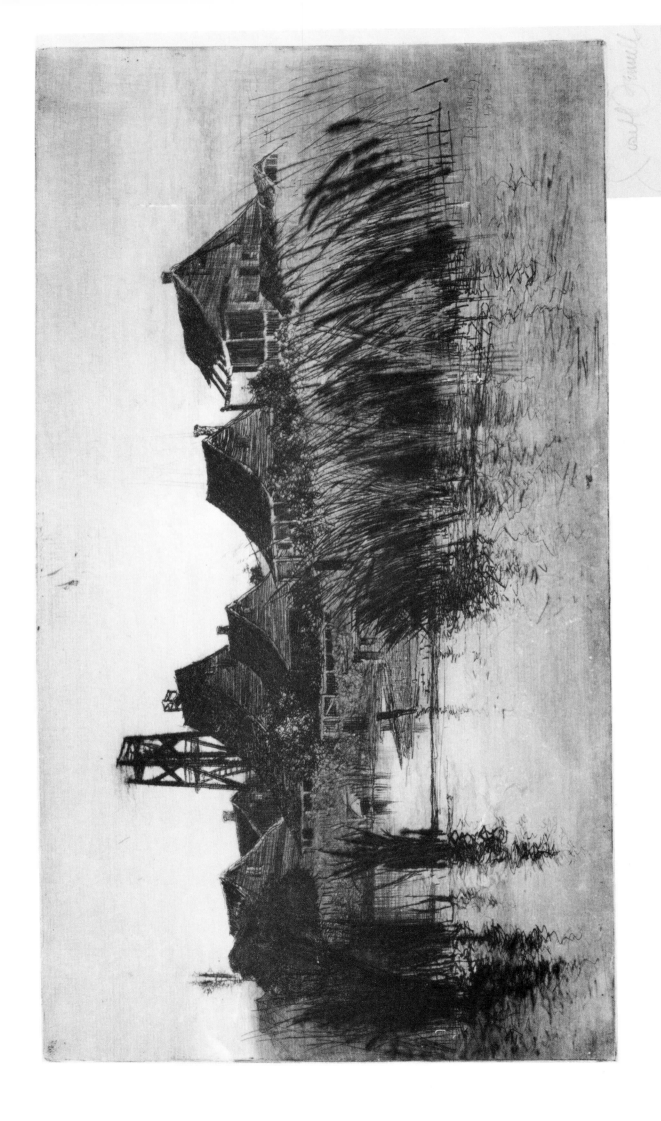

82. JOSEPH PENNELL. *Twilight, Pilottown, La.*, 1882. Etching and drypoint (Wuerth 41). 8⅛ x 15″.

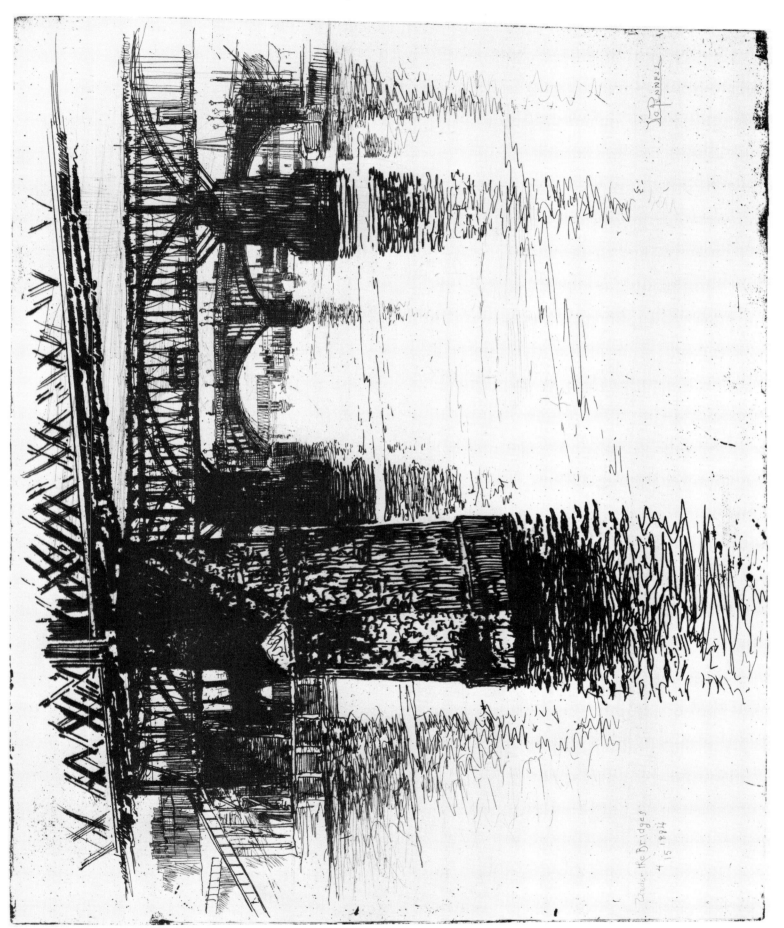

83. Joseph Pennell. *Under the Bridges, on the Schuylkill,* 1884. Etching (Wuerth 92). 10⅜ x 12⅞".

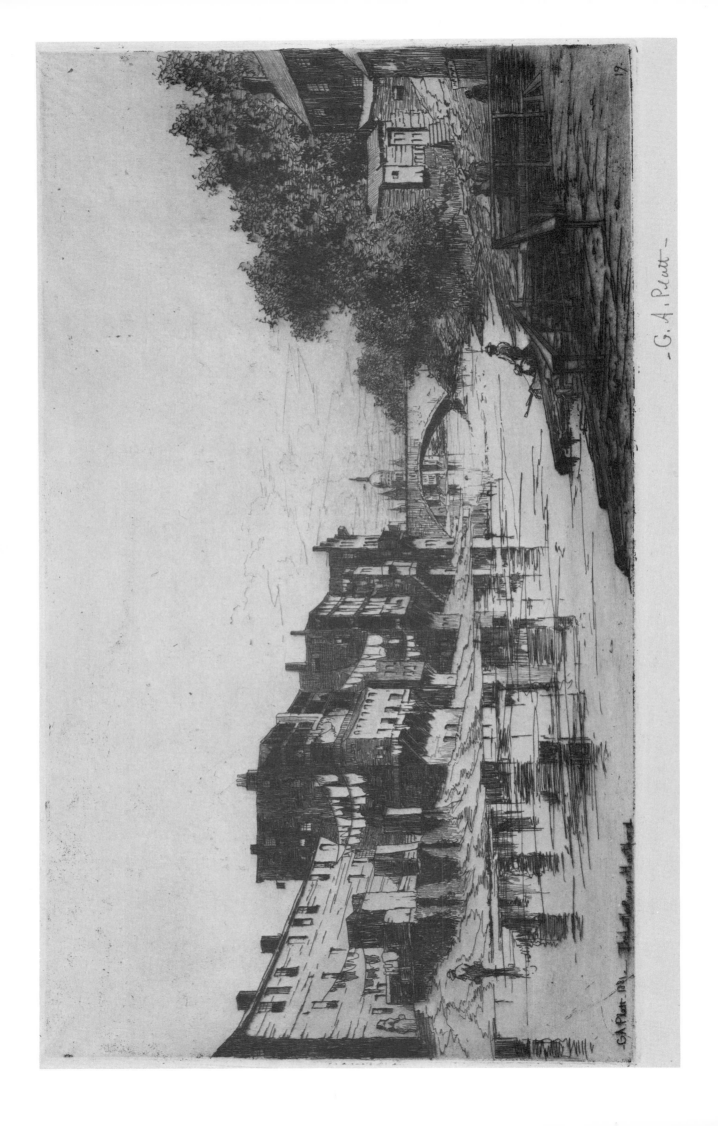

84. CHARLES ADAMS PLATT. *The Little River, Hartford*, 1881. Etching (Rice 18). 7¾ x 13¾".

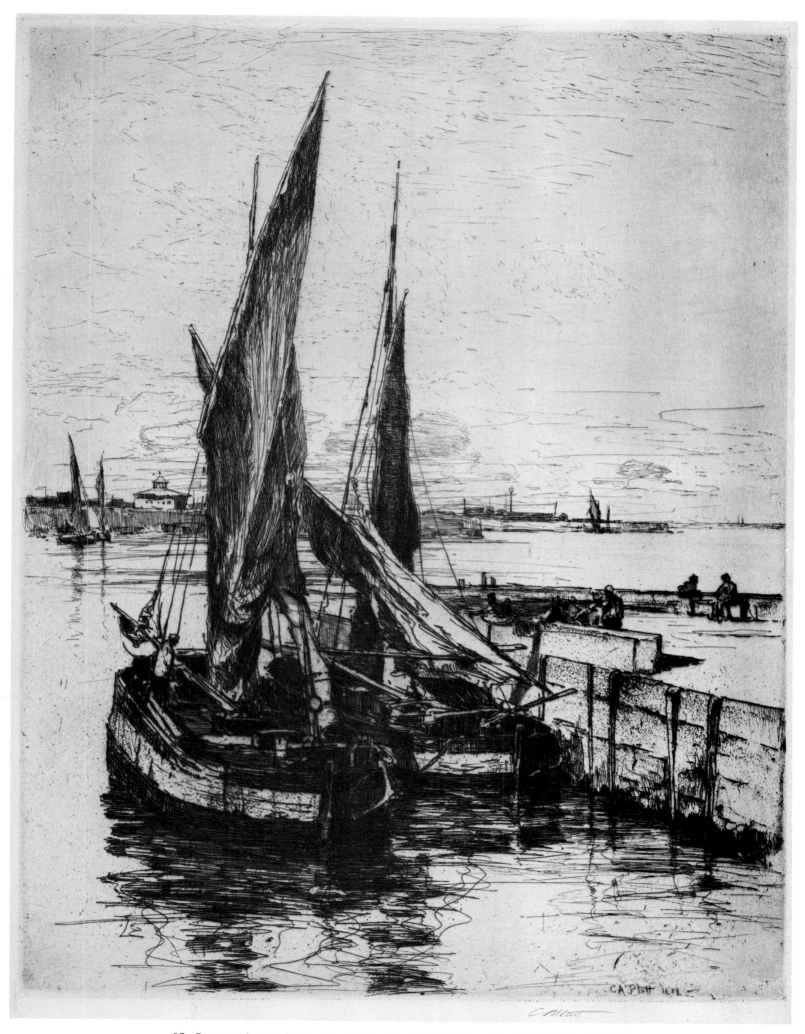

85. CHARLES ADAMS PLATT. *Quai at Honfleur*, 1888. Etching (Rice 100c). 16¾ x 12⅞".

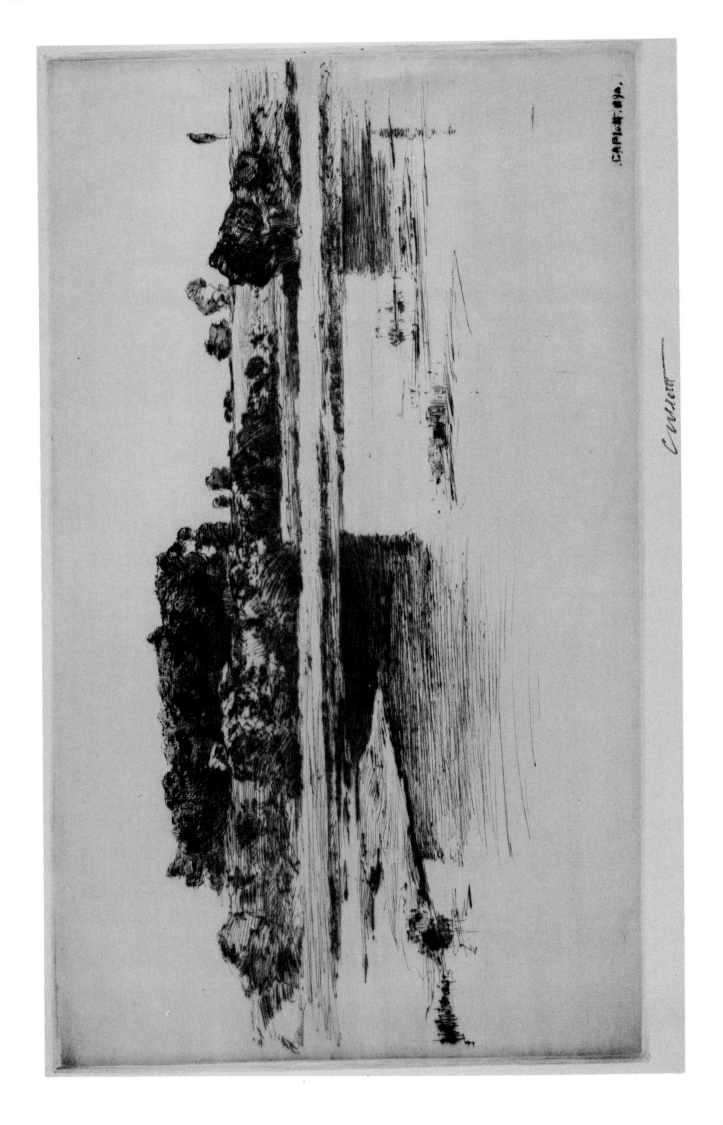

86. Charles Adams Platt. *Charles River*, 1890. Drypoint (Grolier Club 112b). 8¼ x 14¼".

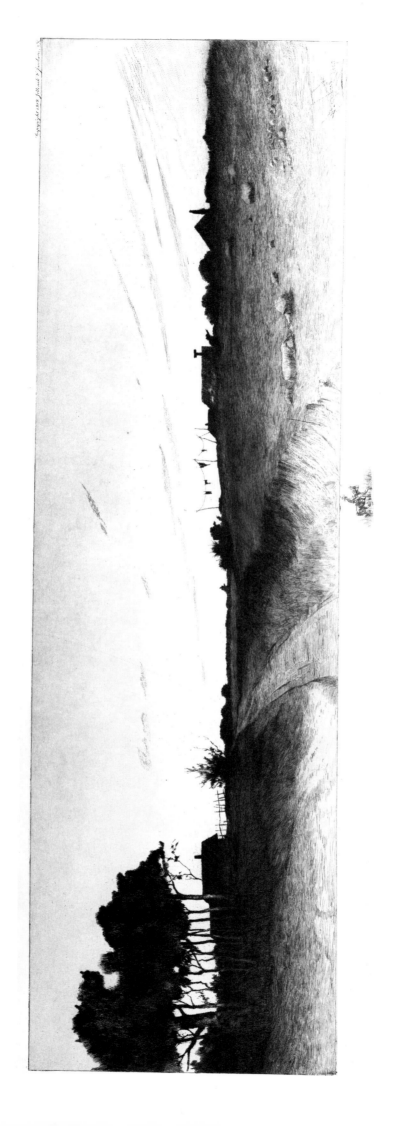

87. HENRY M. ROSENBERG. [A Western landscape], December 7, 1889. Etching. Plate 6⅞ x 20⅞".

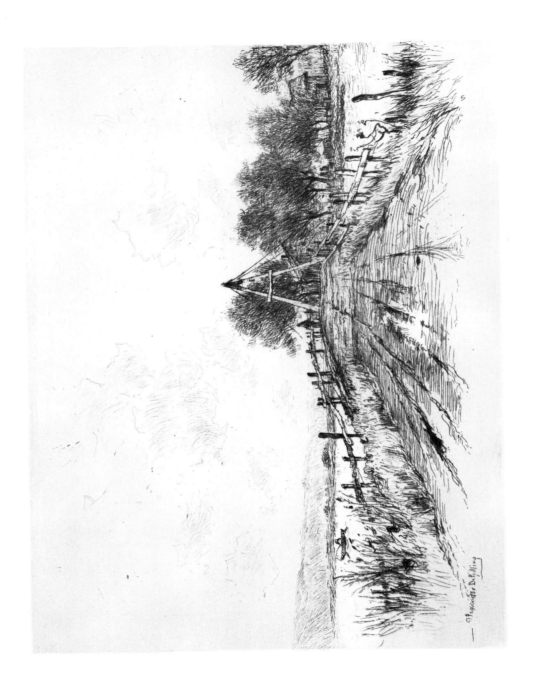

88. ALEXANDER SCHILLING. [A country road], n.d. Etching. Plate 5⅛ x 6¹¹⁄₁₆″.

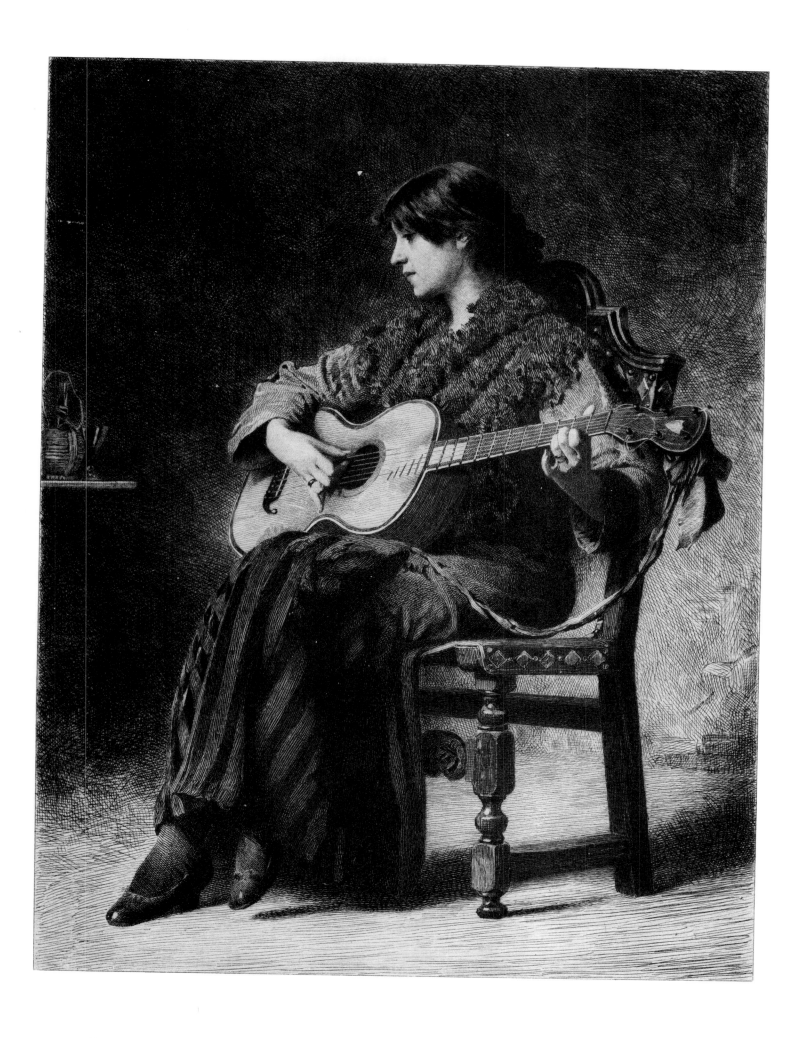

89. STEPHEN ALONZO SCHOFF. *The Prelude* (after a painting by Charles Sprague Pearce), 1886. Etching. Plate 9¾ x 7½″.

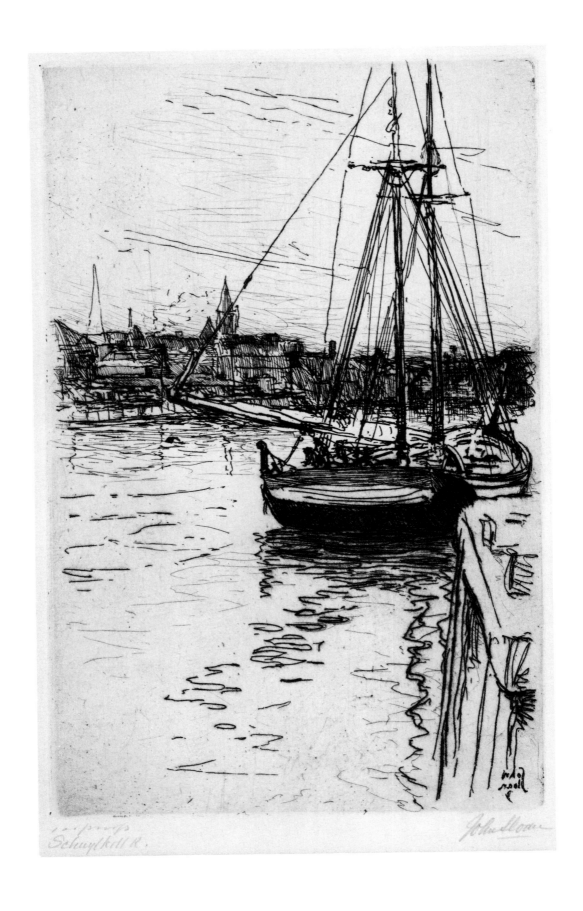

i...proof
Schuylkill R. John Sloan

90. JOHN SLOAN. *The Schuylkill River*, 1894. Etching. 8½ x 5¼″.

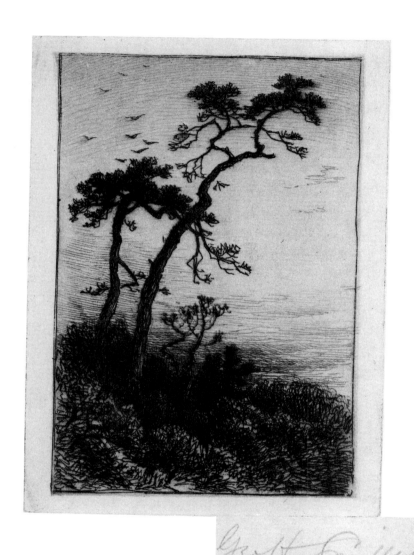

91. GEORGE HENRY SMILLIE. *Florida Pines,* ca. 1882. Etching. Plate 4¾ x 3⅛″.

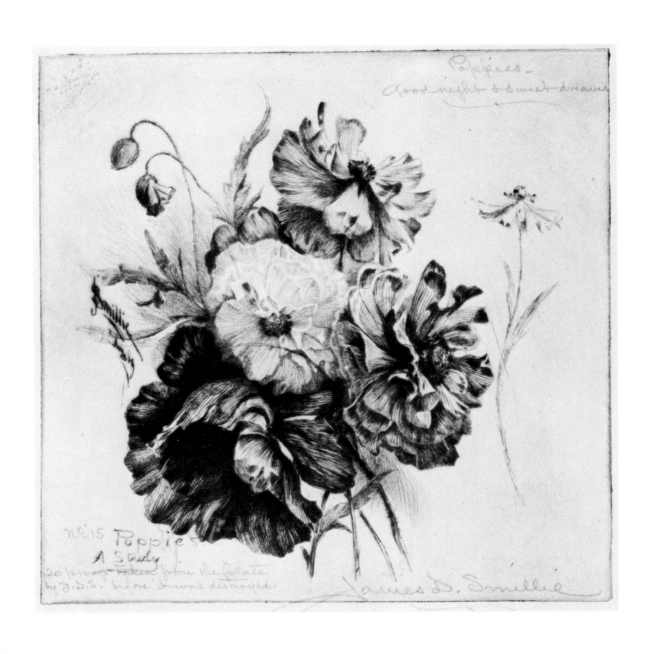

92. JAMES DAVID SMILLIE. *Poppies, A Study,* 1889. Drypoint and etching. Plate 5⅞ x 5⅞″.

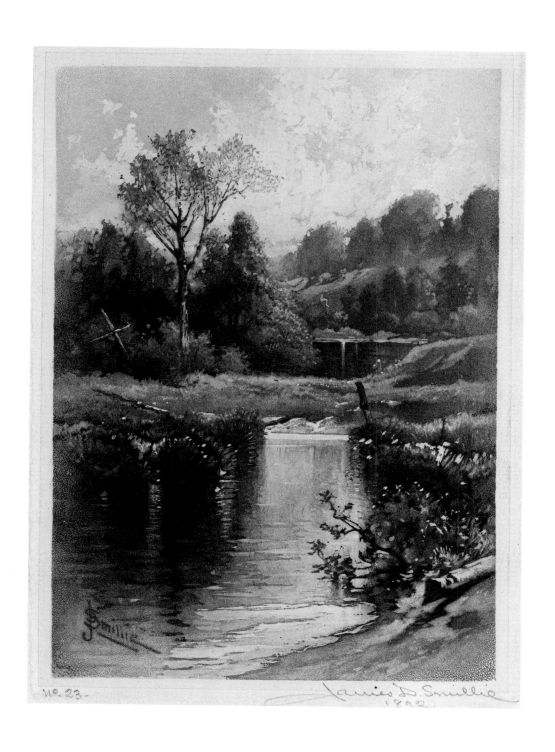

93. JAMES DAVID SMILLIE. *Morning*, 1892. Aquatint. Plate 6⅝ x 4⅝".

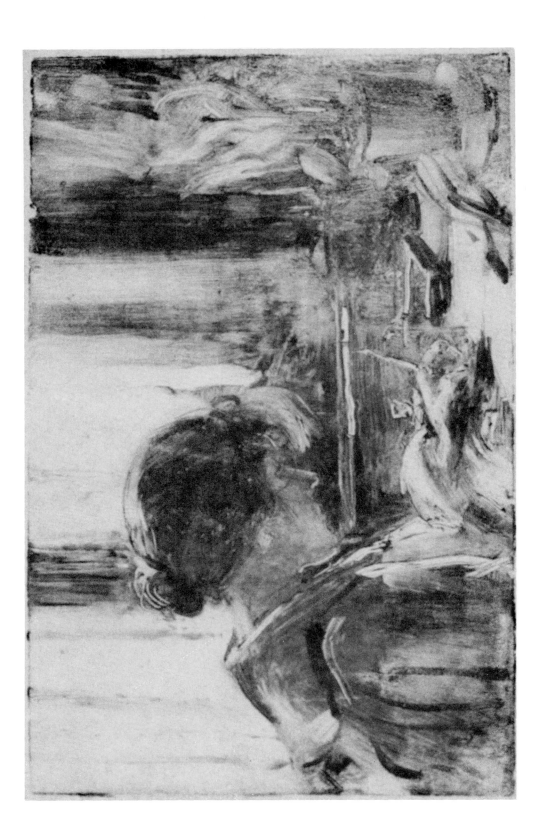

94. ALBERT STERNER. *The Writing Desk*, ca. 1895. Monotype. 6 x 8½".

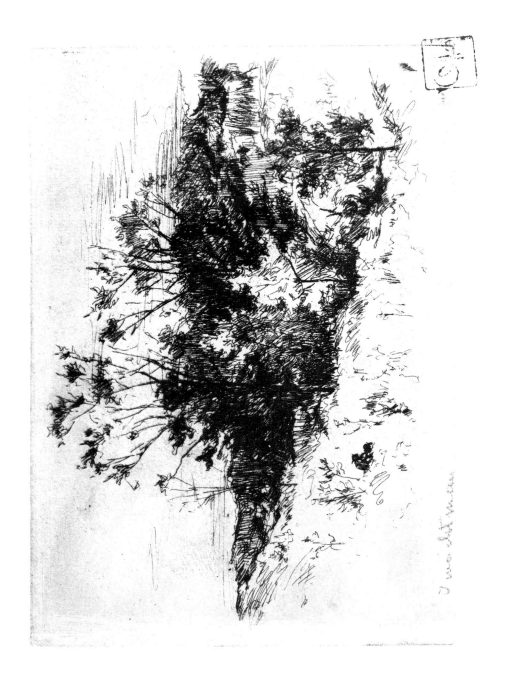

95. JOHN HENRY TWACHTMAN. *Autumn, Avondale,* ca. 1879. Etching (Baskett 111). 4½ x 6¾″.

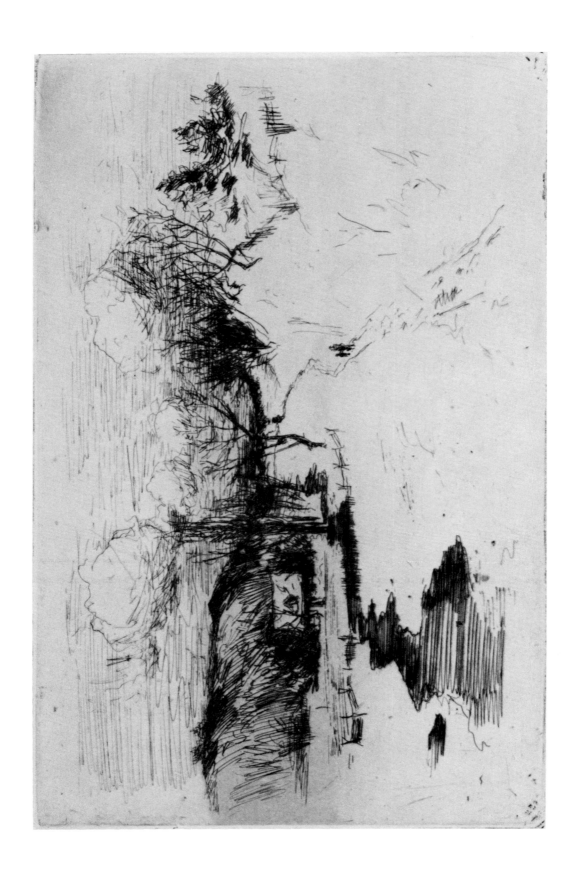

96. John Henry Twachtman. *Winter, Avondale*, ca. 1880. Etching (Baskett 112, only state). 5⁷⁄₁₆ x 8¼″.

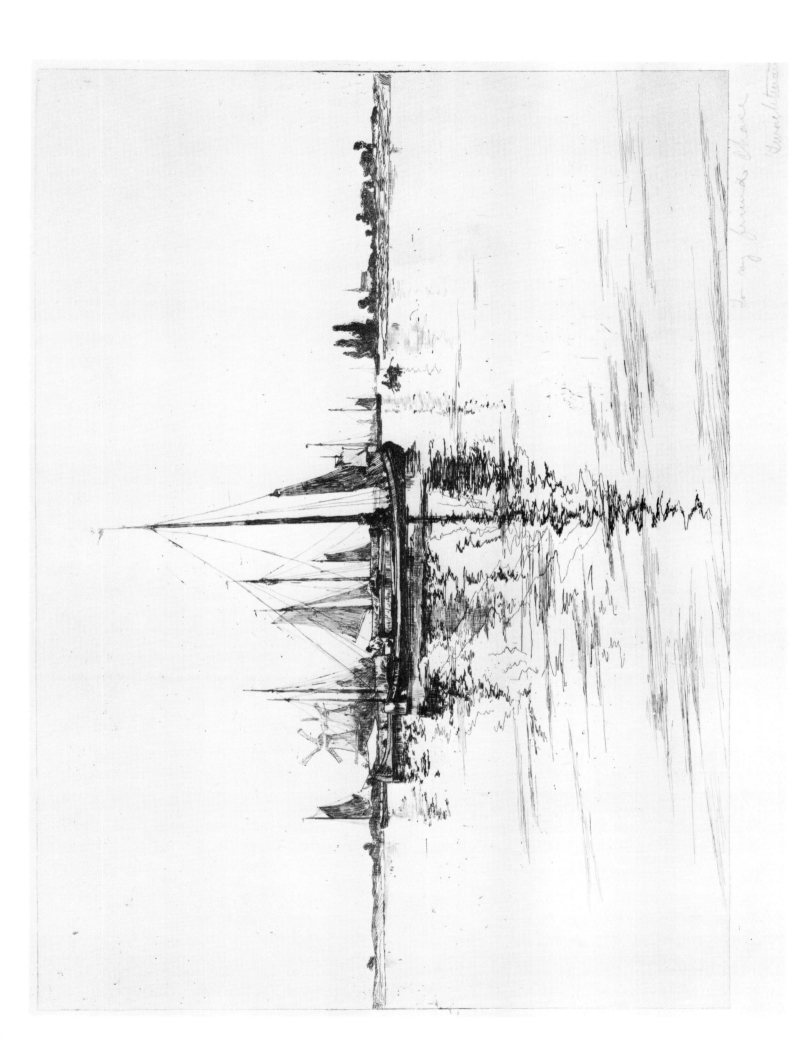

97. JOHN HENRY TWACHTMAN. *Boats on the Maas*, 1881–1883. Etching (Baskett 119, I/II). 12½ x 17¾".

98. MARTHA (MATTIE) TWACHTMAN. *A Ruin on Mill Creek, Cincinnati,* 1880. Etching. 4 x 5⅛″.

99. CHARLES A. VANDERHOOF. [Sea scene], 1891. Etching. Plate 4⅞ x 7¹⁵⁄₁₆″.

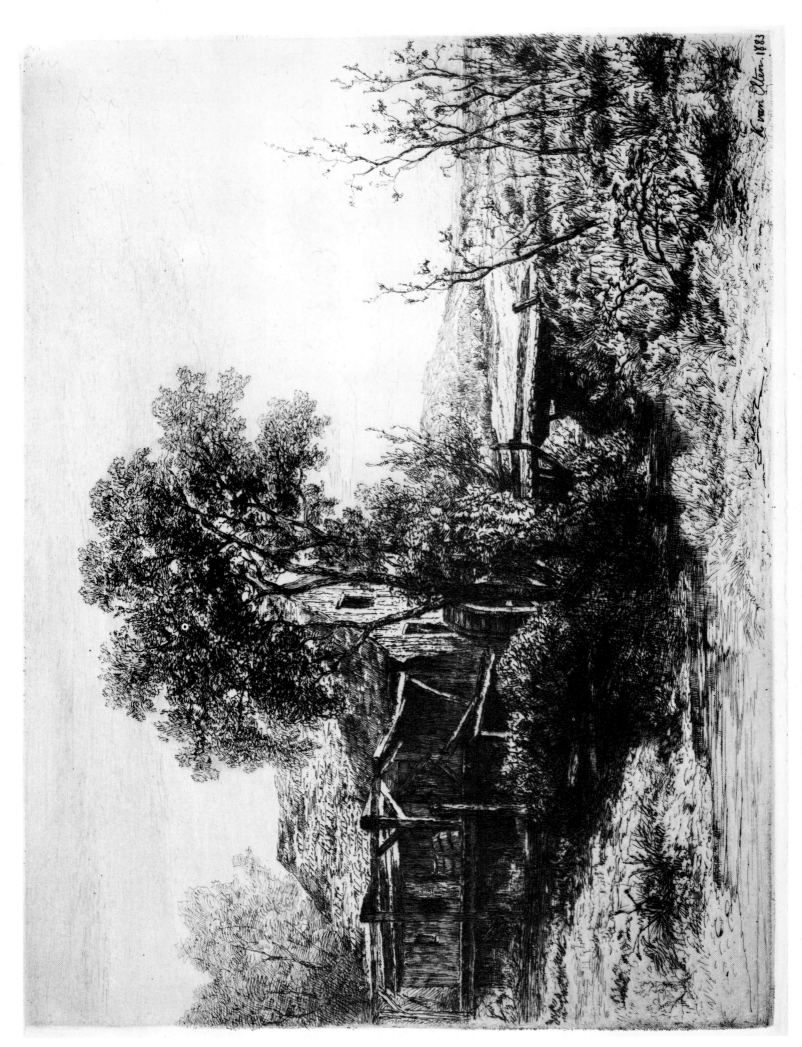

100. Hendrik Dirk Kruseman Van Elten. *The Deserted Mill*, 1883. Etching. 9⅜ x 12½".

101. CHARLES ALVAH WALKER. *Pastoral Landscape*, 1894. Monotype. 22 x 36″.

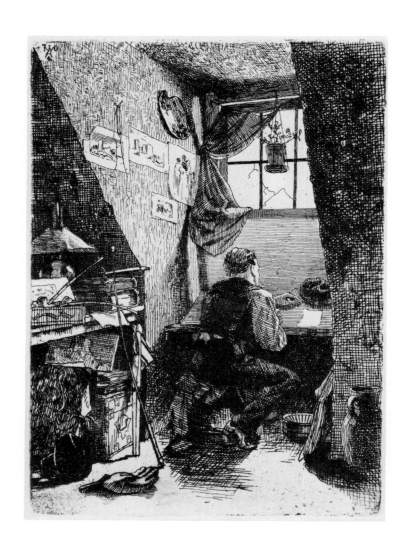

102. ANDREW W. WARREN. *The Etcher*, n.d. Etching. 5¼ x 3⅝″.

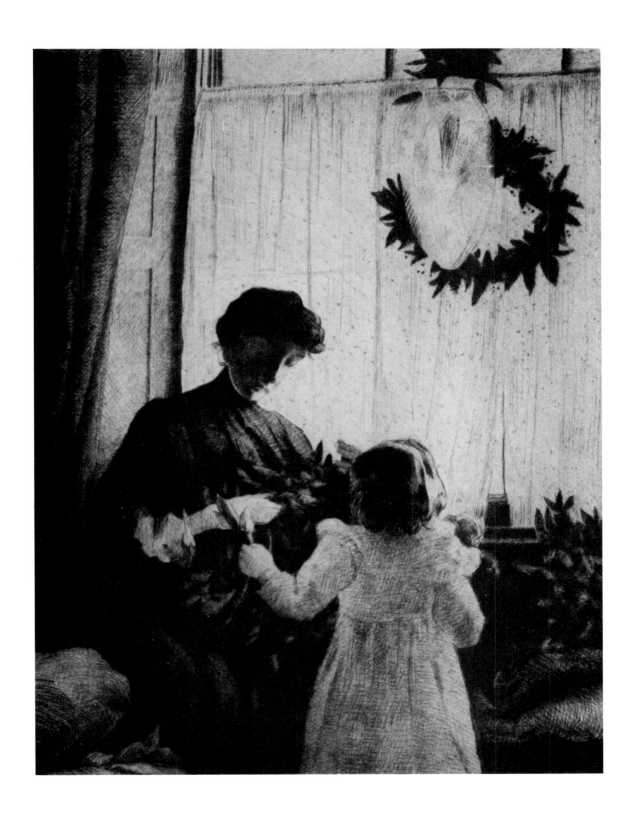

103. JULIAN ALDEN WEIR. *Christmas Greens*, 1889. Etching and drypoint (Zimmerman 4, V/V). 7¹³⁄₁₆ x 5⅞″.

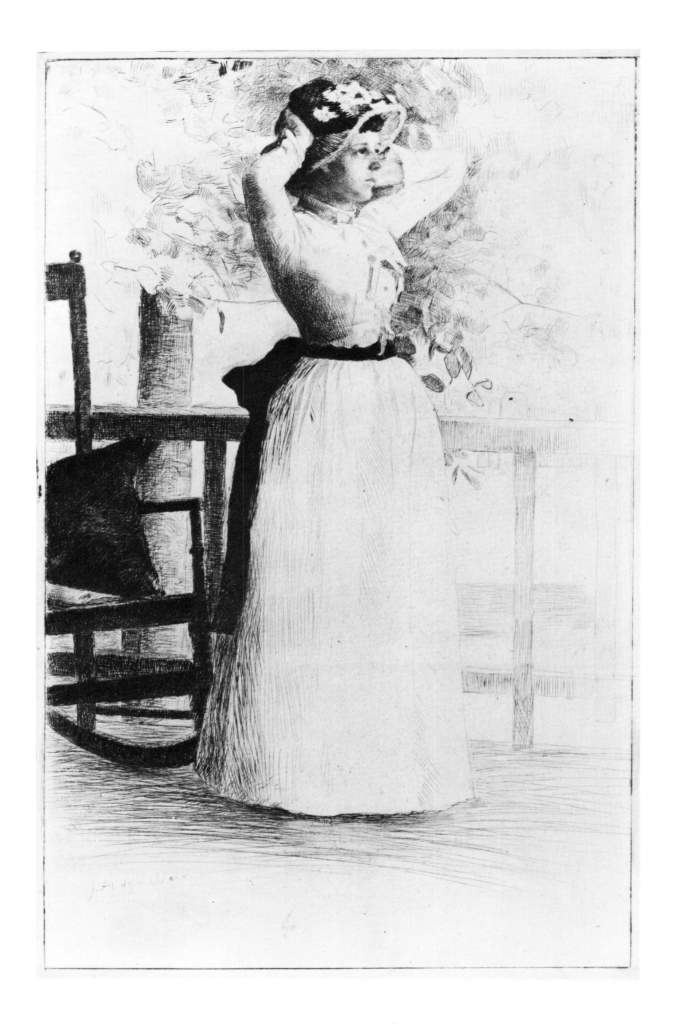

104. JULIAN ALDEN WEIR. *Portrait of Miss Hoe*, 1889. Drypoint (Zimmerman 19, IV/IV). 10 x 6³⁄₁₆″.

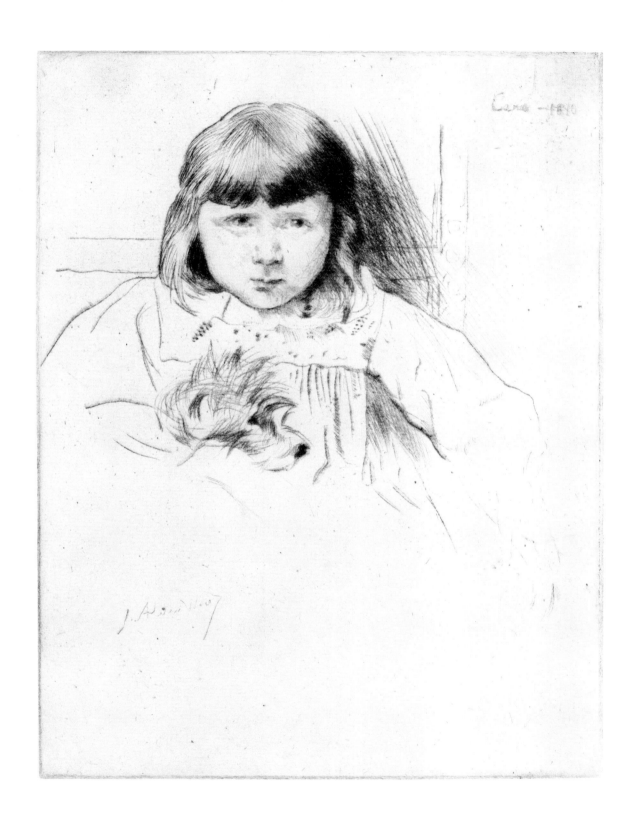

105. JULIAN ALDEN WEIR. *Gyp and the Gypsy*, 1890. Drypoint (Zimmerman 48, only state). 7¹³⁄₁₆ x 5⅞″.

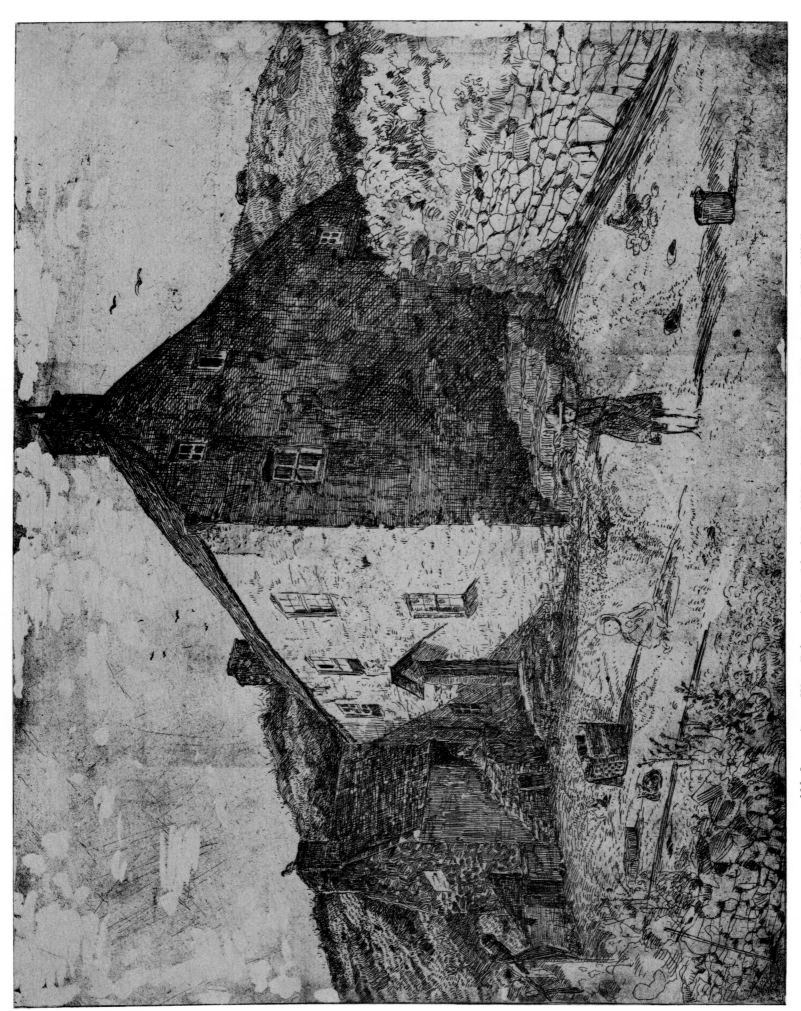

106. Julian Alden Weir. *Fisherman's Hut—Isle of Man*, 1889. Etching (Zimmerman 116, only state). 8⅞ x 11¹³⁄₁₆".

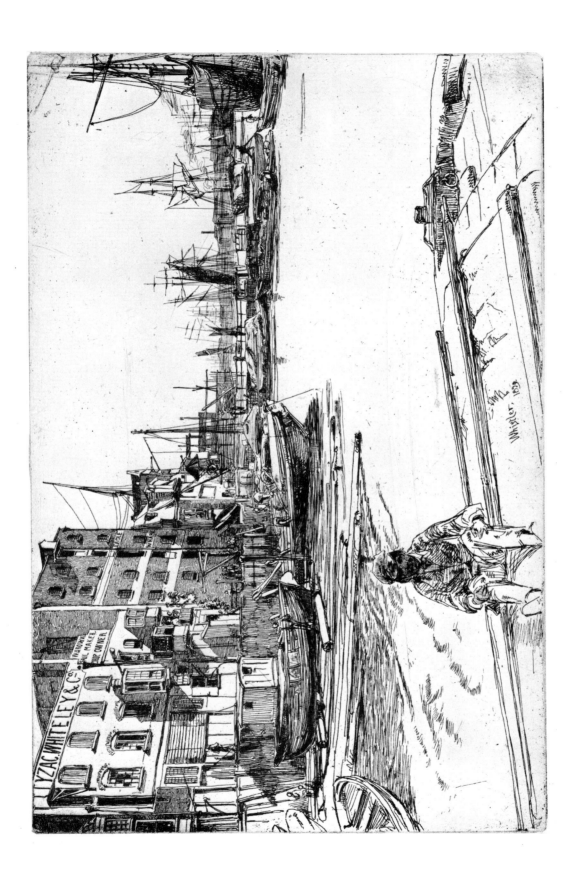

107. JAMES ABBOTT MCNEILL WHISTLER. *Eagle Wharf or Tyzac, Whiteley & Co*, 1859. Etching (Kennedy 41, only state). 5⅜ x 8⅜".

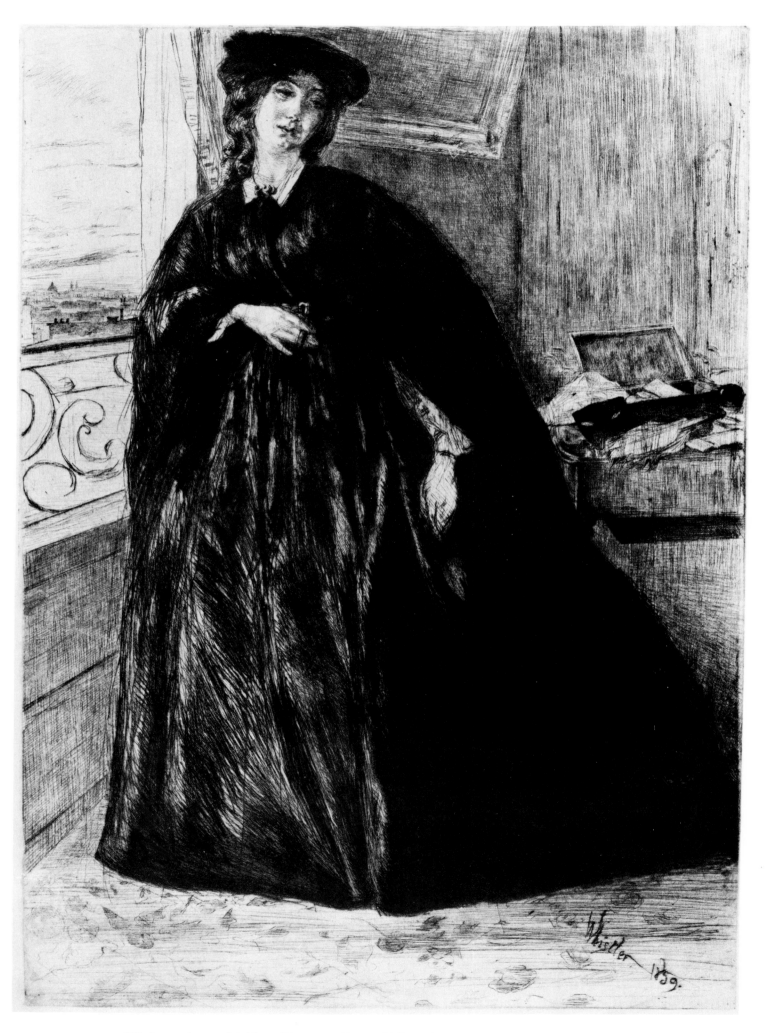

108. JAMES ABBOTT MCNEILL WHISTLER. *Finette*, 1859. Etching (Kennedy 58, IX/X). 11⅜ x 7⅞″.

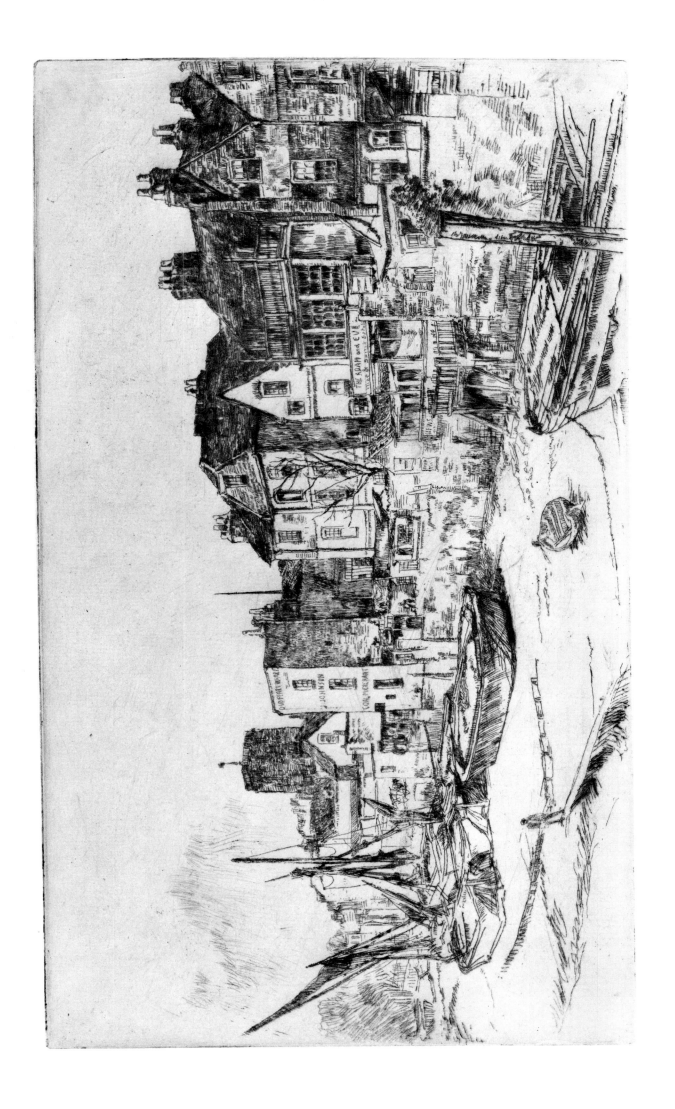

109. James Abbott McNeill Whistler. *The "Adam and Eve," Old Chelsea*, 1879. Etching (Kennedy 175, I). 6⅞ x 11⅞".

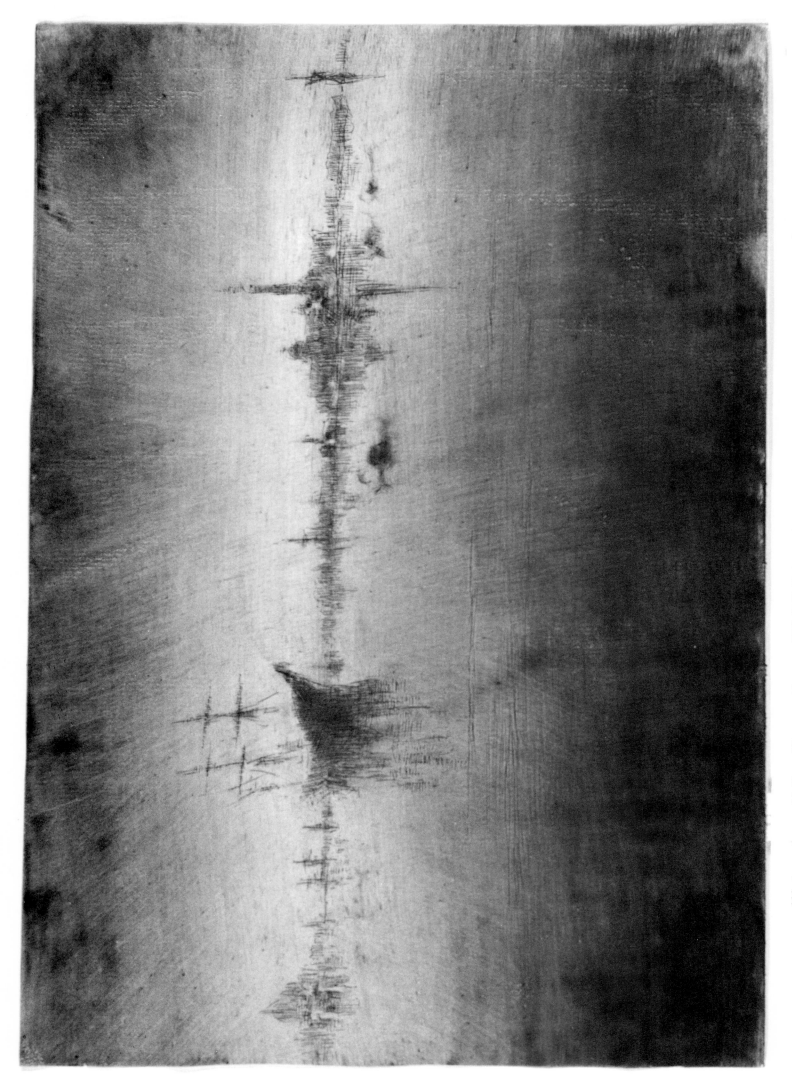

110. JAMES ABBOTT MCNEILL WHISTLER. *Nocturne*, 1879–1880. Etching and artistic printing (Kennedy 184, between IV and V state). 7⅞ x 11⅝".

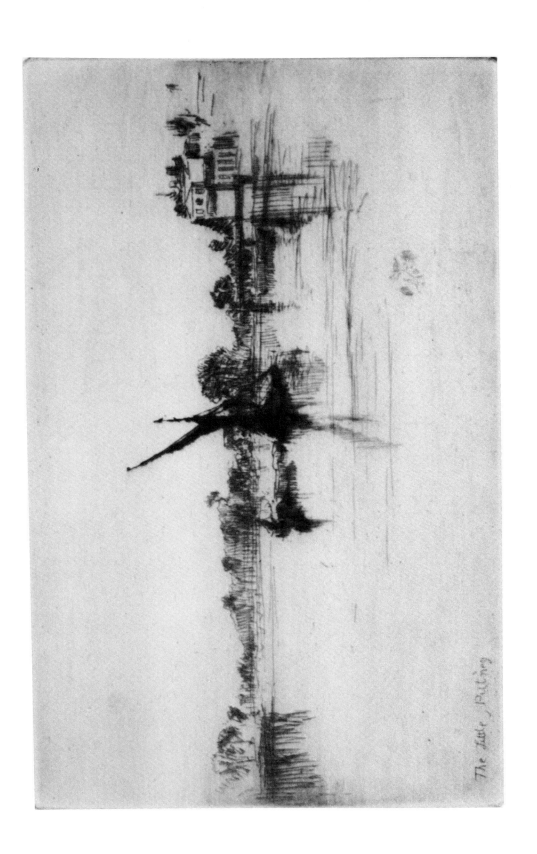

The Little Putney

111. James Abbott McNeill Whistler. *The Little Putney, No. 2*, 1879. Etching (Kennedy 180, III/III). 4¾ x 7⅞".

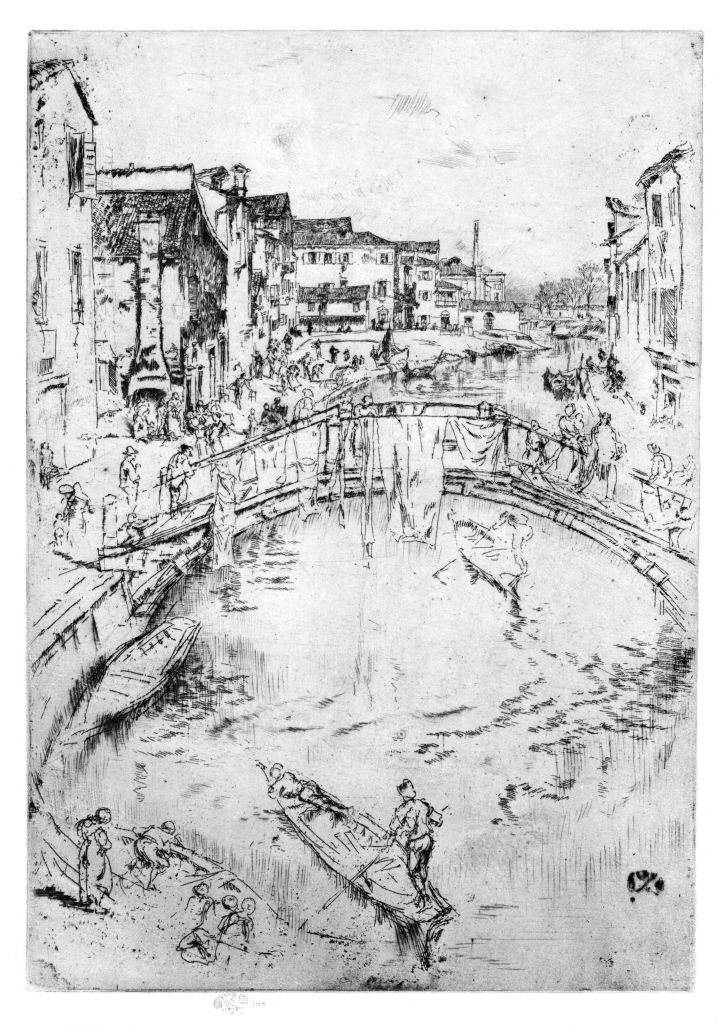

112. JAMES ABBOTT MCNEILL WHISTLER. *The Bridge, Venice,* ca. 1879–1880. (Kennedy 204, V/VIII). 11¾ x 7⅞″.

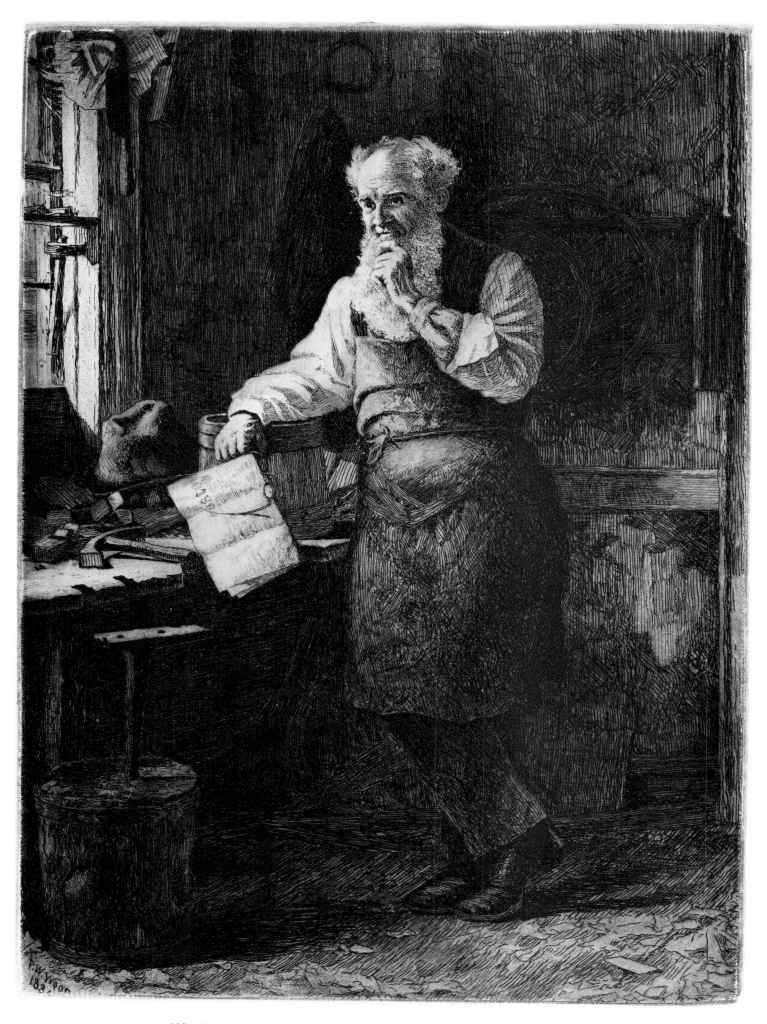

113. THOMAS WATERMAN WOOD. *Thinking It Over*, 1884. Etching. Plate 14 x 9¾".

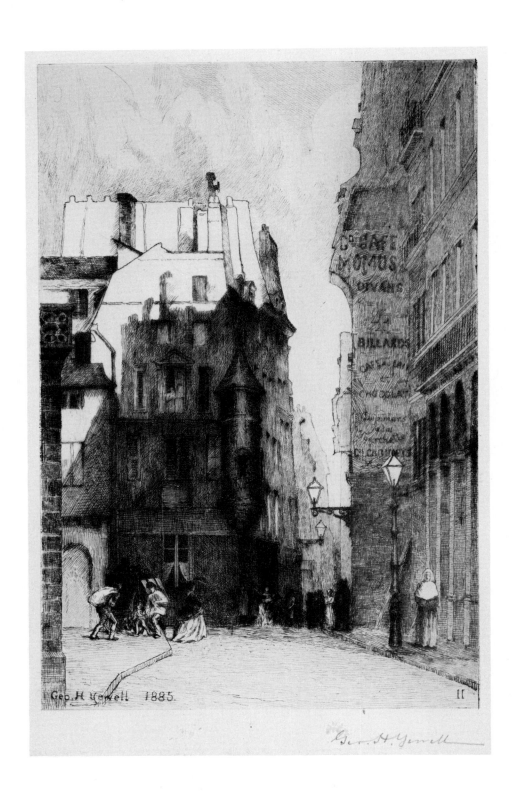

114. GEORGE HENRY YEWELL. *Rue des Prêtres, St. Germain l'Auxerrois, Paris,* 1885. Etching. Plate 7 x 4½".

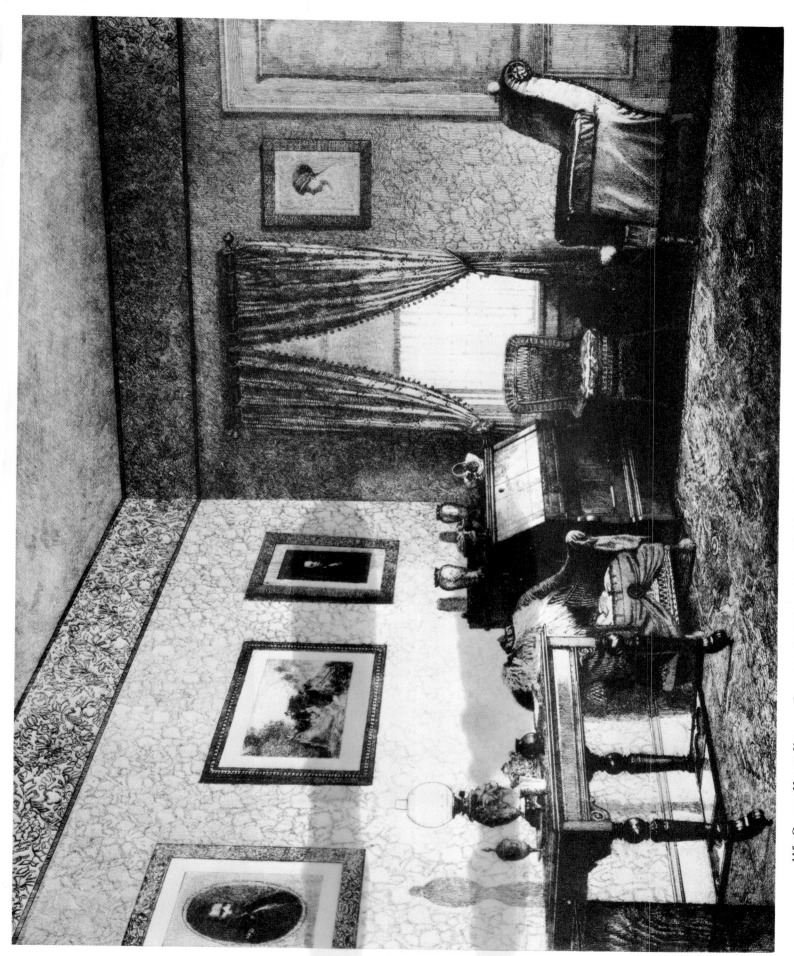

115. George Henry Yewell. *Room in Which General Grant Died (Drexel Cottage, Mt. McGregor, New York),* ca. 1888. Etching. Plate 11¾ x 14¾".